Voices from Amherst and beyond

The transformation of this world depends upon you

Wendy Ewald Thomas Keenan Martha Saxton Fazal Sheikh

Steidl

While I have been here I have been given the opportunity to meet a group of Americans who seek to work for the immigrants in Springfield. In 2006 I helped create a program that provides food from November through March, primarily for people who work in the fields, as it's very cold in this region then. Also we started a program called The Little Clinic in order to give medical services and medicine free to the immigrant community. In this way there has been an improvement in the health of immigrants. We help victims of abuse, victims of domestic violence or victims of abuse at their job, abuse from the police or from any authority. We have gathered together hundreds of students from different colleges and universities to talk to the children about the importance of education. They tell them how they should take the opportunity of being in school, and that the transformation of this world depends upon them, that they have to fight against the slavery of poor people, the slavery of inequality.

Luis Manuel Perez, Just Communities, Springfield, Mass., June 2013

Contents

Wendy Ewald 9 Foreword

Thomas Keenan 13 Introduction

Part One

Martha Saxton 27 The Missionaries

29 Setting Out

33 Reuben Tinker: Doing Good and Doing Well

43 Justin Perkins: False Prophets

57 Henry Lyman: The Highest Reward

63 Henry Van Lennep: The Artist

73 Elijah Bridgman: A Stranger in China

83 Shimeta Neesima: Stowaway

95 Kanzo Uchimura: Christians without a Church

99 The Ward Family: Missionaries of the Future

Part Two

Fazal Sheikh 117 Voices from the Amherst and Springfield Communities

118 Arline Wright

134 Carmen Rodriguez

140 Christine Wells

146 Jafet Robles

160 Rona Thompson

170 Luis Manuel Perez

182 Margarita Albelo

192 Parvin Niroomand

202 Paul Vasconcellos

210 Sellou Diate

Appendix

Molly Mead 227 Working with the Amherst Community

Destry Maria Sibley 229 Directory

233 Editorial note

234 List of Illustrations

235 About the Authors

237 Acknowledgments

Foreword

The project which led to this book began in 2012, when I invited Fazal Sheikh to Amherst College for the fall semester to work with the students in my course, *Collaborative Art: The Theory and Practice of Working with Communities*. I had long admired his groundbreaking portraits and his work with refugee communities in Africa, Afghanistan, India and Brazil, and I thought the students and the local community could benefit from his empathetic photographic eye, his ear for local concerns and conversations, and his masterful storytelling.

When he arrived in Amherst that spring, the country was in the depths of recession and home foreclosures were at a peak. Fazal talked about a project that would address the economic vulnerability of some of the people in the Pioneer Valley—the area in which the wealthy island of Amherst is located.

For several years now, each fall, my students have carried out art projects with members of the Amherst Senior Center, many of them immigrants from Latin America and the Middle East. They live in large apartment blocks in the center of town, near the college, though their presence is mostly hidden by groves of trees. Until they are pointed out, the students are mostly unaware of the more than one hundred public housing units and their residents.

This was where we started. But Fazal wanted to go further. He wanted the students to look beyond their campus environment, beyond the "tofu curtain"—the Holyoke mountain range, which shelters the wealthy colleges and universities of Amherst and Northampton (and the organic farm movement that thrives there) from the Springfield metropolitan area.

In Springfield, 40 percent of the population is Hispanic. A super-highway has cut off part of the city creating a zone that is toxic and virtually inaccessible. Twenty-one percent of Springfield's families live below the poverty level and the crime rate is one of the highest in the U.S.

Terras Irradient—Let them give light to the world—has been the motto of Amherst College since the days when its founding charter

emphasized the training of missionaries to spread Christianity in faraway countries. Now Fazal and I wanted to bring the focus closer to home and to make the connection between Amherst's history in the world and an immigrant community in our midst.

To help with this, Sarah Barr, the director of academic engagement programs at the Center for Community Engagement at Amherst, introduced Fazal and myself to Destry Maria Sibley. Destry is an Amherst College graduate who in 2010 started an organization called "Springfield No One Leaves/*Nadie Se Mude*" supporting tenants and former homeowners living in recently or soon-to-be foreclosed homes.

With all this in mind, we hit on the idea of tracing Amherst's history and its mission and looking at its legacy in the present day. We visited Mike Kelley, at the Archives and Special Collections department at Amherst and learned more about the college's original statement of purpose: "to educate pious indigent young men of promising talents and hopeful piety… to obtain a liberal education with a sole view to the Christian ministry."

Mike's enthusiasm for the missionary archives, especially the photographs and etchings, was infectious. We discovered that between 1830 and 1950 nearly 150 Amherst graduates had travelled thousands of miles to work as missionaries in Hawaii, the Middle East, India and China, as well as across the United States. With this evidence of Amherst's early vision, we decided to use the early missionaries' lives as a backdrop for an examination of the college's community relations today.

The first step was to ask each of my students to research one of the nineteenth-century missionaries and collaborate with a member of the Amherst Senior Center in making an art piece. Meanwhile, Fazal met people from the Amherst and Springfield communities and listened to stories they were eager to tell. In his usual meticulous fashion, he wrote the stories down, made a portrait of each of his subjects, collected and scanned their family photographs, and finally went over each of their stories for approval before publication in this book.

We then asked Martha Saxton, a professor of history and gender studies at Amherst and the author of several biographies, to research and write about some of the early Amherst missionaries' lives. For myself, I was delighted to pore through boxes and boxes

of their photographs, drawings and memorabilia in the college archive.

As a result of these various strands of inquiry, we were able to compare the ambitions that drove those early Amherst College graduates—fueled by religious conviction—with the ambitions and policies of local outreach organizations, including the Center for Community Engagement and No One Leaves, working across the Amherst and Springfield districts today.

Finally, we asked Thomas Keenan, a graduate of Amherst and now professor of the human rights program at Bard College, to introduce the project and consider the work and attitudes of these early missionaries in the light of current-day human rights discourse and practice. His essay reminds us that the actions and assumptions of those who provide aid to others, whether in foreign countries or among our own communities, must be continually interrogated and challenged.

There is a connection—indeed, an evolutionary continuity—between this missionary past and what colleges like Amherst now deem to be their social responsibilities. What does it mean *now* to have a Center for Community Engagement at Amherst College? How might this connect with the words of the college's charter: "to engage the world and lead principled lives of consequence"?

Wendy Ewald, Amherst, May 2014

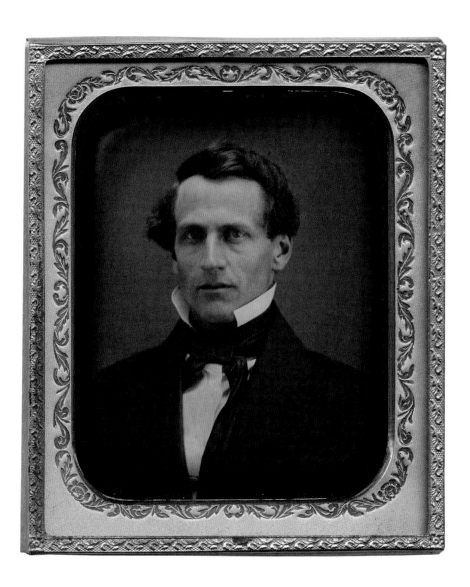

Daniel Bliss, 1852

Introduction

Thomas Keenan

Against all assumed authority
Human rights, civic engagement, and the missionary tradition

In the fall of 1858, Daniel Bliss, Amherst College graduate of 1852 and recently arrived Congregational missionary in Lebanon (then Syria), was relocated from his first posting in the mountain village of Abeih, "the cradle of higher education in Syria," [1] to the more remote village of Sûq-al-Gharb.

There, with his wife Abby, he opened a night school for local boys and young men, but after some initial success most of the students stopped attending. One of them, though, braved the wrath of the monks at a nearby monastery—who on Bliss's account were behind the defections—to continue his studies. The boy made a point, Bliss says, of coming at night with a lantern, not only to find his way in the darkness but also to make it obvious to the monks that he was there. The light was a message of rebellion. Although the boy was not a member of the church, Bliss says of him: "He was a Protestant." And Bliss's explanation makes it clear that this was less a matter of denomination than one of character. The boy is virtually an allegorical figure: "He was a Protestant, protesting against all assumed authority, whether it was claimed by Pope, Bishop, village Priest, or by a Congregational Minister or Presbyterian Session." [2]

What is protest here? In the name of what is it mounted? The boy claims the right to go where he pleases and to choose his own way. He declares his independence. Bliss makes it clear that the dissent is non-sectarian and non-denominational, more an expression of an implicit political theory than a taking-of-sides, but also not a challenge to authority as such. It somehow goes deeper: it identifies authority as a claim, and challenges its "assumption," the way it all too often goes without saying or without justification. There are always authorities, Bliss hears the boy saying, but their power to rule remains contingent. Authority must not be assumed, treated as natural or pre-ordained by birth or status, exempted in advance from questioning. There is no right to rule; rather, there is a right to challenge the assumption of that right. Authority is something that is permanently

subject to protest—hence Bliss sees, in the story of the boy, a lesson about rights and power, and offers a vision of politics as the sphere of permanent contest.

Is it surprising that this is written by a missionary?

A few years ago, the *Guardian* organized a series of commentaries in response to the question: "Is there a distinction between religious missionaries and people who work to spread human rights on secular grounds?"[3]

Sometimes this question is posed in order to provoke responses, not about missionaries, but about human rights activists—it suggests that among them, however secular their creed, there remains a hint (or more) of the desire to convert, to spread a gospel, to bring the light of a revealed truth to those who still suffer in the darkness.

Symptomatically, none of the *Guardian*'s commentators took this path. Indeed, the moral and political legitimacy of the human rights enterprise was not put into question at all. What was asked, rather, under the title: "What's wrong with missionaries?" was whether missionaries might be newly appreciated, or in some sense rehabilitated, by being seen as something more akin to human rights workers. The debate turned around whether there was, among contemporary missions, still a little too much coercion or conversion, and not enough respect for the agency and dignity of the recipients of their attention. Some defended missionaries as a "force for good." Others, such as the feminist philosopher Ophelia Benson, insisted that "there is a difference between spreading beliefs and values, and forcing them on people." Mahablog author Barbara O'Brien took this worry to its logical extreme: "The more zealous the missionary, the more likely the mission becomes a means to act out aggression and to eliminate the other through assimilation." No one said this about human rights activists.

Yet the question of the missionary dimension of human rights work remains. It is a recurrent feature of contemporary critical accounts of the practice of human rights. Miriam Ticktin summarized it admirably in her 2011 book *Casualties of Care*, when she asked about "those who wanted to promote a new *mission civilatrice*, or civilizing mission, in the name of human rights." Where once a colonial project, propelled at least in part by Christian universalism, had sent missionaries and administrators around the world, now another sort of global ethic is the catalyst: today, she writes, "a form of universalism based on rights explain[s] the 'moral obligation' to once again interfere, walking in the footsteps of the colonial legacy."[4]

In a similar vein, a decade earlier, the anthropologist Talal Asad had written memorably: "It is generally agreed that, as an ideal, human rights are intended for a secular world. They derive their authority not from heaven but from this earth. Yet most human rights theorists don't address seriously enough the thought that human rights is part of a great work of conversion."[5]

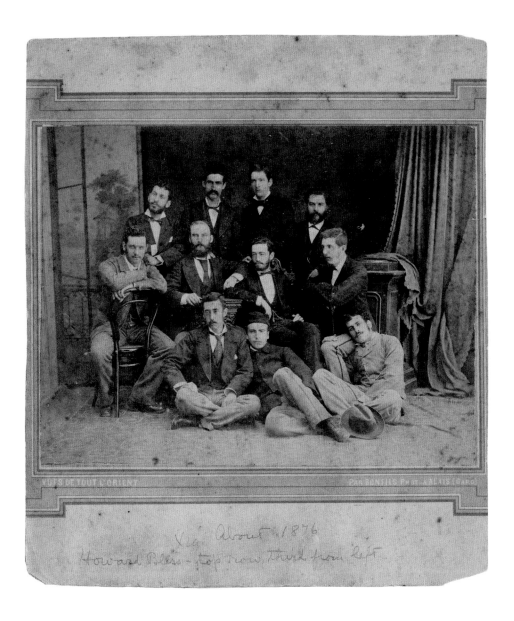

About 1876
Howard Bliss - top row, third from left

Howard Bliss, with Syrian Protestant College faculty, c. 1876

Today, the theorists are increasingly facing this question, but it remains a very difficult debate to have with activists, even as the emergent doctrines of a 'right to intervene' and a 'responsibility to protect' make the political and sometimes military force behind human rights ideals more important than ever to reckon with. And the widespread presence of 'faith-based' non-governmental organizations, from World Vision to Invisible Children, actively doing human rights and humanitarian work makes the analogy between the missionary and the activist much more than a merely abstract identification.

Wendy Ewald and Martha Saxton's explorations in the archives of Amherst College, founded in 1821 under the motto "Terras Irradient"—'Let them enlighten the lands'—and dedicated to the "education of indigent young men of piety and talents for the Christian ministry," bring these questions back with a new force. To be reminded of the words of the founding charter of the college, constituted by the Permanent Charitable Fund that endowed it, is still somewhat jarring. Why was there a need for such a college? Because of "the deplorable condition of a large portion of our race who are enveloped in the most profound ignorance, and superstition and gross idolatry; and many of them in a savage state without a written language; together with vast multitudes in Christian countries of which our own affords a lamentable specimen, who are dispersed over extensive territories as sheep without a shepherd."

The college was created in order to address this pastoral deficit, by men who were "under the conviction that the education of pious young men of the finest talents in the community is the most sure method of relieving our brethren by civilizing and evangelizing the world."[6]

Today, the project of "relieving our brethren," not so much from ignorance and superstition and idolatry as from suffering and injustice, continues to inspire young men—and women—to go to places near and far and confront more and less obvious forms of savagery. That they are generally trying to put an end to the savagery rather than to convert the "savages" makes an important difference, as does the fact that the task of relief is often first and most assertively adopted by those who suffer, before any would-be shepherds arrive from afar.

But the passion to right wrongs suffered by others still bears more than a passing resemblance to the mission of illuminating the world. The universalism proudly defended, in fact embraced by most human rights advocates, loudly asserts a degree of conviction that reaches for the absolute: "No one shall be subjected to torture or to cruel, inhuman or degrading treatment or punishment," states Article 5 of the Universal Declaration of Human Rights, for instance. "No one" means no one; there is no getting around the fact that there are no exceptions to this rule.

This absolutism, with its force of certainty, is deeply entrenched in human rights discourse, yet is rarely acknowledged—and when it is, it comes with a

bodyguard of self-evidence ("You don't think torture is permissible, do you?"). This undercurrent of militancy is neither negligible nor dispensable—the determination to struggle, even to fight, out of absolute conviction is an irreducible and often attractive feature of the language of human rights.

The protestant challenge to "all assumed authority" is part of this too, but it can also undercut that very force of certainty. Bliss's young student, as his teacher saw clearly, was capable of disagreeing not only with the monks and priests but also with the Congregational minister himself, and when that dissidence becomes structural or habitual then the authority that is challenged must reassert and re-legitimize itself—even the authority of self-proclaimed absolutes such as the values of universal human rights. Precisely because "they derive their authority not from heaven but from this earth," as Asad pointed out, there is nothing transcendent about them. Authority is never more than a claim that must be defended. In the case of human rights, that is both a structural feature (nothing beyond we humans underwrites or guarantees them), and a political necessity (however self-evident they might be, rights do not simply enforce themselves).

In other words, there is an oscillation at the heart of human rights discourse. On the one hand, it can be marked by a robust and sometimes even imperial absolutism, a foundational commitment to the natural, universal, unchanging character of rights. The Universal Declaration can look like a holy book in this regard. "Human rights today have become a secular religion," Elie Wiesel said famously, speaking at the Clinton White House in 1999.[7] On the other hand, the invocation of human rights represents a permanent challenge to absolute authority, a humanism of individual agency that has consciously forsaken both coercion and any natural or supernatural guarantees and represents a deep commitment to dialogue and negotiation. Both dimensions are irreducible, and incompatible. The language of human rights is built up around this contradiction. We cannot understand what is happening when people invoke the words "human rights," whether critically or affirmatively, if we do not appreciate this structural tension.

The shepherds who set out from Amherst to civilize and evangelize those whom they considered not strangers but brothers do not seem to have suffered terribly much from such a tension, at least not explicitly. While embracing a version of humane universalism, they were nonetheless secure in their possession of a revealed truth. Their writings express another version of this double bind of egalitarian dialogue and absolutist interventionism.[8]

Mary Van Lennep, the wife and "female assistant missionary" of Amherst's Henry Van Lennep, working in Turkey in the 1840s, expressed the double commitment economically: "I believe it is a general fact that the Orientals are regarded by us Americans as semi-barbarians, or at best as grown-up children. Nothing is more erroneous. The more we associate with them the more we feel that they are entitled to respect and friendship, as much so as any polite, agree-

able people in our own land who are without true religion. With them we must observe the same strict rules of propriety, the same careful attention to the truth without disgusting them. They have the same hopes, fears, affections that we have, but their views of religious truth are dark and cheerless."

Likewise, Elijah Bridgman, another Amherst graduate, assigned to China, was a thoroughgoing humanist: "With their peculiarities, we have little more to do than to understand them with the simple object to meet and hear the Chinese as men, not as infernal or celestial, but as human beings." He was equally confident about how to make things better: "No nation on earth has yet done for itself, much less for others, one half of what it ought to do, or will do, when both the rulers and the ruled learn to act according to…the New Testament." He saw no contradiction between these claims: precisely because the Chinese were human beings, they were capable and deserving of access to the truth, even when opening up that pathway required assertive intervention (including military intervention, as in the case of the Opium Wars). Thus, in 1858, he could applaud the "wide breach [that] has been made in the wall of exclusiveness, which so long interposed a formidable barrier between the heralds of salvation and the perishing millions of this empire." "Opening up" China was for him a matter of nothing less than freedom: at once of trade, of democracy, and of faith. Or as his friend Samuel Wells Williams wrote to him: "I have a full conviction that the seclusion policy of the nations of Eastern Asia is not according to God's plan of mercy to these people, and their governments must change them through fear or force, that the people may be free."

Although Fazal Sheikh, too, has travelled far and wide in the lands of the suffering, from refugee camps to ruined cities, this time he chose to do something different. Confining himself to the vicinity of that same Amherst which had launched so many missions, he explored the lives of some of its less visible denizens. Many of them have come from far away, and all of them have undergone extraordinary odysseys and tribulations. They have stories to tell and claims to make.

The photographer's intervention is at once deep, even exhaustive, and extremely minimal. He takes photographs, he pictures the people he talks with, but mostly he speaks and listens. He reveals an extraordinary commitment to words, and to words produced in conversation.

The commitment to dialogue is at the heart of the portraits collected here. That the records of these conversations bear almost no trace of their interlocutor converts them into passionate testaments of individuality and agency. The monologues that result bear witness to all sorts of suffering, injustice, exploitation, and tragedy, but also to escape, faith, salvation, and even protest. What they all share is the self-assertion of a narrator, a speaker who says "I" and has stories to tell.[9]

In their voices we hear, not an expectation of (far from it), but a demand for, equality and justice, often implicit but sometimes explicit. It almost never takes the form of a formal claim of rights—and when it does, it starts from precisely their absence: "We don't even think to find out what our rights are," says Sellou Diate, from Senegal, and when she does, she learns that "there were many things I didn't know about my rights." But in the narratives of misfortunes and wrongs, what stands out is something like a demand for the recognition of what Hannah Arendt called "the right to have rights," a demand to be seen, and heard, as others who share something basic with the rest of us, namely the fact of being human.[10]

Thus Luis Manuel Perez, who has made a long, dangerous journey from Mexico, can say: "I just want people who don't believe, or don't know immigrants, to understand the reason we are here in this country, so that [they] can put their hands on their hearts and accept us as any other human being and give us the opportunity to live in freedom."

The speakers express this demand for human equality and recognition in different ways. Some start or join activist organizations (No One Leaves) or social service providers (Project Coach), teach and work in clinics and drop-in centers, create institutions to provide food and medical services to those without them (The Little Clinic). Their militancy ranges from the quiet and humanitarian to the organized and outspoken: Diate wants to "stand up to injustice," and Perez listens with pride as a group of college students he's organized tells immigrant children that nothing less than "the transformation of this world depends upon them." They have to "fight against the slavery of poor people, the slavery of inequality."

Surely there are activists and missionaries (religious faith plays a major role in these narratives) lurking in the vicinity of many of these activities, but the testimonies do not dwell on them, underlining not so much the importance of advocacy on behalf of others as the necessity of speaking for oneself. Jafet Robles' account of "trying to do a speech" is exemplary. Born in Puerto Rico, but raised in Springfield, Mass., he insists: "you gotta have, like, courage to talk with these people, and you know, I have that courage. I'll speak up with what needs to be said, whether people want to hear it or not."

The self-effacing photographer wants to, and lets us, hear all this. Negotiation and dialogue are his watchwords. But no record of his voice appears here. His presence remains essential to what is said but his own interests, commitments, passions are elusive. His portraits show us who is speaking, but otherwise his role is limited to haunting the texts engendered by his intervention.

With a couple of exceptions.

Paul Vasconcellos, suddenly, shockingly, addresses him in the second-person, and does so in a way that makes his mode of operation public and

explicit: "I developed a trust with others, as I have with you," he tells Sheikh, "so I can speak about these things more openly, more freely. From the work you are doing, we see someone, but we have no idea what that person has really been through. You look at the surface and then delve beneath that surface to listen to what the person holds within them."

The producer of flat surfaces, then, the portrait-maker, is also a listener—and an active one. He is the catalyst of the speech of the other; the means by which "what that person has really been through" comes to expression. Because you are here, he is told, I can speak about these things. That is what dialogue means—not two people simply 'expressing themselves' or 'telling their stories,' as if the stories and the expressions were already there, just chattering along, but two people enabling each other to speak, bringing out the words of the other, often in unanticipated ways.[11] There is no dialogue without this sort of intervention.

And the photographer is also named—just once, but it matters.

"Fazal, you have to keep praying for me," says Sellou Diate. Her prayer for a prayer is both an imperative and a request, a call to the photographer to do more than just record her image or her words. He needs to say something, she seems to say. Or perhaps not: she asks that he "keep praying," *keep* doing what he's been doing, for her. In that sense, we should understand the photographs and the faithfully transcribed words here as a prayer in their own right, another sort of entreaty, another form of appeal or intervention, a true *intercession* on behalf of Diate and the others.

The photographer is neither a missionary nor a human rights activist, at least not by profession, but he prays and he transmits a demand for justice. In a word, he protests.

Being a missionary and being a human rights worker is not the same thing. But the doctrinal certainty and the zeal to rescue that often motivates both enterprises lend them a certain family resemblance. Those who profess a conviction about what they call human rights need to face up to the possibility that "when human rights as politics becomes a fighting creed, a call to arms," as it always does in one way or another, it runs the risk of erasing at least some of the borders between these figures.[12]

What is striking, though, in the Amherst missionary archive, is not the desire to convert, nor the demand for submission to the truth, nor the imposition of authority on the unenlightened, but rather the rich spirit of dissidence, critique, and confidence in the rebelliousness of ordinary people that is legible there. That so many of the future missionaries began their college educations by not only attending classes but also teaching them—often literacy classes, to the free black parishioners of the African Sunday School—was telling. Reading and writing are not simply skills, nor simply for Bible study; they open up individuals to places

and times beyond the horizon of the present, constitute subjects not just as passive receptacles of wisdom but as producers and critics of knowledge themselves.

The missionaries, at least some of them, took those lessons in autonomy abroad with them. Justin Perkins praised the "sacred spark of freedom," Henry Van Lennep recognized the raw force of "the voice of public opinion," and Paul Ward insisted on the necessity of "tact and sensitive understanding of the realities of what non-westerners call imperialism." Bliss admired the defiantly independent spirit of protest in his young student.

Robert Kaplan, in the account of the nineteenth-century American missionaries in the Middle East that opens *The Arabists*, credits them with nothing less than the advent of Arab nationalism. Their track record in conversions was not particularly good, he writes, but "by setting up schools and medical clinics... and by identifying with and learning the languages of the region they served in, the Congregationalists were starting to become more like romantic explorers and Peace Corps volunteers than real missionaries." Those schools were not just night schools in remote villages, either. Daniel Bliss's proudest accomplishment was the creation of the Syrian Protestant College, today known as the American University of Beirut. Kaplan considers it to be "probably the most inspired idea in the history of American foreign aid." In particular, he writes, it "became an instrument for the promotion of Arab sovereignty." The exemplary piece of evidence for this claim, he writes, is *The Arab Awakening*, "the seminal work of Arab Nationalism published in 1938 [by] George Antonius," in which the author traces "the first organized effort in the Arab national movement" to the Syrian Protestant College in 1875.[13]

There are, of course, more complicated geopolitical readings of the project of starting overseas educational institutions on an American model, readings that focus on the strategies of soft rather than hard power. Those complications are important to introduce. But too often in their hermeneutics of suspicion they miss something more obvious and interesting. Where the school projects of people such as the Blisses are concerned, the surprising feature is what Kaplan calls their "egalitarian spirit," exemplified in Bliss's cornerstone-laying speech for the Syrian Protestant College in 1871. There the Congregational missionary said: "This college is for all conditions and classes of men without regard to color, nationality, race or religion. A man, white, black, or yellow, Christian, Jew, Mohammedan or heathen, may enter and enjoy all the advantages of this institution for three, four or eight years; and go out believing in one God, in many gods, or in no God. But it will be impossible for anyone to continue with us long without knowing what we believe to be the truth and our reasons for that belief." [14]

This spirit and practice of argument, the provision of reasons rather than conclusions, a trust in the other to reach his or her own decisions—a distrust of

all assumed authority and a fidelity to protest itself—had marked Bliss from his college years on, at least in his own telling of his life.

At his Amherst graduation ceremony in 1852, he gave a speech, a political one and one that was about politics as such. Irritated by a Congressional resolution silencing "agitation of the slave question during the session," he chose "Agitation" as his topic. His targets were: "the wise man and the sober-minded man and the conservative man [who have] declared that the peace and union of society required that all agitation should stop."

He drew some conclusions from this: "Agitation in politics?—No: the edict has gone forth, and finality is now written on Agitation legislation. Finality! Strange word in the vocabulary of political language; doubly strange in light of the nineteenth century, and triply strange in the land of the free. [...] O! tell it not lest the crowned heads of Europe rejoice. Finality! There is no finality this side of the gates of the New Jerusalem or the brazen bars of Hades. Chain the lightning in its track and hold the thunder still, but freemen will discuss and agitate principle as long as:

> Liberty like day
> Breaks on the soul and by a flash from heaven
> Fires all the faculties with glorious joy."[15]

With conviction, he said: "there is no finality," and certainly not in politics. Politics, particularly the politics of the free, is a matter of contest, dispute, and discord—which is to say, of speech and the exchange of speech, of principles in agitation, of the protest against all assumed authority.

It seems strange to hear this from someone who was about to become a missionary. Of course, politics and discussion were for him things of this world, and he expected that another world—whether the New Jerusalem or Hades— would surely follow. And he was not at all hesitant to engage in discussions, free discussions, about salvation and the soul, discussions that aimed at religious conversion.

But he disavowed coercion—the commitment to agitation is a commitment to the autonomy of the other, to the discussion between "freemen." In that respect, Bliss remains an unavoidable ancestor of civic engagement and human rights projects today, even or especially when, to quote the current director of Amherst's Center for Community Engagement, "engagement implies working with, rather than working for, and getting to know people, not simply give them something that they did not even ask for."[16]

At their best, the Amherst missionaries of the nineteenth-century already practiced this principled commitment to discursive exchange and collaboration, and it echoes, too, in the testimonies induced by Fazal Sheikh's conversations in

and around Amherst. Yet the specter of finality, of absolutes, of principles worth fighting for continues to inform these projects as well.

Can we speak of human rights without finality? Where human rights work is concerned, there is no simple distinction between the absence of coercion and the refusal to compromise on basic rights. There is only a blurred and often uncomfortable negotiation between the commitment to negotiation and the insistence that some things are simply not negotiable, between agitation and finality. Only the dogged maintenance of challenges to all assumed authority keeps this compromise respectable.

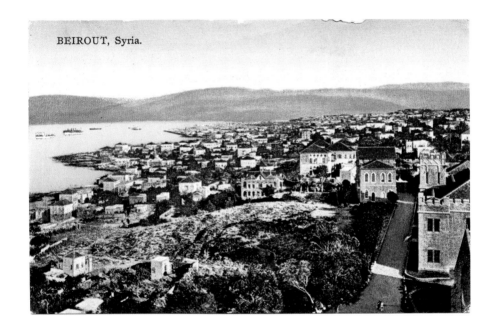

Beirut, Syria, postcard c. 1928

1. *The Reminiscences of Daniel Bliss*, Edited and Supplemented by His Eldest Son, New York: Fleming H. Revell Co., 1920, p. 131.

2. *Ibid.*, p. 111.

3. What's wrong with missionaries? Comment is free, *Guardian* (31 May 2010), http://www.theguardian.com/commentisfree/belief/2010/may/31/missionaries-religion-christianity. See also Jonathan Benthall, "Missionaries and Human Rights," *Anthropology Today* 11, No. 1 (Feb. 1995), pp. 1–3.

4. Miriam Ticktin, *Casualties of Care: Immigration and the Politics of Humanitarianism in France*, Berkeley: University of California Press, 2011, p. 78.

5. Talal Asad, "What Do Human Rights Do? An Anthropological Enquiry," *Theory & Event* 4, no. 4 (2000), sec. 50.

6. Cited in Edward Hitchcock, *Reminiscences of Amherst College: Historical, Scientific, Biographical, and Autobiographical*, Northampton, Mass.: Bridgman and Childs, 1863, pp. 160–161.

7. The White House, Office of the Press Secretary, "Remarks at Millennium Evening: The Perils of Indifference: Lessons from a Violent Century," (12 April 1999), http://clinton4.nara.gov/WH/New/html/19990413-850.html

8. All the quotations from Amherst missionaries (except those from Bliss's *Reminiscences*) are drawn from Martha Sexton's texts in this volume.

9. All the quotations from Fazal Sheikh's interviews are drawn from his interviews in this volume.

10. Hannah Arendt, *The Origins of Totalitarianism*, New Edition with Added Prefaces, San Diego: Harcourt Brace and Company, 1979, p. 296.

11. Director Anne Aghion captured a remarkable version of this in her film about the aftermath of

the Rwandan genocide, *In Rwanda we say ... The family that does not speak dies* (2004, 57 min.), during which a woman who lost most of her family to the killing squads addresses a man who was likely among them: "Rwamfizi, if you don't want this weight on your heart, if you want to be freed of it, reach out to me, let us speak in trust. In a real discussion, who knows where words will lead. Something will come out and you'll have your say." (I'm grateful to Anne Aghion for her transcription of the scene.)

12. Michael Ignatieff, *Human Rights as Politics and Idolatry*, Princeton: Princeton University Press, 2001, p. 22.

13. Robert Kaplan, *The Arabists: The Romance of an American Elite*, New York: The Free Press, 1993, pp. 25, 37, 34, 39.

14. Bliss, *Reminiscences*, p. 198.

15. Bliss, *Reminiscences*, pp. 74–79. The final lines come from Cowper's "The Task" (1785), a passage widely quoted in political sermons and speeches of the time, in particular anti-slavery orations.

16. See Molly Mead, "A Problem Shared: Working with the Amherst Community," in the appendix to this volume.

Part One

The Missionaries

Martha Saxton

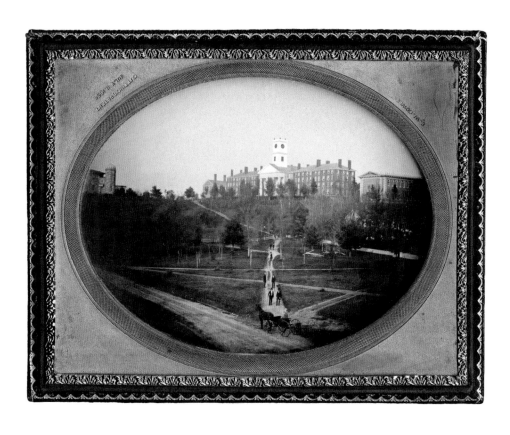

College Row, 1854 (original ambrotype)

Setting Out

Amherst College, founded in 1820, was one of many institutions and organizations that emerged during the Second Great Awakening, the series of religious revivals that heated up American congregations from the 1790s through the 1850s. As the movement spread across the country, so often did religious enthusiasm fire up congregations in northern New York State, particularly along the Erie Canal, that it became known as the "Burned Over District." These revivals infused Protestants—Congregationalists, Methodists, Presbyterians, Baptists, even Anglicans—with a desire to purify their lives of sin and share their new love of Christ and their testimonies of salvation. Very often, women converted first and tried to bring their family members along with them.

Conversion could be a painful process. It involved accepting the infinite depth of one's sinfulness and the impossibility of escaping it without reliance on the love of Jesus. But it resulted in relief from guilt and the fear of hell by dedicating one's life to God. Conversion meant seeing life through the lens of early nineteenth-century Protestant doctrine and culture. In New England this could include rejecting dancing and other activities considered frivolous, an emphasis on Bible study and serious and constant introspection, the subordination of wives to husbands, though with the understanding that women's piety was equal to, if not more powerful than men's. In evangelical families children were to be strictly obedient, men and women were to avoid extravagance, worldly display, and sensual indulgence. In the North, most evangelicals were anti-slavery and abstainers from alcohol.

The Second Great Awakening powered both conservative and liberal tendencies in the post-Revolutionary period. Its insistence on patriarchal authority, traditional sexual and personal morality closed off some of the radical possibilities of the Revolution, and did little to challenge the economic inequality that accompanied the industrial revolution transforming the Northeast. But it fuelled some of the activity against slavery and in favor of women's equality, and it supplied leadership and supporters for the reform of institutions such as prisons and insane asylums.

Noah Webster—now better known for his dictionary than his evangelical fervor—wrote of the founding of Amherst College, that it was to support indigent young men of "promising piety" to become ministers and spread the Prot-

estant "empire of truth" throughout the country and around the world. The college was the project of the Trustees of Amherst Academy, a private co-ed school where local boys and girls were educated. One of them, Mary Lyon, would go on to found the evangelically-inspired Mount Holyoke College, that would train women to teach in the U.S. and do mission work around the world. Many Mt. Holyoke graduates worked with Amherst men at missions and schools.

A breathtaking optimism characterized most converts of the Awakening and infused the missionaries' efforts with an unshakeable conviction in the rectitude and significance of their aims and activities. Contributors to Amherst agreed with Webster that they were fortunate to live in a "new era in the history of man—an era when reason and religion begin to ensure their sway, and to impress the heavenly truth, that the appropriate business of man is to imitate the Savior, to serve their God, and bless their fellow men."

While Amherst supplied a disproportionate number of missionaries, it was graduates of Williams College who produced the most important organization of the missionary movement. Five young awakened and ambitious Williams' men met in 1805 to discuss the absence of Christianity among Asian people. Five years later, they founded the American Board of Commissioners for Foreign Missions (A.B.C.F.M.), the organization that coordinated the work and travels of the missionaries, sending the first small group to India in 1812, others soon after to Hawaii, to the Cherokees in Tennessee, and then to Ceylon, China, Siam, Singapore, Greece, Turkey, Persia, Syria, Cyprus, South Africa, as well as to other southeastern Native Americans: the Creeks, the Choctaw, and the Chickasaw. Missionaries sent back reports on the people with whom they were working, and the *Missionary Herald*, founded by the Board in 1821, published this material. Initially, American missionaries tended to get their ideas about the religious availability and needs of regions of the globe from British missionaries, but the Reverend Rufus Anderson, who took over the Board in 1831, sent delegates around the world and traveled himself, bringing back information about the religious, political, and security conditions of prospective regions for missionizing.

Over time, Amherst College would send about 140 missionaries to foreign countries. These men, and the 285 women who worked with them, many from Mt. Holyoke, translated the Bible into local languages, founded schools, provided medical aid, and, of course, gave instruction in Christianity. The following stories about the experiences of some of these Amherst missionaries give a sense of the range of places they visited, their achievements and the obstacles they faced; their family lives, their blind spots, and the various ways they reacted to their strange new environments. They were bold and adventurous men and women urged on by a powerful religious and humanitarian impulse that was, however, inextricably entangled with nationalism and capitalism, and tinged with intolerance and chauvinism. Their stories are dramatic, and, inevitably, complicated.

NOAH WEBSTER, LL.D.

N Webster

Presented by Amherst College

A Plea for a Miserable World.

No...

I.

AN ADDRESS,

DELIVERED AT THE LAYING OF THE CORNER
STONE OF THE BUILDING ERECTING FOR
THE CHARITY INSTITUTION IN AMHERST,
MASSACHUSETTS, AUGUST 9, 1820, BY
NOAH WEBSTER, ESQ.

II.

A SERMON,

DELIVERED ON THE SAME OCCASION, BY REV.
DANIEL A. CLARK, PASTOR OF THE FIRST
CHURCH AND SOCIETY IN AMHERST.

III.

A BRIEF ACCOUNT OF THE ORIGIN OF THE
INSTITUTION.

BOSTON:

PRINTED BY EZRA LINCOLN,
NO. 4, SUFFOLK BUILDINGS, CONGRESS STREET.
1820

Noah Webster, with the opening page to *A Plea for a Miserable World*,
Webster's address at the laying of the cornerstone at Amherst College, 1820

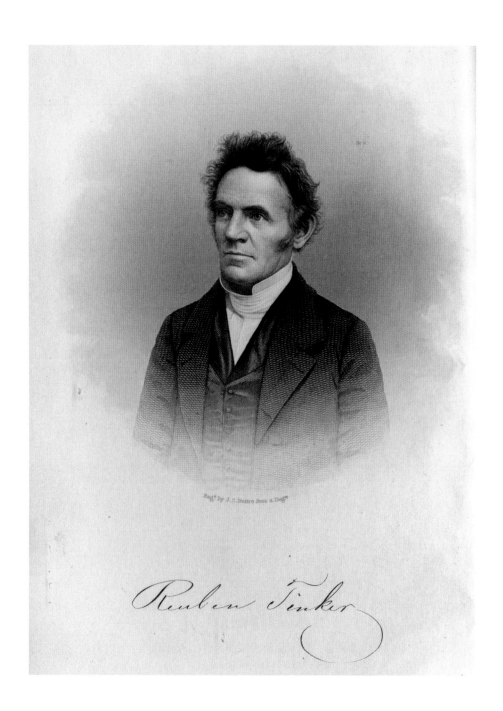

Reuben Tinker, from *Sermons*, by Reuben Tinker, 1856

Reuben Tinker

Doing Good and Doing Well

The first Amherst graduate to answer the college's founding mission was Reuben Tinker, who came from a farming family in Hartford, Connecticut. Born in 1799, his earliest ambition had been to become a merchant, but he soon changed his mind and decided to fulfill his mother's desire for him to become a minister. In 1820, the year he turned twenty-one, he converted and joined the Congregational church. He wrote to his mother, asking her to forgive "all the pain I have caused you, and the ungrateful returns I have made for your maternal goodness and prayers for me; and be assured if your son's prayers can gain acceptance with God, you will be blessed."[1]

Like all Congregationalist converts, this meant Reuben accepted complete dependence on Christ's forgiveness of his sins and willingness to welcome him into heaven at his death. No matter how hard he worked for this goal, only the mercy of Christ could save him. The majority of early nineteenth-century missionaries shared this conservative Calvinist orthodoxy. Although by this time more liberal Protestants were rejecting the idea that man could have no influence on his own salvation, they were not usually represented in the missionary ranks.[2]

Many of Reuben's colleagues in mission work also credited their mothers in shaping their spiritual lives and goals. Despite Tinker's belief in the impotence of man to effect his own conversion, Protestant clergy had begun to stress the importance of women in making their children ready for salvation. Missionaries made a point of teaching this as women's duty and saw it as a part of 'elevating' women worldwide. For their part, missionary wives modeled this behavior abroad.

After Reuben's mother's death, her wishes loaded his awakening with purpose. The 'deathbed pulpit,' was famous in the Second Great Awakening for the power it gave the dying to persuade the living to feel their mortal need of God's love and grace. As the health of Americans declined during the nineteenth century, the ubiquity of illness and death in homes facilitated countless conversions.

On his way to Amherst, since he lacked the money for a stagecoach, Reuben had walked, with a handkerchief containing his possessions, the fifty miles from Hartford to begin his education for the ministry. On the second day of his trip, a heavy spring storm dropped eighteen inches of snow. He later recalled chiding himself: "What, you Reuben Tinker, expect to be a minister and perhaps a mis-

sionary to the heathen, and be disheartened at *this*? So I sang *Windham*[3] to keep my courage up, and went on." (Probably only a Congregationalist would find *Windham* encouraging. It begins: "Broad is the road that leads to death and thousands walk together there…")

At Amherst, Reuben swept the college hall, rang the bell, and ate cheaply to support himself. He and his fellow students studied Greek and Latin, natural philosophy, mathematics, 'Oriental' literature (civilizations of the Middle East and Asia), and theology. Later the curriculum would expand to include subjects such as botany and astronomy. Like many at Amherst who became missionaries, Reuben preached on Sunday evenings to the African Sunday School. He felt that "the poor people [there]…seem to be strongly attached to me."[4] The gratitude of this small congregation, where free blacks came together to study religion and learn to read,[5] warmed many prospective missionaries and strengthened their sense of purpose.

By the nineteenth century, slavery no longer existed in Massachusetts, but free blacks endured poverty and pervasive discrimination. The Sunday School— another organization that emerged from Second Great Awakening—provided a place to acquire literacy, study the Bible, and pray together. Male students and college women often taught in these schools.

Although Reuben struggled with his faith, his struggles also affirmed the significance of his service. "Become of me what may, I am resolved to try to serve God, to make His word the rule of my life, and to do all I can to persuade *others* to escape from the wrath to come. I have *dark, dark* hours, a hard struggle with sin and the Devil, and often, I fear, am overcome and led into captivity."[6] Self-doubt was a characteristic of early evangelicals, but activity in the field and efforts to convert the "heatherns" subdued most missionaries' uneasiness and sense of personal sin.

Reuben Tinker graduated from Amherst in 1827. Knowing that the A.B.C.F.M. would urge him to marry before sending him abroad, he wondered, "Where in the wide world is she who was made from my rib?" "Have you seen her?" he asked a friend. "I have a notion she is no beauty, but rather good-looking, well-instructed, well-behaved, modest, peaceable, industrious, a spinner…for the tabernacle of God."[7] By the time he graduated (third in his class of twenty-six) he had found her in Mary Throop Wood, a brave and sturdy young woman from Massachusetts, ten years his junior. He was ordained on November 3, 1830 and they were married eleven days later.

According to his memoir, Tinker had wanted to work in Greece, but instead the American Board sent him to the Sandwich Islands in the Central Pacific— what is now Hawaii. Cook had discovered the archipelago in 1778, and a year later was killed there after a quarrel with the islanders over his gathering wooden icons for firewood. Accounts of his travels drew European and American

NATIVES MAKING POI FROM TARO PLANT.

TARO PLANT

Page 95

LOADING CATTLE.

A TOUR IN HAWAII IN 1823. 199

Plates from *Hawaii and Its People: The Land of Rainbow and Palm*,
by Alexander Stevenson Twombly, Boston, 1899

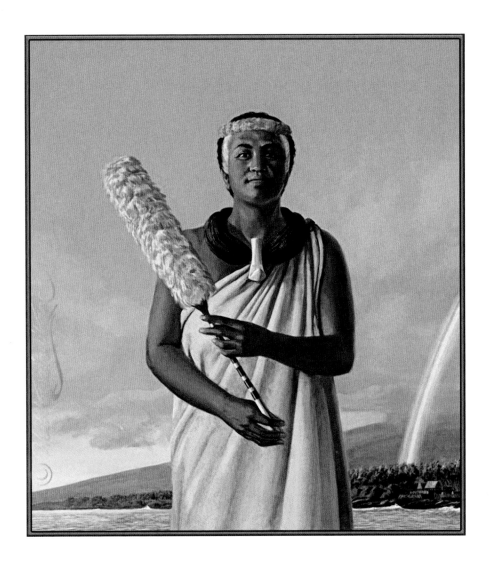

Queen Kaahumanu, a painting by Herb Kawainui Kāne (1928–2011)

explorers and traders to the islands, which, in 1810, had been united into one kingdom under King Kamehameha I.

On a sunny day in late December 1830, only six weeks after their wedding, Reuben and Mary Tinker sailed on the *New Englander* from New Bedford. Friends on the shore said prayers and sang a hymn.[8] Tinker who, unlike many of his colleagues, had a sense of humor, noted that their stateroom was not "marvelously stately," but was convinced that they were "much better accommodated" than Jonah had been in the belly of the whale.[9]

Their journey took almost six months, and when they finally arrived in Honolulu on June 7, 1831, Mary Tinker's first pregnancy was already well advanced. The Tinkers and four missionary companions lodged with Hiram and Sybil Bingham, the first Americans and the first Christian missionaries in Hawaii, who had arrived in 1820. (The only other missionaries in Hawaii at the time were French.) On August 14, Mary gave birth to a son, Samuel.

By the time the Tinkers arrived, missionaries had been in Hawaii for just over a decade, and in 1825, the ageing, powerful Queen Regent, Kaahumanu, stepmother to the twelve-year-old king, Kauikeaouli, had been baptized. She had asked for more missionaries to spread Protestantism (as well as to combat drinking and expel Catholics from the islands), and wrote to thank the American Board for the "new teachers...We have seen their eyes and their cheeks... Now we wait while they study the native language... then they will sow in the fields the good seed of eternal salvation."[10] Tinker arrived in Honolulu for the last year of Queen Kaahumanu's life.

Missionaries had already established many schools, and in accordance with the Congregational belief that reading scripture was essential to progress toward salvation, the New Englanders spread literacy to an eager population. Reuben studied the language and learned to read and write Hawaiian well, though he never was comfortable enough with it to take on his own congregation. He did give occasional sermons in Hawaiian and preached regularly to sailors and traders who visited the islands.[11]

One enthusiastic missionary claimed that by 1845, nearly every Hawaiian could read, although Tinker found there were many places where missionaries had not yet arrived.[12] While the missionaries were proud of their own achievements, they gave faint praise to the Hawaiians. As two missionaries from the nearby island of Lahaina wrote in 1833: "Were we to select a few of those who... have the best knowledge of religious, moral, and general subjects, and then draw a picture of the dark part of their character, you would scarcely recognize it as belonging to a human being, much less to a virtuous and civilized man."[13]

A friend and biographer quoted Tinker's early assessment of the Hawaiians, noting that there was now "no open idolatry, no offering of human sacrifices, or burying alive of infant children or old people. These things we hope are at an end..." But, he continued, "[The Hawaiians] are childish and fickle. They embraced Christianity at the desire of their chiefs. And under the same influence, most of them would not hesitate to return to their former superstitions."[14]

In 1833, the Tinkers, now four, after the birth of Joseph on January 20, moved to Wailuku on western Maui, the second largest island where Reuben would become assistant to the Rev. Jonathan S. Greene.[15] In a letter to a medical friend back home, he gave a droll account of his precious theological library, which had arrived only to fall into the sea. It was, he wrote:

a tale of misfortune such as you are not often permitted to hear. It was to me a matter of some interest to remark, as I hauled them out...how the different worthies [with]stood the perils of the deep....What surprised me and grieved me much, was to find that my great grand-uncle [John] Bunyan, who had immortalized himself by his Progress before [was] as ready now to halt, and actually lost his hindermost parts in the brine...In short, they all suffered...from sea-sickness and drowning; and I am nursing them, rubbing them, and rolling them over, as you physicians do to drowned people and am causing the trade winds to blow into their interiors. Some of them show signs of recovery; others are apparently dead; while still others are dead beyond a doubt.[16]

A year later, the Tinkers were back in Honolulu, where Reuben undertook the publication of a semi-monthly religious newspaper in Hawaiian. During his editorship, he began to object to the A.B.C.F.M.'s silencing of missionaries who wanted to write about their activities for publication in the United States. When the Board stonewalled him, Tinker decided to dissociate himself from them, hoping he could support himself and continue his missionary work.

He moved his family to Koloa, on Kauai, north of Honolulu, and rented land to farm from one of the chiefs. While the building of a mission house and the Waioli Hui'ia church was being completed, the first sugar plantation was opened in Koloa. This was one of many projects that would transform land usage in Hawaii and force many Hawaiians into paid labor for American investors.

From the beginning of the American Republic, government officials and missionaries had promoted individual acquisition and capitalism among the Native Americans, disrupting and undermining their economies based on sharing and mutual responsibility. In the same way, missionaries and entrepreneurs in Hawaii encouraged the privatization of native lands to bring local residents into the cash economy, where they acquired new material wants and usually lived in poverty.

Missionaries commented on the rapidly falling Hawaiian population, but did not connect it either to changes in the economy or to imported diseases exacerbated by crowding in schools and congregations. Like most nineteenth-century Americans they thought the vulnerability of Hawaiians to disease, as with Native Americans, had to do with the inherent inferiority of their "race."

Hawaiians would later say that U.S. missionaries came to do good and ended up doing well. Tinker's colleagues helped to change the islands' ancient laws that reserved land ownership to the chiefs and opened up land sales to anyone. Tinker did not profit personally from the strategies that by the end of the century had put Americans in control of the local economy and a great deal of its land, but a majority of his associates and their children did.

American missionaries passionately desired to reform local family life and "elevate" the roles of women. With the model of the subordinate, pure, and morally

ear. Such were the royal fêtes, in which king, chiefs, women and natives delighted in 1823.

The costumes of most of the chiefs on state occasions, or when foreigners were received, were quite civilized;

HAWAIIAN GIRLS.

but Liholiho's royal dress suit consisted of a colored cloth around his loins, a green silk mantle fastened over his right shoulder, a string of beads around his neck, and a wreath of yellow feathers on his head.

From *Hawaii and Its People: The Land of Rainbow and Palm,* by Alexander Stevenson Twombly, 1899

influential woman in mind, missionaries tried to train Hawaiian women to reject polygamy and adultery and to stop the customary instruction of young children in sex play. They deplored the prostitution that had become very common with the rapid increase in sea traffic since Cook's landing in the eighteenth century. Missionaries wanted Hawaiian women to put on clothes and cover their heads with bonnets instead of flowers, accept direction from their husbands and offer their children Christian moral guidance.

Mary Tinker wrote in 1834, looking at her newborn daughter, that she felt "a gleam of sadness steal over me when I think of her lot in common with us all, should she live to become a mother."[17] That year, Hawaiian missionary wives had formed a Maternal Association, modeled on those in the Northeast U.S., which provided women with support and counsel in the endless, difficult, and anxiety-provoking tasks of evangelical mothering.

Missionary mothers left their children little unstructured play time, disciplined them rigorously, kept them at their books, and began separating them from Hawaiian children at the age of two—many fencing off their yards in order to keep them from learning and sharing the sexually free Hawaiian ways. Many missionary families, including the Tinkers, gave up their Hawaiian servants, partly because, as abolitionists, they feared they were engaging in a kind of slavery, but also because they feared the bad moral influence of Hawaiians on their homes. Though Mary wrote that the plan "cost her much self-denial," since the servants' chores largely fell to her, as a proper evangelical she nevertheless decided it would do her good.[18]

A year before Tinker arrived, the missionaries had established a temperance society to which they all subscribed. John Adams Kuakini, the brother of Queen Kaahumanu and Christian governor of Oahu, banned the sale of alcohol. He received a petition to sell it only to foreigners. The Rev. Hiram Bingham wrote with satisfaction that the governor replied: "To horses, cattle, and hogs … you may sell rum; but to real men you must not on these shores."[19]

In 1840, Tinker, who proved unable to farm and support his family independently, applied to the A.B.C.F.M. for money to return home. He gave increasingly poor eyesight and a concern to educate his children properly as his reasons but he hoped the return would be temporary. Educating their children among the people they called heathens made most missionaries very uneasy. Missionaries in India had petitioned the A.B.C.F.M. for assistance in sending their children home for education. The Board initially rejected the idea, but in 1834 concluded that missionaries had put up uncomplainingly with most of the sacrifices of life in the field. The Board thought it would cost at the most, $50 a year to support boys and $40 a year to support girls in the homes of mainland relatives while they were enjoying a healthy climate and getting an education that would prepare them for work compatible with their "rank."[20]

Some Hawaiian missionaries also took advantage of this policy and sent their children home to be educated, afraid that their fences and the exclusive Punahou School that they founded in 1842 would not be enough to protect them against the Hawaiian taste for leisure and pleasure. But Reuben did not wish to break up his family, "scattering them about ... thus breaking ... the foundation of civilized society and of human welfare."[21]

In October of 1840 he, Mary—again pregnant—and their five children, set sail for Falmouth, Massachusetts. Mary delivered their sixth child on board. Eight Tinkers arrived in Falmouth in May 1841. Reuben wrote to a friend that he "[knew] not how to relinquish the missionary work,"[22] but he could not figure out how to afford a trip back without the Board's assistance.

Reuben never found his way back and resigned himself to the idea that God had called him to a different task. In 1844, he began to serve at a Presbyterian church in a small N.Y. town near the Pennsylvania border, where he became very popular, delivering humorous and sincerely felt sermons.[23] He taught Americans about Hawaiian culture as he had experienced it and supported missionary efforts around the world. In 1853, he lost a leg to cancer, and eventually his life. In his last two sermons he created a literal deathbed pulpit, using the spectacle of his own dying to dramatize death's imminence in the lives of everyone.

He had played a small and, to some degree, unwitting part in the economic and political changes that all American missionaries in Hawaii underwrote, helping to subordinate the native population to foreign, largely American investors. On the other hand, the large number of schools that he and his colleagues founded produced graduates who had access to learning, were able to understand the changes that were tearing their world apart, and in some cases acquired the tools with which to adapt. For some Hawaiians, too, Christianity offered guidance, inspiration and solace.

Sixty years after Tinker arrived in Honolulu, a group of European and American businessmen overthrew the monarchy, and in 1898 Hawaii was annexed to the United States. In 1959, it became the 50th and most recent addition to the Union. In 1998, a century after the monarchy's dissolution, Congress agreed an "Apology Resolution", signed by President Clinton, a belated gesture of acknowledgment to the Hawaiians of the role America had played in the destruction of its kingdom.

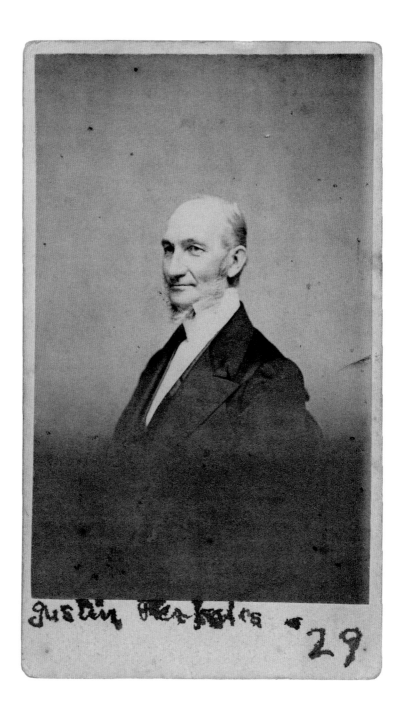

Justin Perkins, c. 1850

Justin Perkins

False Prophets

Toward the end of his freshman year at Amherst, Reuben Tinker's classmate Justin Perkins, another farmer's son, this one from nearby Holyoke, decided to "pass [his] days among the heathen." As he wrote later to a colleague: "I was led to a formal decision with reference to myself far earlier than I probably should otherwise have been by a conversation with Brother Reuben Tinker…The wants and woes of the heathen, and the Savior's last command seemed to leave no room for me to doubt respecting duty."[1]

As a boy, Perkins had worked on the family farm, and it was only after "much importuning" that his father agreed to his turning to study. He converted at the age of eighteen. After entering Amherst, he tutored students (including the celebrated preacher Henry Ward Beecher, the brother of Harriet Beecher Stowe) in the winter months to pay for his education. He became known as the "twenty-four-hour boy" because of the few hours he allotted to sleep. As with Tinker, Perkins's mother figured significantly in his life's work. He dedicated his book about his first eight years as a missionary to: "Judith Perkins…who, in widowhood, age, infirmity, and dependence gave her son to the missionary work."[2]

Perkins followed Tinker to the Andover Theological Seminary. There, in January 1833, the Rev. Eli Smith and H.G.O. Dwight spoke excitedly about their travels for the A.M.B.C.F. to the Orient. At that time "Orient" could refer to any of several countries in the East, but in this case it meant part of what we now know as Turkey, Persia (Iran) and Lebanon. In northwest Persia, Smith and Dwight had discovered a group of Nestorians (also known as Assyrians), followers of an early form of Christianity, whose history they knew, but whose existence they had not discovered until their travels.[3] The missionaries believed that the Persians would permit them to work with the Nestorians. They envisioned the establishment of a mission that would help to overturn what they referred to as the "Muhammedan delusion," from which they could light "a fire which would shine out upon the corruptions of the Persian…and upon the barbarities of the Koord…until all shall come to be enlightened by its brightness, and a triumph of faith will cover his labor of love."[4]

Rufus Anderson, the secretary of the A.B.C.F.M., foresaw Perkins's work as nothing less than "enabl[ing] the Nestorian church, through the grace of God, to exert a commanding influence in the spiritual regeneration of Asia." Perkins, less

modest than Brother Tinker, took up the challenge, asserting that, "the Muhammedan powers are crumbling to ruins. Christians nations are soon to rule over all the followers of the False Prophet."[5]

Aiding him in this task was Charlotte Bass of Middlebury, Vermont, whom he married in July 1833. They left Boston on September 21 on their six-month journey. Charlotte was extremely seasick, though, as Perkins wrote with stunning understatement, "her fortitude…was destined to encounter still severer tests."[6]

Perkins' first trip abroad provoked a series of lively observations, usually ending in praise for the incomparable institutions and morality of his own country. He recorded the ship's captain's remark that American boys made poor cabin boys because they were not submissive enough. "Americans scorn to be slaves," Perkins noted approvingly. "May the sacred spark of freedom which glows so early in American bosoms, in the low as well as the high, never be smothered, but blaze forth and spread itself throughout the world."

From the ship, he noted jumping blackfish, "valuable only for oil," and admired a shoal of dolphins. He was annoyed that when the captain harpooned one it sank to the bottom "as if to deprive us of the entertainment we had anticipated of inspecting it." When they passed Gibraltar, they saw "the Old World for the first time. It was an unfortunate part of it—poor Africa, robbed of its children and crushed under accumulated wrongs." When looking across the Mediterranean toward Europe, the company was "impressed" that they were viewing "the lands of darkness, where the Pope on the one hand, and the False Prophet on the other, sway their bloody and corrupting scepters."[7]

They landed first in Malta.[8] Walking the streets, they found the "incessant chiming of the bells soon sickened our hearts," and Perkins concluded that nowhere had he seen "a more squalid, miserable, priest-ridden populace." Like most white Americans of his time, Perkins was closely attentive to skin color. He described the Maltese as "about as dark as the American Indians" and "tawny and degraded," but much more polite and "respectful" than "the mass in New England…No one doubts the superiority of [Americans] to all other nations," he added, not to be taken comparing the tawny Maltese favorably with Anglo-Saxons "unless it be the English cousins who may be nearly their equals."

From Malta they chartered a boat to take them to Constantinople, the farthest outpost of American mission activity in the region. Perkins found the captain, "a very superior man for a Greek." They remained there for five months. Perkins was appalled by the "heartlessness of [Greek Orthodox] worship…genuflexions (sic), crossings and bowings before pictures…" He found the Turks, on the other hand, "manly" and attractive, although living under tyranny. He distinguished the Persians from the Turks as "Orientals, who, although they had "affable insinuating manners" were, underneath, full of "treachery and falsehood in the extreme," and wrote, after encountering a large funeral, that, "tears flowed

profusely…but Orientals can weep without emotion." According to Perkins, they routinely broke each of the Commandments and practiced "the yet more abominable sin of Sodom." He was disgusted at the power the "Moolahs" had in their villages and their capacity to affect even the Persian king's policies. Like Tinker and other missionaries he abhorred the "beastly intemperance" he found in Persia and was appalled to discover that the only U.S.-manufactured product the country imported was New England rum.[9]

From Constantinople, the Perkinses sailed up the Bosphorus and into the Black Sea, going east to Trebizond, then on horseback, with three armed guards, over cold mountains, along "frightful precipices" of up to 5,000 feet, camping in lush meadows, riding on past Mount Ararat and on to Erzurum. Charlotte Perkins, far along in her first pregnancy, traveled over the frigid, magnificent, and terrifyingly steep mountain trails with one guard holding her horse and another securing her saddle. They ate "yogoord" with pleasure.[10]

At Tabriz they found a doctor for Charlotte. There she bore a little girl, but suffered terribly. His wife's ordeal prompted Perkins to make this tribute, at once condescending and self-referential, but also heartfelt, to women missionaries: "We witness in many of the females sent out by our churches…devotion…but also a *heroism*, which is able calmly to meet and cheerfully sustain the trying emergencies that often almost crush our sterner energies. It is preeminently on missionary ground that woman is a helpmeet for man."[11]

Perkins traveled on to Urmia while his wife and daughter—another Charlotte—stayed behind. There he met with members of the Nestorian clergy, including the young Bishop Mar Yohannan, who returned with him to Tabriz. Perkins studied Nestorian with Mar Yohannan for the purpose of translating the scriptures. Mar Yohannan introduced him to the Patriarch, or head of the church, who wanted to have schools and to have the Scriptures circulated. This opened the door for Perkins—and the missionaries who later joined him and his wife—to work with about 6,000 Nestorians living among the 32,000 residents of Urmia and eventually with between 100,000 and 150,000 in the region. In 1835, Judith and Dr. Asahel Grant joined the Perkinses in Urmia, and subsequently the mission grew with the addition of missionaries William Stocking and Albert Holliday, who brought a printing press.[12]

Perkins found the Nestorians, though Christian, "very degraded; and even the best of them are *morally* as weak as infants, and must be treated with great patience and forbearance, 'as a nurse cherishes her children.'" On the other hand, he found them more feeling than many Americans and openly demonstrative of their grief, for example, when thinking about the crucifixion. The Nestorians' emotional style of worship both pleased and unsettled the missionaries. They valued—even envied—its power and sincerity, but they valued their own rational control more.[13]

The Lord's Prayer translated into Nestorian by Justin Perkins

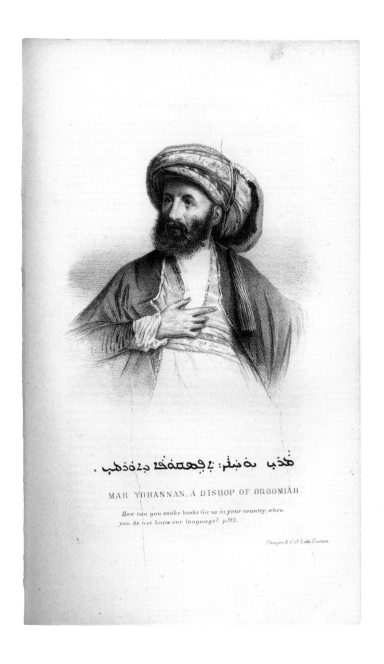

ܡܳܪܝ ܝܘܿܚܰܢܳܢ: ܐܦܶܣܩܘܿܦܳܐ ܕܐܘܿܪܡܝܐ.

MAR YOHANNAN, A BISHOP OF OROOMIAH.

*How can you make books for us in your country, when
you do not know our language? p.173.*

Thayer & Co. Lith Boston

A portrait of Mar Yohannan, from *Travels in Little Known Parts of
Asia Minor*, by Rev. Henry J. Van Lennep 1870

Perkins seems to have worked with some success with the Nestorian clergy, as long as their aims for education overlapped. The Patriarch was happy with the medical services and that the regional ruler apparently was on good terms with the Americans. However, he held missionary doctrines "as cheap as an onion," when they differed from Nestorian ones, and would subsequently conflict with the Americans more than once.[14]

Typically, Perkins spent eight hours a day, working with a Nestorian priest, "reducing" the particular Syriac dialect spoken in the region to a written form and translating pieces of scripture from Greek into Nestorian for teaching. He eventually finished the Bible and translated some hymns and Protestant commentaries of value. He taught English two hours a day in the seminary, preached twice on Sundays, and attended various meetings throughout the week. Among the many local religious practices with which Perkins disagreed was the Nestorians' frequent fasting, which he considered an "artful contrivance of Satan" to divert them from the "pure religion of the gospel which works by love, sanctifies the heart…and regulates the conduct."[15]

Perkins thought the locals did not value women in the proper way. "What a change would there be," he wrote, if the Nestorians could appreciate the "worth and proper rank of females." The birth of his son, William, prompted him to note that a boy's birth in Muslim countries produced "immoderate joy" while sorrow greeted the arrival of baby girls: "so little is the worth and influence of females appreciated in Muhammedan countries." The Nestorians, he judged, did better at this than the Muslim women, who used the veil to hide their flirtations and sexual transgressions. He thought Persian matrimony had little to recommend it because the words: "wife" and "home" did not exist in the native languages. They used instead "woman" and "house." He concluded his assessment with the observation that the "Moolahs—the priesthood—are themselves the licensers and managers of the public brothels. And regard them as an important source of income."[16]

Perkins was delighted that when he invited Nestorian families to have dinner, they came as couples, whereas customarily men and women ate separately. He believed that both wives and husbands "were equally gratified with the [unusual] arrangement." He was glad to provide an example of what ideal family life should be and thought this was "an important" reason…why missionaries should in general have families."[17]

William's birth also led Perkins to contemplate the unique risks and opportunities for missionary children. On the one hand, he and his wife worried about raising children "amid moral pollution." They also worried about them dying young (he and Charlotte had already lost a child). If, however, children survived and were pious, he thought, they would make better missionaries than their parents, as they were "born on benighted ground," knowing the

A NESTORIAN GIRL, CARRYING WATER.

A Nestorian girl carrying water, from
Travels in Little Known Parts of Asia Minor

MISSION SEMINARY AT OROOMIAH

Mission Seminary at Urmia, from Van Lennep's
Travels in Little Known Parts of Asia Minor

language, the country and its customs from birth. If they were not pious, however, "utterly unavailing will be the toils and the tears of the faithful missionary...and what scandal must such children bring upon the cause..." Perkins had observed, with admiration, that some missionary families produced more missionaries.[18]

Charlotte Perkins and her husband, like most missionary couples, did not practice birth control, though its use was increasing among nineteenth-century white, middle-class families. In its absence, women had to rely on their husbands' willingness to abstain. Missionaries of the first generation were theologically conservative and seem to have believed that being fruitful was part of their God-given duty. Numerous children were essential for missionaries to showcase Protestant family life.

The Perkins's first daughter, Charlotte, did not survive, nor did their second son, Justin Humphrey, who died at one year old in July 1839. The following February, as Persia and Britain seemed on the brink of war, Charlotte Perkins was nursing the infant daughter that Judith Grant, Dr. Asahel Grant's wife, had left motherless the month before. Between February 2 and February 7, 1840, little

Judith Sabine Grant, William Perkins, who was almost four, William Stocking's son, Charles, and Catharine Holladay, daughter of Albert Holladay, all died of measles.[19] Infant and child mortality, high in the U.S. in this period, was higher where sanitation and nutrition were poor.

Perkins tried to make sense of this heartbreaking tragedy with traditional, Puritan "providential thinking"—the assumption that God was punishing the missionaries for falling away from Him. He and his co-workers had heard about revivals in Hawaii. That "those unlearned savages who could scarce understand the simplest doctrine of atonement," were converted, he wrote, "was marvelous in our eyes." But when he suggested that they create another meeting, hoping to generate such a revival in Urmia, no one agreed. He wrote that the Lord had become "kindled against this Mission" and struck down a "tender weakly child." But this sign had no effect, and "the Lord was wroth," and He "smote ... again and again."[20]

Charlotte soon had another child, Judith, but after this birth and the death of so many of her other children, her health was so poor that the family got permission from the A.B.C.F.M. to go home. Charlotte rested and recovered for a year with her parents in Vermont. During her stay, she met in Chicopee, Mass., with a group of returned and prospective missionaries, giving advice to women, though it is hard to imagine that her counsel was very comforting.

Bishop Mar Johannan had traveled back with the Perkinses to the U.S. and met many prospective missionaries there. He had been deeply impressed with Judith Grant's mastery of Syriac and Turkish, and with her general erudition, and he found inspiration in the Female Seminary at Mt. Holyoke for the project of educating women.[21]

Judith, stepping in for her departed brother, William, answered her father's prayers as the emblematic child of missionaries who shone as a model of Christianity and demonstrated the female virtues of Protestant family life. When the family returned to Persia, in 1843, she became her sick and depressed mother's indispensable companion, sometimes making the family bread, helping her mother lead family prayers, helping her father with his translations, and looking after her younger brother, Henry, and the other small children at the mission.

In Urmia, Judith studied in the female seminary that had been organized by Fidelia Fiske, a graduate and teacher from Mt. Holyoke, the model for the school. Fiske's teaching emphasized moral purity, preparation for salvation through critical self-examination, and a wide range of academic subjects designed to equip young women to be the intellectual and spiritual companions of young men, if not their equals. They encouraged Nestorian boys and girls to mix, distinguishing them from more traditional Nestorians, and from the dominant Muslim society. Nestorian girls stood out at the Fiske Academy because they did not wear

the veil. While Fiske's curriculum and spiritual charisma made the school grow, these violations of the gender code and the special treatment given to Nestorians attracted the hostile attention of Muslims with whom the Nestorians had lived as a largely secure minority for many years.

The school that the mission built in 1843 was so large that some Muslim officials worried it might be a military installation. The mission employed only Nestorians as workers, adding to Muslim jealousy and suspicion of the evangelicals and the special privileges they gave the Nestorians. British missionaries, who were, according to Rufus Anderson of the A.B.C.F.M., trying to replace the Americans, sided with more conservative Nestorians, encouraging a Kurdish chief to exploit the weakness created by this split. He commandeered the school as the fortress from which he raided and slaughtered 50,000 Nestorians living in the mountains—fully a quarter of the population. Thousands of refugees came to Urmia, some of whom found their way to the Fiske Academy.[22]

In 1846, Sanum, a Nestorian refugee from the mountain massacres, underwent an explosive spiritual crisis, translating her traumatic survival through the unsparing evangelical framework that she had learned. This led to the wrenching awakenings and conversions, evangelical-style, of about fifty Nestorians to the Congregationalists' kind of Christianity.[23]

After returning to Persia, Charlotte Perkins had two more children, Fidelia and Justin, both of whom died. This only aggravated her poor mental and physical health and in 1852, the family planned a trip to Erzurum to try to restore her.

On the way, Judith contracted cholera. Her father dosed her with camphor, calomel—a mercury-based purgative that would have contributed to her misery—and laudanum. But in his distress, he somehow lost the laudanum. Her little brother Henry, who was beside himself in this terrifying crisis at their campsite, asked, "O Judith, my dear sister… you look as though you would die. O, dear sister Judith, what shall I do?" He wondered who would walk with him, and play with him, and who would help him with his lessons. Her mother asked Judith what she wished to say to Henry, and, exemplary to the last, she told him to be a Christian, a "good boy, and mind his parents in everything; and stand up straight." Judith asked if her mother would bury her next to her sister Fidelia. Days after her death on September 4, 1852, her parents fulfilled her wish.[24]

What remained of the family returned to the United States in 1857, and according to a note in the family records, Charlotte Perkins entered an insane asylum. Henry, their only surviving child, stayed in America, but Justin Perkins made the trip to Persia back and forth twice more, finally coming home in very feeble health in June 1869. By this time, Henry was attending Andover Theological Seminary, and his mother was well enough to look after her husband until his death on the last day of December 1869. One of Perkins's final requests was to hear the hymn *Jordan*, by William Billings, a song that describes the beauties

At the age of six years.

"How delightful it will be to go up to that Heaven and see God who never dies."

Judith Perkins, at age six, drawn by Van Lennep, from *Persian Flower: A Memoir of Judith Grant Perkins of Oroomiah, Persia (1853)*

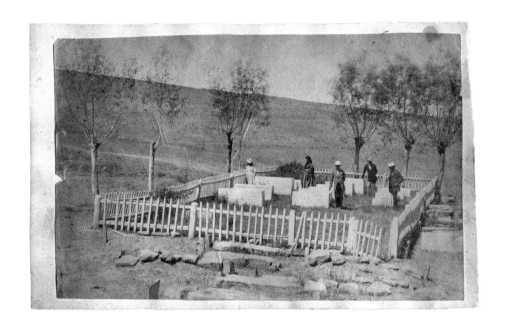

Missionary Cemetery, Seir, Urmia (top), verso of image (below)

waiting in the Promised Land. Justin and Charlotte and their companions had sung it and many other songs on their first voyage to Persia so many years before.

Henry Perkins went on to write a short book describing his father's life as a pioneer, scholar and ardent missionary, but he did not become a missionary. Charlotte Bass Perkins lived with her son and his family for much of her life, dying, improbably, at the age of 90.

By the end of his life, Perkins had decided that preaching was the most important missionary duty—schools, and printing next—despite his translations of the Bible, of theologians, and other works.[25] This was also the conclusion Rufus Anderson, Secretary of the A.B.C.F.M., came to in the 1840s, as he surveyed the American Board's mission work and found few converts and many texts and translations. The Perkinses, Fidelia Fiske, and others had helped to establish the mission schools in Urmia that had educated boys and, for the first time, girls. Perkins and his mission's work, especially education for women and their encouragement to the mixing of the sexes, brought literacy and other positive changes to Nestorian women. But it also brought the hostility of the dominant Muslim community to focus on the Nestorians and their favored relationship with the United States.

Unlike France and Russia, the United States had no policy toward Persia until 1880. That year, Ohio Congressman Rufus Robinson Dawes, who had a missionary sister and brother-in-law, intervened. Another Kurdish attack on the Nestorians prompted him to seek government aid in establishing diplomatic relations with Persia. Protecting this and other Christian minorities in this region came to be characteristic of U.S. policy in Persia, Turkey, and Armenia well into the twentieth century. The favored status of Christians in these areas was not lost on the surrounding Muslim societies and has contributed to our poor relations in this region.[26]

HENRY LYMAN.

Portrait of Lyman from *The Martyr of Sumatra: A Memoir of Henry Lyman*, by Hannah Lyman Willard, 1856

Henry Lyman

The Highest Reward

While Justin Perkins was still at Amherst, on April 27, 1827 a young student called Henry Lyman knocked on his door and stood there trembling: "What shall I do to be saved?" he asked. Until that point Lyman had been known as something of a prankster at the sober institution. He soon returned to confess to Perkins that his interest in salvation had been a mistake, and he no longer cared about the state of his soul. But, as the "twenty-four-hour boy" noted meticulously in his journal, by the next day Lyman's faith had been revived, and on April 28 he converted.

Lyman wrote passionately to his family from Andover Theological Seminary: "I suppose you know that while you are enjoying your tea and coffee, a great many children in Asia are thrown by their parents into the sea, or to the wild beasts, or into the streets. The parents think it right to do so…and all this because they never had the Bible to teach them about God and Jesus."[1]

Perkins remembered Lyman's "extraordinary ardor and energy." After his conversion, Lyman took to walking forty or fifty miles a day, often eating only bread and water. He wrote feelingly about the time he spent with African American parishioners in Andover. He attended the Sunday School, held four miles from town, went to neighborhood meetings, and sat with a dying man, who:

> though guilty of a skin not colored like our own was not guilty in
> having neglected his Savior in health, and is rejoicing in Him [in]
> a room about fourteen feet square and seven feet high, warmed by
> a little sheet-iron stove, being not only the nursery, but the parlor,
> kitchen, sickroom…In it was a boy of twelve years, sick in another
> bed with the measles, and beside the child lay the man's mother,
> while under the table a dog slept. Yet the Lord I trust was there.[2]

Lyman found his spiritual sustenance in being with others. He said that it was in trying to bring African Americans to "the fountain to drink that induced me to drink myself, though I knew not that I was dying for thirst," adding that this work "seems a kind of foretaste of missionary labor."[3]

After graduating from Andover in May 1833, Lyman married Elizabeth Pond late in the same month. In June they sailed from Boston with Henry's close companion, Samuel Munson, his wife, Abby, and two other missionary couples, for Batavia (Jakarta), on Java, where the Dutch East India Company had its headquarters.[4]

Arriving in Batavia, Henry studied Malay, and he and Eliza set up house. Lyman wrote that he needed "grace to enable me to rule over this household with humility and in the fear of the Lord," while also trying to deal with the lizards, white ants, mosquitoes, the "terrible moral degradation of the city," and having servants they did not trust.[5]

The drinking and opium smoking he found amongst both foreigners and Indonesians horrified Lyman. He recounted to an A.B.C.F.M. member the debauchery of an Englishman in India who had found a method of warding off the terrible heat that alcohol in that climate only exacerbated. The Englishman and his friends would drink till they were uncomfortably hot. At that point their host would "fasten weights to the legs of the table and chairs, and sink them in the canal [and continue sitting there] till daylight, drinking."[6]

Lyman and Munson laid out plans to visit the territory controlled by the warlike Battas in order to reach the Nyas, who they believed were open to Christian teaching. They anticipated a dangerous jungle trip. Lyman described the people they were planning to visit as gentle, agricultural people whose only flaw was that war made them malign "and whenever a captive is taken, a feast is celebrated in which his flesh is devoured, while his skull is suspended as a trophy in the house of his captor. Such is human nature without the Gospel."

A writer in the *Chinese Repository*, a journal edited by Elijah Bridgman, a friend and classmate of Lyman's just arrived in China, who had visited Indonesia in 1823, was initially skeptical about whether the Battas practiced cannibalism. On interviewing a number of them, however, he became convinced that they routinely ate war captives, law-breakers and slaves, and considered the palm of the hand a particular delicacy.[7]

Henry Lyman thrived in Indonesia, as Perkins had in Persia, while Elizabeth, like Charlotte Perkins, became very unwell. When departing for the Nyas, Lyman had to say goodbye to his wife, "perhaps forever, as her health is so delicate." He reminded himself that "We all need to live as though journeying to the grave," though he felt he needed the Lord's particular help to keep from "imagining [Elizabeth] pining away in disease without the attention and care of her husband."[8]

Lyman and Munson set off believing fervently that "the salvation of hundreds of thousands of souls is involved." They found the Nyas, on a small island west of Sumatra, appealing, intelligent, friendly, ingenious, and "with a cast of mind superior to any Asiatics we have yet seen." Lyman expressed his delight to the headman, who passed on his message to the villagers. They gave Lyman and Munson three cheers in reply. "I shall never forget my feelings," he wrote. "Their homes shall be purified."[9]

Although Nya men bought their wives, Lyman thought the women were "treated with more respect than in any heathen nation." He judged that they had

Phrenology drawings by Henry J. Van Lennep, undated

"more of the wife and mother about them than I have seen in the natives of Java and Sumatra."[10]

There was subsequently dispute over why the pair set off on the next leg of the journey. Some insisted they were warned that it was dangerous; others argued that those who said so wished to shield themselves from blame. Lyman and Munson knew that the native Indonesians hated the Dutch, and distinguishing an American from a Dutchman might not be very easy in a heated moment. Lyman deplored the Dutch use of debt to sell local people into slavery, and he knew about the widespread warlike conditions that this trade produced. But the travellers believed the peacefulness of their purposes would protect them.

Lyman's own words, however, at the beginning of this particular trip display more than a little love of risk—even death, the possibility of which he often discussed in his letters: "I envy not one of my New England settled class-mates. I am ready to be offered."[11]

Whatever he and Munson believed, around 4 p.m. on Saturday, June 28, 1834, according to one witness, they met five Battas who advised them to turn back. They continued. Soon after, about 200 Battas from a village fortress nearby surrounded them in a wood, and after trying to disarm them—Munson refused— shot Lyman and ran Munson through with a sword. Their interpreter, Si Jan, who managed to hide during the killing, reported that the Battas cut the two men up in pieces.[12]

The news reached their wives many days later. The violently bereaved women wrote: "Well may Zion mourn: *our* only consolation is their abundant preparation for a change of worlds."[13] In time, the A.B.C.F.M. sent the widows $1700, and they returned to New England.

In what must have been among the most macabre happenings of his tenure as Secretary, Rufus Anderson eventually received the skulls of the young missionaries that had been retrieved by subsequent travellers. Apparently phrenology had come in handy when identifying them. Hannah Lyman Willard, editor of her late brother's memoir, wrote: "It was not difficult to distinguish them from the Asiatics [decorating a village]...When they reached America it was easy to tell which had contained the calm and thoughtful brain of Munson, and which the busy, energetic one of Lyman." Anderson gave the skulls to the widows, who had them buried.[14]

In a sense, Lyman and Munson had achieved the highest reward missionary service offered. Evangelicals—missionaries or not—disciplined themselves to think about death and reminded others to keep it in sight all the time. They admired a good death, one in which the dying expressed joy, felt no fear, only the presence of the Lord. Justin Perkins had written admiringly of the "rapturous deathbed" of Judith Grant (the best deathbed he'd sat at, he said, for twelve years), after whom he and his wife named their last daughter.[15]

Of course, Lyman and Munson made no converts, except possibly the "China-man" to whom Lyman had given the Bible his mother had presented to him on going away to Amherst. So, from Rufus Anderson's and the Board's perspective, they had failed.[16]

On the other hand, Lyman and Munson became famous. They inspired missionaries in the field to keep up the struggle and filled evangelical young men and women with awe and a desire to make their own contributions. As W. H. Medhurst, an English missionary in China, put it dramatically: "the Lord can bring good out of evil, make the blood of martyrs the seed of the church, and render the melancholy end of our brethren only the means of whetting the edge of keen desire with which the youths of our native land are burning to enter the lists with the prince of darkness."

Elijah Bridgman, writing as editor of the *Christian Repository*, defended them warmly. "Their grand objective was to benefit their fellow men…Had they resolved to hazard nothing and encounter no difficulties, surely they would not have left their native land…We deeply regret the loss of men…but never, until more light is thrown upon the case, or until we know that their conduct has been disapproved by the great Captain of their salvation, shall we dare to say they did wrong."[17]

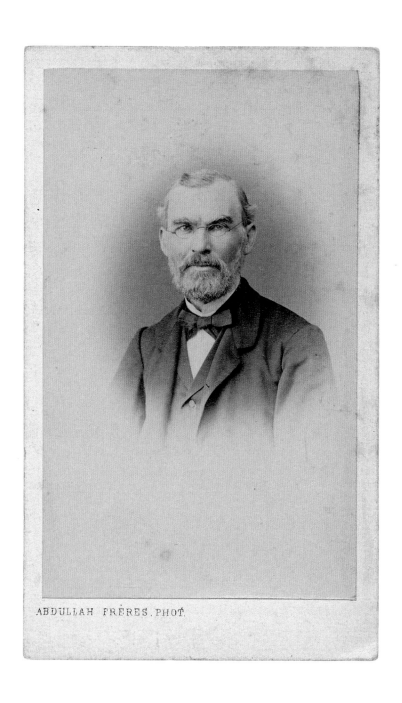

Portrait of Henry Van Lennep,
by Abdullah Frères, Constantinople

Henry Van Lennep

The Artist

While Perkins and Lyman were at Amherst, they became members of a secret missionary society, started on July 14, 1828. Other members included Elijah Bridgman and, later, Edwin Bliss and Henry Van Lennep. They called themselves the "Friends" and would meet on Saturday nights or Sunday after prayer meetings to share and recharge their missionary passion and "to become acquainted with the wants of the world."[1] Perkins was the society's first president.

Van Lennep had come to the United States in 1830 as a fifteen-year-old from Smyrna (now Izmir) in Turkey, where he was born. He planned to become a missionary, and, in 1837, graduated from Amherst as valedictorian. He studied under the Rev. Joel Hawes and in 1839 married Emma L. Bliss, his classmate Edwin Bliss's sister, who had been educated at Mt. Holyoke. When he and his young wife sailed back to Smyrna, Edwin Bliss and his wife, Isabella, went with them. But shortly after their arrival, Emma Van Lennep died. In time, Van Lennep began a trans-Atlantic correspondence with Mary Hawes, the Rev. Joel Hawes' daughter.

Mary was a frail young woman who lived in a circle of minsters and missionaries in Massachusetts. With her father's approval and encouraged by Henry's letters and his marriage proposal, she decided to join him in his mission to Smyrna. They were married on September 4, 1843, and a month later sailed from Boston for Smyrna, accompanied by Mary's father.

Mary and Henry traveled much the same route that Justin and Charlotte Perkins had. Mary wrote about the fine drawing her husband had made of the Rock of Gibraltar and about the number of times he called her on board to witness a fine sunset or mountainous wave. When they arrived off the coast of Spain, Mary wrote wonderingly to her mother, "How little I thought that my plain Yankee eyes would look on such scenes." Like the Perkins party, they anchored off Malta where they, too, were overwhelmed by the bells, and considered the religious delusions that all that ringing represented. But Mary also wrote that she longed "to hear the matins bells. It seems very pleasant to hear land sounds, and yet the sounds which float to us are by no means home-like … The stars are shining gloriously, and the dark walls before us are partially illuminated by the lighthouse, and here and there other lights appear, while almost every moment the bells are chiming, and mingle their voices with the ceaseless roar of the sea as it breaks along the shore."[2]

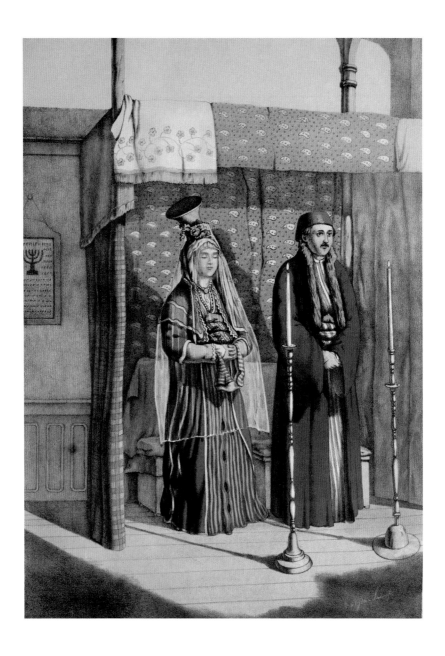

'Jewish Marriage,' a lithograph by Van Lennep,
from *The Oriental Album*, 1862

'Armenian Woman,' a lithograph by Van Lennep,
from *The Oriental Album*

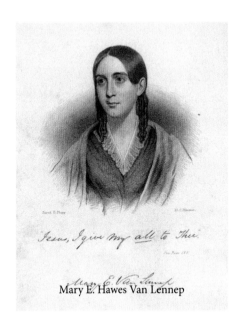

Mary E. Hawes Van Lennep

'Our old home,' a drawing by Van Lennep, 1855 (top),
and portrait of Mary E. Hawes Van Lennep, from the frontispiece
of *Memoir of Mrs. Mary E. Van Lennep* by Louisa F. Hawes, 1848

Mary and Henry thought Catholicism a "veil of darkness" over *real* Christianity, but both were capable of a wide range of responses, many positive, to cultures that were strange to them. For Van Lennep, acceptance of a varied world came easily, as he had spent his earliest years in Smyrna in a household in which both French and Greek were spoken. By the end of his life he had mastered many more languages including five Arabic dialects.

Perhaps influenced by her husband, and certainly moved by her own unbiased interest in others, Mary often wrote about how much she loved the East and how many misconceptions Americans had about it and its inhabitants:

> I believe it is a general fact that the Orientals are regarded by us Americans as semi-barbarians, or at best as grown-up children. Nothing is more erroneous. The more we associate with them the more we feel that they are entitled to respect and friendship, as much so as any polite, agreeable people in our own land, who are without true religion. With them we must observe the same strict rules of propriety, the same careful attention to the truth without disgusting them. They have the same hopes, fears, affections that we have, but their views of religious truth are dark and cheerless.[3]

Like Van Lennep's first wife, Mary lived only a short time as a "female assistant missionary." She contracted typhus and died in 1844, a protracted but reportedly happy death. Henry wrote to her parents that she had expected to die throughout her illness and joyfully anticipated heaven. She was buried in Constantinople, not, as he initially desired, among his relatives in Smyrna. "She went to Constantinople at a great personal expense, solely for the sake of the Armenians who she loved, and in their midst let her sleep among the living and the dead."[4]

Van Lennep worked for the A.B.C.F.M. for almost three decades in Constantinople, Smyrna, and Tokat. In 1850, he married Emily Bird, a stronger woman than her predecessors, who bore him six children and outlived her husband. During his missionary years, he traveled widely, studying the habits and customs of people in the "Bible lands" to better understand the Bible's meanings. He hoped to find a key in nineteenth-century behavior to stories and allusions several thousands years old, and although he failed, he collected quantities of valuable information about Armenians, Jews, Turks, Arabs, and Greeks that was observed, if not "objectively," then carefully and with unusual respect for his subjects. Unlike Justin Perkins, he preferred to call the religion "Islam" and its practitioners "Muslims," as they called themselves, rather than the prejudicial "Muhammedans."

The exception to his unusual fairness was his opinion of Turks, whom he dismissed as being "notorious chiefly for their gross... vices, seldom relieved by redeeming qualities. Their rule has been the blight and ruin of the fair lands upon which, locust-like, they have alighted."[5]

Turkish women on board the Russian Steamer Juno

2. partly shorn large tailed Sheep

Turkish women sleeping on board the steamer *Juno* (top) and
a partly shorn sheep, sketches by Van Lennep, undated

Sketches of Armenians by Van Lennep, undated

He was also disgusted by many of the gender-based customs he encountered. Polygamy in particular revolted him:

> It perverts the relations of the sexes and separates them, thus depriving each of the wholesome influence of intercourse with the other... In speaking of his wife [the husband] calls her his house, and in conversation with other men prefixes to the word "woman," "wife," or "daughter"... the phrase "I beg your pardon," just as politeness requires him to do before mentioning the word garlic, onion, a donkey or a hog. When a man is absent, and writes to his family, he does not address his letter to his wife, but to his son, even though his son may be a babe in his mother's lap."[6]

In his judgment, the method of proselytizing that worked best was distributing Bibles and letting their words speak for themselves. He looked to the 20,000 Turkish men and women who had already become Christians as an omen that the people of the Bible lands would become Protestants. "The minds of men were moved by an invisible agency, almost simultaneously throughout the country to inquire after religious truths, and to compare their faith with the Bible standard ... It is our conviction that the Christian religion... will, at no distant time prevail." Like American missionaries from New England—from whom he differed in many ways—he also believed the transformations that Protestantism would wreak would also bring to these Turkish converts the "blessings of a higher civilization than they ever enjoyed before, together with fertility to their wasted lands, the free enjoyment of the fruits of their industry, secured by a good government."[7] People would want to convert, not only because of the truth of the religion, but also because it came "to them, as the faith of the most highly civilized, prosperous, powerful and free people on earth."[8]

Van Lennep traveled extensively in Turkey and Greece and made extraordinary sketches and paintings until his eyesight began to fail in 1860, when he returned to America to teach. He eventually went blind. Many of his drawings illustrate Justin Perkins's book on his first eight years in Persia. Van Lennep collected paintings for his *Travels in Little Known Parts of Asia Minor*, which he published in 1870. His artworks, like his words, illustrate his interest, curiosity and respect for the places he encountered and the people he met.

Sketch for a building, possibly a church, by Van Lennep, undated

Elijah Bridgman, an engraving
by J. C. Buttre, c. 1860

Elijah Bridgman

A Stranger in China

Another of the secret friends in Perkins's and Lyman's group at Amherst was Elijah Bridgman, the son of a farming couple from Belchertown, Massachusetts, who graduated in 1826, the year before Lyman. He went on to the theological seminary at Andover, and in 1830, he sailed for China.

Bridgman had converted very early—at the age of eleven—and like so many other missionaries praised his mother for nurturing his spiritual development. She had taken him to "maternal meetings" (i.e. Maternal Association meetings, common in New England and upstate New York, like the ones initiated in Hawaii), an unusual practice that he recommended to others to ensure the early conversion of children. "My dear mother talked, prayed and wept over me ... To have her weep over my stubbornness was too much; I could listen to her words, but her *tears* I could not stand."[1] He remembered with reverence his mother's exemplary death: "So peaceful, so full of faith, Christ so precious ... "[2]

At Amherst and after, he helped at the African American Sabbath School and preached at the Poor House. At Andover, he made up his mind to "preach to the heathen." A quiet and generally unassuming man, Bridgman thought the assignment of being the first to China was too important a post for him, but since no one else was available, he agreed to go. He was ordained on October 6, 1829, and sailed eight days later. In a break with the A.B.C.F.M.'s preferences, he left a bachelor.

Bridgman arrived in the East Indies in January 1830, and toward the end of February landed in Macao (where the Chinese had permitted foreign traders to live and work since the seventeenth century). He was met by Eliza Armstrong Morrison, the wife of the then legendary Rev. Robert Morrison, a shoemaker's son from Northumberland who had been the first Protestant missionary in China. Morrison had arrived in 1807 and was famous among missionaries for translating much of the New Testament into Chinese. Justin Perkins had written about his pioneering efforts, and, with admiration and some envy, of Morrison's son, who took up his father's work after his death.

The Chinese were attempting with less and less success to keep their society closed to foreigners. They did not permit missionaries to preach or proselytize and forced them to live in either Macao or Canton (now Guangzhou), cities reserved for foreign traders. Canton, on the Pearl River Delta, was the capital of

the southern province of Canton (from which many of the nineteenth-century immigrants to the U.S. would come). Bridgman lived in, or more accurately outside the walls of the city, in one of the "factories" owned by the thirteen Chinese merchants who were licensed to trade with foreigners.

After a few months in China, he referred to himself as "a stranger in a strange land." To illustrate his alienation, he wrote of the executioners who beheaded their victims near the factories. They were said to drink alcohol mixed with gunpowder before their work and sometimes ate "the vitals of the wretched victims."[3]

Looking back over his first lonely year, Bridgman had studied the language, preached to the few Chinese willing to hear, prepared and distributed books and, like most missionaries, carried on a rich correspondence. His first Chinese convert was Leang Afa, a man of about fifty-two. He also acquired three "boys," a fifteen-year-old, who he had baptized, and two of eleven. These were the children of poor parents who were happy to see them housed and clothed in exchange for Christian training. The boys helped Bridgman learn the language, however, they were hard to keep, as teaching Chinese to foreigners was against the law, and the punishment was severe.[4]

In 1833, Samuel Wells Williams, a twenty-one-year-old graduate of the Rensselaer Institute, a college for the sciences in Troy, New York, joined the lonely Bridgman, bringing with him a printing press given by the Presbyterian Church of New York. Williams and Bridgman formed a harmonious working relationship and a lasting friendship. When Bridgman finally married, years later, he wrote to Williams with the news, addressing him as his "true yoke-fellow." Williams later reflected: "What a difference it would have made with me if I had been joined in the first years of my residence here with a freaky, impulsive man!... Blessed be God for Bridgman's example and influence!"[5]

Williams helped Bridgman edit the *Repository* and printed pamphlets and educational materials. After three years, Bridgman's Chinese was good enough for him to preach, though Williams wrote of the risks their Chinese language teachers had run for them. One teacher brought poison for suicide in case he was caught by the police and tortured. Another teacher always brought a woman's shoe with him to show the police that he was a shoe manufacturer there to do business with the foreigners.[6]

Bridgman's stay spanned the two Opium Wars between Britain and China (the first 1839–42; the second 1856–60) and the opening up of China. He noted that 1832 brought greater than usual agitation in the relations between the two countries. Some Chinese had long used opium, but the British introduced the practice of smoking it with tobacco, which fast became popular, and the East India Company began to import it into China about 1800. Qing dynasty officials refused to legalize the trade and tax it to make revenue as the British and some

Chinese merchants wanted, preferring to ban it. In 1834, the East India Company's monopoly on British trade lapsed, and Americans became competitors in the opium business. By the end of the decade the British and the Chinese were at war.

Bridgman, despite his fierce opposition to strong drink, was on the side of the British, believing that China had to change and modernize through contact with foreigners, especially the British, who supported Protestant missionaries. He thought that the dynastic rule over the enormous country must fall. "The government stands, not by the voice of public opinion, but by its own mastery, and when that mastery is lost, and it is daily becoming weaker … there must come a change of dynasty… No nation on earth has yet done for itself, much less for others, one half of what it ought to do, or will do, when both the rulers and the ruled learn to act according to … the New Testament." Opening up China to religion and trade—even drug trafficking—was for Bridgman, as it was for the missionaries in Hawaii and elsewhere, all part of the same righteous project.[7]

While loathing Buddhism for its worship of "miserable idols," and thinking that the Chinese should change their government and their policies or have them changed by others, Bridgman nevertheless sometimes wrote of the people of China in a way that was reminiscent of Mary Van Lennep's attitude toward "Orientals."

> Probably the Chinese people have more peculiarities than can be found among any other people; this, however, does not except them from feeling grief, pain, reproach, honor, hope, fear, and the like as keenly as any other mortals. With their peculiarities we have little more to do than to understand them with the simple object to meet and hear the Chinese as men, not as infernal or celestial, but as human beings.[8]

Bridgman's substantial achievements included *A Chinese Chrestomathy in the Canton Dialect* (1841), a lengthy volume of Chinese words and phrases, with a pronunciation guide, translations, and explanations culled from moralists and experts, to help students learn the language and something of the culture at the same time. For example, his section "Kindred Relations" lists all the possible relationships among family members, explaining their duties to one another. Although he presents the very unequal relations between husband and wife without comment, including phrases such as: "May you have a hundred sons and a hundred grandsons," he allows himself brief opinions here and there. In a footnote, he wrote, "By comparing for various reasons here given for divorcing, refusing, or retaining a woman as a wife, it is very apparent that Chinese moralists never thought of elevating females above the ignorant and degraded state in which they found them." This work was painstaking and, if not free of judgment, nevertheless sustained by a great curiosity for the language and customs of the Chinese.

From Missionary Herald. Feb. 1902.

For Young People.

A RECOVERED TREASURE.

BY REV. C. R. HAGER, M.D., OF HONG KONG.

WHEN the allied armies pressed their way towards Peking during the embroglio of 1900, there was connected with the German staff a young man by the name of Edwin Kleine, of Amoy, whose father was of Danish or German extraction, while his mother was a native of China. During the stay of the allied troops in Peking, the servant of Mr. Kleine secured by loot a silver cup and plate with an inscription which was partly illegible. Seeing that the pieces were of solid silver, the young man bought them from his servant, and when the work of the allies had been accomplished, he carried them back to Amoy, little knowing the historic value of his purchase.

After a time Mr. Kleine was taken sick, and Dr. J. A. Otte, of the American (Dutch) Reformed Mission, was called to attend him. Dr. Otte found his patient suffering very acutely, and once while speaking to him of the nature of the disease with which he was afflicted, he told him how Dr. Manson had described his disease. Whereupon Mr. Kleine said, "I have a cup and plate that were presented to a mission by Dr. Manson, which I brought with me from

A CHRISTIAN OF SOUTH CHINA.

Peking." To which Dr. Otte replied, "You must be mistaken, for Dr. Manson was not a Christian man; please let me see the relics." Mr. Kleine showed his valuable silver pieces, and the silver being tarnished a little, the name was at first not discernible; but having polished the plate, the inscription was clearly deciphered as follows : —

China. Perhaps it was given as a thank-offering to the American Board, for it was principally on account of the appeal of Dr. Morrison that the Board decided to open a mission at Canton. Five years before the presentation of this gift, Dr. Morrison had sent an earnest appeal to the American Board for American missionaries, with a view of laboring not only among the Chinese, but also among the American seamen who found their way to Whampoa anchorage, eleven miles from Canton. "Of the seamen who understand the English language," wrote Dr. Morrison, "there are annually at Whampoa

A SCHOOL AND TEACHER AT HOI-IN-KAI OUTSTATION, SOUTH CHINA MISSION.

from two to three thousand, of whom, on an average, about 200 die every year." It was undoubtedly this appeal that moved the American Seamen's Friend Society, in the latter part of 1829, to send to China, Rev. David Abeel with Rev. E. C. Bridgman, of the American Board. But in the beginning of 1832 Dr. Bridgman was the only American missionary in Canton, and the gift must have been given to him, as he not only instructed several Chinese in English, but also held English services for the English speaking people of Canton, for the seamen at Whampoa, and the foreigners at Macao. The presentation of these sacred utensils was an act of sublime faith on the part

Because all Christians before 1842 were barred from preaching in public, Bridgman gathered small groups who were interested in discussion and preached on the Sabbath to foreign seamen and merchants. He "plodded" on patiently, believing that missionaries needed to be ardently pious and willing to be "the *least* of all and *last* of all in the field; [to have] a spirit to do much and say little." He thought a missionary had to be cheerful and "be willing to be called the worst of names...and still be able to keep his temper."[9]

Bridgman fitted his own description. He passed out Christian material on the street, although the police more than once confiscated his scripture lessons, beat his assistants, including Leang Afa, and seized the men who did his printing. Bridgman ended up paying $800 to free all those persecuted on his behalf. Williams remarked that it was thirteen years before they would risk working with locals again.

Perhaps the years of opposition made Bridgman believe that the Chinese "should feel the power of foreign arms..." British troops arrived in Canton in April 1840, and conquered the Chinese, taking Hong Kong and forcing China open for British business. Bridgman applauded the Treaty of Nanking (August 29, 1842): "The spell which gave this government its fancied elevation was broken, its wall of seclusion breached, and a highway projected whereupon the sons of Han may enjoy free intercourse with those of every race and in every clime."[10]

In 1844, the American minister Caleb Cushing arrived to negotiate an American treaty with China. Bridgman interpreted for him and was adviser to the legation. The treaty, he was pleased to report, would "secure to foreigners without molestation or restraint, a residence at five ports, Canton, Amoy, Fuchou-fu, Ningpo, and Shanghai." In 1845, the Emperor of China issued an edict tolerating Christianity throughout the nation.[11]

In the year of the treaty, the 44-year-old Bridgman established a school for thirty pupils in Macao and married, on June 28, Elizabeth Jane Gillett, a British Episcopalian missionary. Bridgman liked married life, as he explained to Samuel Wells Williams: "Mrs. Bridgman relieves me from all domestic cares, and renders assistance in many ways, studies Chinese as she goes about the house, reads with the teacher, and now and then sits by my side. Then we go to the hospital, and she leads the singing in Chinese. Just the help, just the wife I needed." He notes that their home was filled with visitors, to whom Mrs. Bridgman attended.[12]

Elizabeth Bridgman never had children. While relieving Elijah Bridgman of all domestic cares, she brought three Chinese girls into the family. Ah Lee came into the Bridgman establishment because her father, a fortune-teller, could not support her until her marriage, which was already arranged. Elizabeth Bridgman wrote that she was filthy, with a very few dirty clothes and seemed "uncared for, and I pitied her." At first, she had tantrums because, Elizabeth Bridgman surmised, "her will had never been subdued," a responsibility missionary parents

took very seriously. They conferred with her father, and all agreed that Ah Lee needed "the rod." Elizabeth Bridgman thought the results were satisfactory, and in time the little girl helped her learn Chinese and performed tasks at home.[13]

King Meh, a second adoptee, had a mother who was suspicious of the Bridgmans but allowed her to live with them. They also acquired another little girl "covered with vermin" named Alan. These girls formed the core of the academy for girls that Elizabeth Bridgman would establish.[14]

The Bridgmans, like their colleagues elsewhere, worked to Christianize and educate girls and nurture what they considered their inherent potential for moral guidance in their homes. Elizabeth Bridgman wrote that the typical Chinese woman "is sitting down in darkness without love to shelter her head [or] home to illuminate her solitude, because the heaven-born instincts kindling in her nature ... which God implanted into her womanly bosom, having been stifled by social necessities, now burn sullenly to waste." She disapproved of the seclusion of women, and speculated that, because of the difficult conditions of their lives, mothers, probably "immediately after birth ... quench[ed] the fire of maternal love and close[d] its existence by suffocation ... They do not wait for ... the smile of the expanding infant to work upon the maternal bosom—this would be too much for a mother's heart, even for a heathen Chinese mother." She lamented the high rates of female infanticide.[15]

The presence of the girls, as well as full toleration of Christianity after the Treaty of Nanking, persuaded the Bridgmans to force the issue of attendance at prayers for the people who worked in their home. At first they simply invited their "domestics and workmen," but after three invitations, attendance remained spotty, at which point, wrote Bridgman, "it became necessary for us to take a stand." They told their workers that they had to attend morning and evening prayers or quit. They also instituted strict temperance, banning alcohol, tobacco, opium, and enforcing a 9 p.m. curfew. Everyone threatened to leave, and some did so. "No pains were spared in endeavoring to show and convince them that all our requirements were proper, and such as would promote their best interests ... Since the middle of last month, all have come ... They read, or hear read, the word of God in their own tongue and kneel in prayer with us at the family altar ... but who can touch their hearts?" Bridgman suffered from the distance he saw between their formal observance and the absence of felt religion.[16]

The Bridgmans were much heartened by the liberty they had after the Treaty to walk about freely and even to distribute books. However, when they took an outing in the countryside, Chinese pelted them with stones as they made their way back in a boat. The crowd yelled, "The foreign devils have killed our people, and we will kill you, and avenge our wrongs ..." Because of the violent resistance to the Treaty of Nanking, the British sent troops in 1847 to "secure a compliance with the treaty stipulations made by the Chinese."[17]

In 1847–8, the Bridgmans moved with Ah Lee and Alan to Shanghai so that Elijah could work with colleagues on revisions of Morrison's translation of the gospel. He found the city "narrow, filthy and close" and impossibly squalid. Working with Chinese ideograms caused him to reflect that, "Although the supposition that Satan had a special agency in the formation of the Chinese language" seemed unlikely, "yet we can hardly conceive of a tongue better adapted to promote his evil designs; and certain it is that no nation ever has been for so long a time shut out from the counteracting power of the Word of God."

Although Bridgman recognized the humanity in individual Chinese, he found the power of Satan in the regions of the Pacific. "These eastern nations are the dark places of the earth; and here the wicked one holds the oldest empire with broad and deep foundations."[18]

Toward the end of 1851, Bridgman contracted a fever in Shanghai, and he and Elizabeth, who was also ill, were sent back to the United States. They took with them their student, King Meh, despite her mother's resistance, after arranging that she would care for a boy on board ship and that her mother would receive $15 for her service. They landed safely in New York in June 1852.

Bridgman had been away for more than two decades, and they returned, as his wife wrote, to the "region of enterprise and progress. Railways, the electric telegraph, and all the developments that two and twenty years had produced…" He regained his health rapidly in his four-month visit. On their return journey they went by way of Cape Horn to San Francisco and then to Sacramento from where they embarked for China in February 1853.[19]

In Canton they found that opponents of Christianity had forced the missionaries to relocate to Shanghai, where Bridgman began to assume the duties of pastor full-time. In 1855, he baptized King-Meh, who began to help convert Chinese in the area. In that year, more than twenty Chinese—almost all women and girls—attended Bridgman's church. By 1858, he presided over a revival and wrote enthusiastically of the "wide breach [that] has been made in the wall of exclusiveness, which so long interposed a formidable barrier between the heralds of salvation and the perishing millions of this empire."[20]

The Taiping Rebellion broke out in 1850. Southern revolutionaries, under their leader Hong Xiuquan, wanted to overthrow the Manchu dynasty and replace Confucianism and Buddhism with their version of Christianity. Hong Xiuquan had received Protestant missionary tracts in 1836, probably from the missionary and Yale graduate, Edwin Stevens, who had worked briefly with Bridgman. Inspired by this evangelical literature, and by a number of dreams, Hong Xiuquan came to believe that he was the brother of Jesus Christ. The rebels were also in favor of the equality of the sexes and sharing property. Bridgman thought their ideology a mixture of good and evil.

As foreigners, missionaries were not supposed to interfere in politics. The Bridgmans wanted to "escape [the] fury," of warfare, and boarded one of the American ships stationed for protection. Elijah noted that he was "one of the very few who would not arm."[21]

As the Rebellion finished in China, the Civil War began in America. Bridgman found the war "dreadful," but he also saw that "God's hand is in these troubles, and … He will *purify* his people." In the autumn of 1861, Bridgman contracted dysentery. He suffered for several weeks before dying on November 21. His death was not marked by exaltation: it is reported that the stricken missionary could only say: "This is hard work." His wife quoted the eighteenth-century British poet, Edward Young.

> *The chamber, where the good man meets his fate*
> *Is privileged beyond the common walk*
> *Of Virtuous life, quite on the verge of heaven.*[22]

Elijah Bridgman went off alone to China to create Christians. He learned a very difficult language, promoted educational and cultural exchange between China and the U.S., supported Protestant–style education and the "elevation" of Chinese girls and women, and significantly advanced American understanding of Chinese language and culture with his writing. He also applauded and personally aided China's coerced entry into nineteenth-century international trade and global politics and Britain's persistent distribution of opium there.

In 1844, he had published, in Chinese, *A Short Account of the United States of America*, to acquaint the Chinese with his own country's history and institutions and their relationship to Christianity. Bridgman saw in Christianity more than the solution to both individual and national sin and error. It was inseparable from the political and economic arrangements of the United States, and individual conversion on a massive scale ultimately promised the transformation of nations into that country's likeness. His book would contribute to the Christian effort in Asia in an unpredictable way.

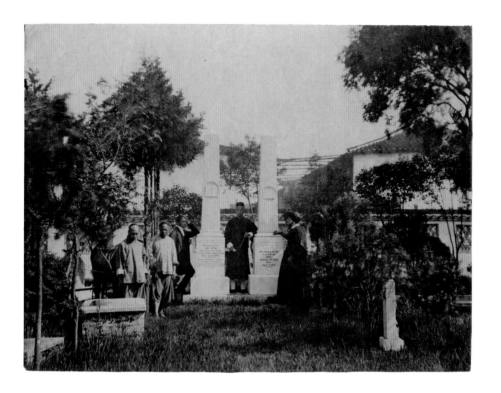

Elijah Bridgman, his wife and servants, photographed in the
Missionary Cemetery, Canton, China, 1826

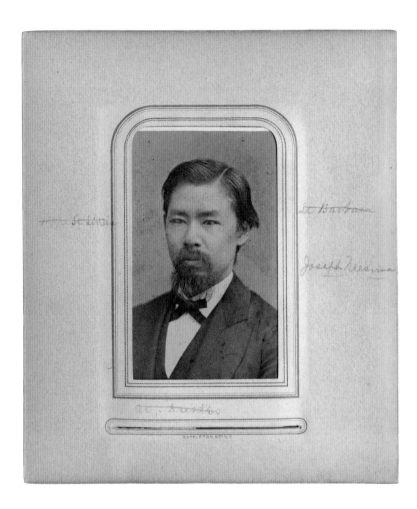

Joseph Neesima, c. 1870

Shimeta Neesima

Stowaway

After Elijah Bridgman's death in 1861, his wife Elizabeth left behind a few copies of his history of the United States, written in Chinese, in Yokohama. Three years later, one of them came into the hands of Shimeta Neesima, a studious young Japanese from a traditional samurai family. Reading it strengthened his conviction that he must escape from Japan and travel to the United States, where he would study for missionary work and then return home.

Later he described, in his inimitable adolescent English, the enormous impact Bridgman's book had on him: "I was read it many times, and I was wondered so much as my brain would melted out from my head, picking out President … Free School, Poor House, House of Correction and machine-working … O Governor of Japan! Why you keep us down like a dog or a pig? If you govern us you must love us as your children."[1]

Neesima was born in Edo (now Tokyo) in 1843 into a samurai family that enjoyed the feudal privileges of education, the right to wear a sword, and the inherited position of writing master in the house of a prince. He studied Japanese and Chinese and dreamed of learning English. A scholarly, idealistic, and ambitious young man, he did not enjoy teaching children—part of his feudal responsibility to his prince—and spent as much time as he could studying.

Neesima was nine when Commodore Matthew Perry demanded that the Shogun extend trading privileges to the United States. When the Shogun signed the Treaty of Kanagawa in 1854, he gave in to American demands and opened two ports, Shimoda and Hokadate, to American trade. Elijah Bridgman's "yoke-fellow," Samuel Wells Williams, translated for Perry on both of his visits to Tokyo and wrote to Bridgman, in language almost identical to that of his friend's, that, "I have a full conviction that the seclusion policy of the nations of Eastern Asia is not according to God's plan of mercy to these people, and their governments must change them through fear or force, that the people may be free. Corea [sic], China … and Japan, must acknowledge the only living and true God, and their walls of seclusion must be removed by us, perhaps … "[2]

Like many Japanese, particularly of the samurai class, Neesima was extremely distressed by the Shogun's weakness and his inability to expel Perry from the country. He was sympathetic to the growing movement to make his

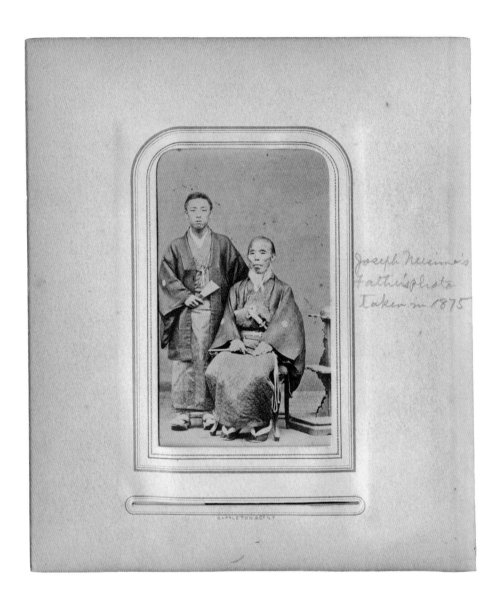

Joseph Neesima's
Father's photo
Taken in 1875

Photograph of Neesima's father, dated 1875

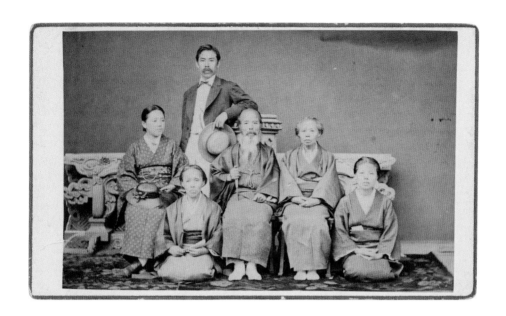

1 my wife
2
3 My wife's mother
4 „ father
5 „ mother
6 „ sister.

2

6 5 4

1

3

Neesima – Oct '90

Photograph of Neesima's family (top) with verso of photograph

country more martial and less corrupt, but because of his family's dependent position, he had to be loyal to the Shogun's policies and party.

Neesima's adolescence paralleled the extended crisis of identity and direction in his homeland. He read a Chinese copy of the Bible—thereby risking his own life and his family's safety—and was greatly drawn to the Christian message. Responding to both national and personal dilemmas, he came up with a plan that combined his new faith in the Christian God with his great wish to reform his country. His decision to leave home to study American Protestantism placed him at odds with the laws and traditions of Japan, his family obligations, and his feudal responsibilities to his prince.

Neesima was attached to his mother and particularly to his grandfather, who loved him "very deeply, very intensely, and very affectionately." He justified leaving his family because he "recognized God as [his] heavenly Father … I felt I was no longer inseparably bound to my parents. I discovered … that the doctrines of Confucius on the filial relation were too narrow and fallacious … I must serve my Heavenly Father more than my earthly parents. This new idea gave me courage to make a decision to forsake my prince, and also to leave my country temporarily." As he wrote, "What kept my courage was the idea that the unseen hand would not fail to guide me … [and] I may render some service to my dear country."[3]

He put away his long sword and began to dress his hair simply instead of in samurai fashion. He made his way to Hakodate—one of the two cities opened to foreigners by the Kanagawa treaty—to study English. Through a series of contacts he reached Captain William Savory of Salem, Mass., who smuggled him out of Japan to Shanghai. From there he sailed with Captain Horace Taylor on the *Wild Rover*, a brig that belonged to the evangelical merchant Alpheus Hardy. He arrived in Boston in August 1865.

Taylor helped the slight twenty-two-year-old learn English and, faced with the challenge of pronouncing Japanese, changed his name from Shimeta to Joseph. He put him in touch with Alpheus Hardy and his wife, Susan, who supported the A.B.C.F.M.'s endeavors generously with profits from Hardy's fleet of trading ships. They became Neesima's foster parents and saw him through his education at Phillips Academy in Andover and at Amherst. Their affection for their young protégé deepened and lasted their lifetimes.

At first Neesima was wary of wasting his precious time on what he saw as irrelevant, if required, subjects, but eventually he enjoyed even botany, because it led him to think that "God would not forsake me, because he cares for the minutest flowers." He wrote to Susan Hardy from Amherst that he was "just as busy as bees."[4]

When he entered Amherst, he joined the secret "missionary band" that met on Sunday mornings. He heard the news from missions in Turkey, China and

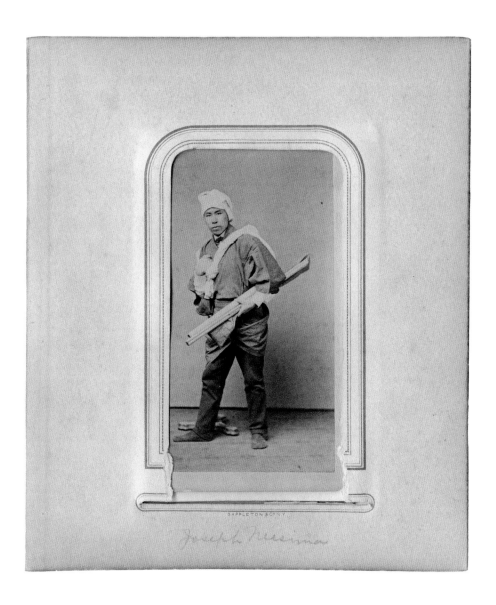

Neesima, dressed as a stowaway, photograph by
Daniel Appleton and Company, N.Y.C., 1875

elsewhere. His family wrote from Japan that the Shogun's palace in Tokyo had been burned and that elite Japanese were cutting their hair short and beginning to wear Western clothes. From this rapidly changing society, his father wrote that he was happy that his son was getting a Western education.[5]

The United States was also going through tumultuous political and social changes. The Civil War had freed four million slaves but was irreconcilably divided about what that freedom should mean. Chinese immigrants had quickly become central to the construction of the railroads in the West as well as an important source of agricultural labor. The Irish continued to arrive on the East Coast, and soon men and women from other parts of Europe would begin pouring into the country. The American Missionary Society's secretary preached to Amherst students in October 1869, in characteristically heated language, about "what fearful point the American people stands now." As Neesima recorded, "They have 8,000,000 Irish people and many Germans and French, 4,000,000 [N]egroes in South (sic), many thousands of Chinese and a few Japanese on the Pacific Coast. Unless American people stretch out their hands to enlight (sic), elevate, and educate them with the Christian truth they will ruin the free institution which is the pride of the nation."[6]

Neesima graduated from Amherst in 1870 and went on to finish his studies at Andover. In 1872, a prestigious delegation from Japan—the first of its kind—came to Washington to study American education. They summoned Neesima as a translator and consultant to the minister charged with making a report to the Japanese government about the delegation's findings. According to Alpheus Hardy's son, Arthur, the editor of Neesima's *Life and Letters*, Neesima's advice and observations "laid the foundation for the present educational system [1891] in Japan." From his early reading of Elijah Bridgman's book, Neesima had been attracted to the protection of individual rights in the American Constitution. But he distinguished himself from the other young Japanese on the mission by making it clear that, though he was working with the minister for the government, he was not a "slave" to be given orders by that government. He declared himself a "free man, a free man in Christ."[7]

The commission traveled to Scotland, London, Paris, Switzerland, Copenhagen and Petersburg. Neesima's health broke down under a combination of stress and his own internal demands, and in Germany he rested for a time in Wiesbaden. When the minister returned to Japan, Neesima resisted pressure to return with him in favor of finishing his studies.[8]

He was back at Andover in September 1873, when he heard from his father that the old man was living on his savings: the abolition of the feudal system had taken away his post with the prince's family that he and his ancestors had served for so long.[9] A few months later, the Secretary of the A.B.C.F.M., Nathaniel Clark, who had succeeded Rufus Anderson in the mid-1860s, asked

Postcard drawings by Neesima, with verso,
made while at Amherst College

Neesima if he would like to do missionary work in Japan, joining two missionaries who had gone there in 1869. "Of course I made an unconditional surrender to his call."[10]

On September 24, 1874, Neesima was ordained. His object on returning to Japan was to provide education that contained Christianity within it but was not limited to it. He wished to win over others of his class with a demanding curriculum that would attract students who would form an educated, native ministry.[11]

He arrived back in Japan at the end of 1874. He had planned to bring Christianity to the interior, but changed his mind and aimed for the "sacred city" of Kyoto, dotted with temples. The missionaries reluctantly agreed to his plan to establish a fee-paying school for religiously trained teachers that would be for the public, not just for specialists in religion. The governor of Kyoto bought five-and-a-half acres for the site. In 1875, Neesima married the governor's sister, Yamamoto Yaye, who was a teacher in a school for girls.[12]

Neesima's vision for what became Doshisha University was a Christian college in which a rigorous academic life supported a religious life. The political, social, and intellectual turmoil in Japan created an opportunity for Neesima's project. As a member of the samurai class, who was giving direction to Japan's political changes, asking for individual rights and a constitution and founding schools, Neesima had a strong hand.[13]

After his return, his parents converted to Christianity, and Neesima took down the family gods and idols from their places of honor. His sister joined in the prayer meetings at Neesima's house, and his wife "offered Biblical exercises at the school. We are perfectly happy," he wrote, "and I am trying to make my home like the Christian home I found in America."[14] He also helped found two schools to train "young girls for the great work to be done among the women in the land," in their role as helpmeets. He repeatedly expressed his support for the Christian education of women.[15]

Doshisha produced its first graduates in 1879. At first, Kyoto officials were suspicious of the school, and Neesima had to steer his fledgling institution with care. He had to deal with both Americans and Japanese; the former employed, in Hardy's description, "straight forward methods of procedure, so foreign to the semi-indifferent, indirect Japanese mind." But, for Neesima, perhaps the most important goal was creating a respected institution of learning. He feared being left

> [in the] lower strata of [the] educational system, and fail[ing]
> to lay hold of the best class of students. Our good missionary
> friends have thus far tried to teach the Bible too much and
> neglected scientific teaching. Some missionaries do not take
> pains enough to adapt themselves to our way...they are getting

quite unpopular...They are still Americans...They want to get too many foreign reinforcements instead of raising up native workers by their own hands. They cannot talk as the natives can...They cannot bear the heat of the day as well as natives can. They cannot live in a cheap rented house so patiently as the natives can...Christians must not be charged with being ignoramuses, or we shall not get the respect of the people.[16]

Neesima, who habitually drove himself hard, suffered from poor health. It did not improve things that, when he thought about "the millions of [Japanese] passing into eternity without acknowledging Christ, it seemed as if he would go crazy."

Despite his poor health, he returned to the United States in 1884 to raise money for a medical school at Doshisha. He warned Americans that Japan needed Christians in many fields, not just for founding churches. He saw the establishment of land grant colleges in the West and teachers being sent to the South after the Civil War as analogous to what he was trying to do in Japan. Christian educational institutions in a variety of fields would combat what he viewed as the worrisome prospect of European unbelief that was competing in his country with Christianity and which failed to develop the morality that should accompany intellectual growth.[17]

After ten months in the U.S., including three at a sanitarium in Clifton Springs, N.Y., where he tried without much success to stop thinking about Japan and its problems, he returned home. In 1887, he received news of Alpheus Hardy's death. He wrote to Hardy's widow, Susan, "I think I love both of you more than my own parents. I am begotten by your love...Noble affection binds us much firmer than some natural ties...I feel quite lonely. I feel my real father is gone; yea, he has been to me more than all my Japanese friends here."[18]

Neesima presided over the expansion and continued excellence of his university. Connecticut donated $100,000 for a Science building. He saw more than 800 students graduate from Doshisha and witnessed the establishment of numerous churches—even one by a formerly incarcerated man who had converted to Christianity. After several bouts of illness, Neesima died in January 1900 of peritonitis.[19]

His achievements were remarkable. He was interested in domestic and moral change in Japan, but not in turning the Japanese into Americans or in turning out preachers and teachers who knew nothing but the Bible. Like American missionaries, he wished to exemplify what he took to be American evangelical family life. He worked to reproduce the affectionate ties he had experienced among the Hardys and to reshape Confucian ideas of obligation and obedience to family with the Christian God as the ultimate source of moral authority. Like American missionaries, he too thought highly of American

political institutions based on individual liberty and informed by Christianity. But Neesima also thought Japanese Christians could work within their own demanding academic traditions to develop and purify systems of governance of their own.

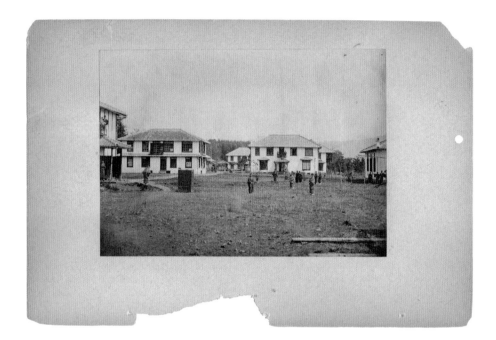

Doshisha University, c. 1880

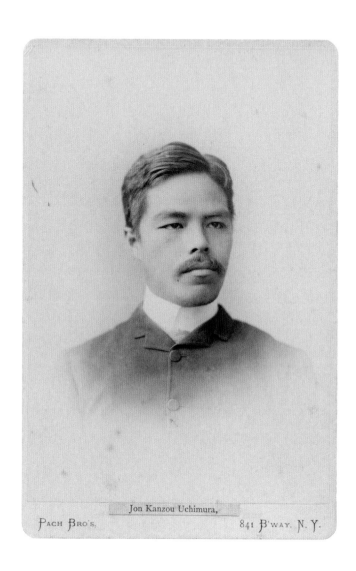

Jon Kanzou Uchimura,

PACH BRO'S, 841 B'WAY. N. Y.

Jon Kanzo Uchimura, c. 1885,
photograph by the Pach Brothers, N.Y.C.

Christians without a Church

In his *Diary of a Japanese Convert*, Kanzo Uchimura (or Uchimura Kanzō), like Neesima, a Japanese of the samurai class, located his birth in 1861, eight years after the national trauma of Commodore Perry's entry in Tokyo Bay and the opening up of ports to American trade. Uchimura's education reflected the changes in Japan that had taken place since the signing of the Kanagawa Treaty. As a boy, he attended Christian services weekly with a friend to hear "a talking man with long hair shout and howl upon an elevated place, flinging his arms and twisting his body." Not yet converted, he attended a Christian college "run by an Amherst graduate and missionary," and found in monotheism an escape from the sometimes contradictory demands of worshipping many gods. But his adolescent conversion seems to have been largely because of the pressure he felt from the school and from his classmates.[1]

Uchimura's father was a Confucian scholar and a skeptic. His mother he described as burying her need for philosophy in endless domestic work. In the opening of his *Diary* he reflected on the "pathos" of "heathenism" as "noble as hers,"[2] introducing with a sting the word he would admonish missionaries for using so indiscriminately. He described his father as a heathen, as well as a dignified and learned scholar: obedient and reverent to his superiors, sincere and harmonious in his friendships and lenient with his subordinates.[3]

After college, Uchimura worked for three years in a government agricultural agency, spending much of his time with other young Christian men. Initially he believed Christians and heathens were "entirely different set[s] of people" and imagined that the Christian nation of the United States must be filled with the pure and noble. In order for him to visit this imagined utopia, he and his family spent three years economizing. In 1884, he bought a steerage class ticket to San Francisco, where he intended to study practical philanthropy.[4]

By then, the egalitarianism of the Civil War and Reconstruction era had been largely smothered by the Republican embrace of big business and its fear of immigrants, and labor activism. For three decades Chinese from the Pearl River Delta had built American railroads, dug mines, washed clothes, and developed Western agriculture, working for very little. In response to the organized labor movement's resentment of the Chinese, and the politicians' exploitation of rac-

ism, the government passed the Chinese Exclusion Act in 1882, barring Chinese skilled and unskilled laborers from entry into the U.S.

Uchimura and his companions arrived to find virulent racial hatred, theft and profanity. He noticed how many keys Americans employed to protect their property and how little they tolerated Native Americans and African Americans. He marveled that "The land which sends missionaries to China, to convert her sons and daughters to Christianity from the nonsense of Confucius … the very same land abhors the shadow of a Chinaman cast upon its soil … Is Christian mission a child's play … that it should be sent to a people so much disliked by the people who send it?"[5]

He found scenes of "cockfighting, gambling, horse racing, football, pugilism, lynching, rum-traffic, demagogism (sic) in politics; denominational jealousies in religion; of capitalists' tyranny and laborers' insolence; of millionaires' fooleries; of men's hypocritical love toward their wives, etc."[6] After this shocking introduction to America, Uchimura began to rethink his low opinion of Japan, deciding that it had the "harmonic beauty of true proportions … with its own historical individualities." He even found himself envying his mother's indifference to systems of belief.[7]

After traveling the country from west to east, he began his formal study of practical philanthropy by working for the Pennsylvania Institute for Feeble Minded Children. Here he found a corner of the nation he could admire. The superintendent, Isaac Kerlin, Dr. James B. Richards, and the head matron, all impressed him deeply with their discipline, selflessness and single-minded desire to help the children under their care. He was touched by Kerlin's affection, and wrote: "He … humanized me. My Christianity could have been a cold, rigid, and unpractical thing" without his example and friendship.[8]

In Pennsylvania, Uchimura came to a deeper understanding of his own faith and its relation to other beliefs. Dr. Kerlin's wife was a Unitarian, a very liberal Protestant denomination against which Uchimura had a strong prejudice, preferring old-style Puritan orthodoxy. But he liked and admired Mrs. Kerlin's warmth, her dedication to her work and family, and her affectionate and sensitive treatment of him. In this unlikely crucible of "700 demented souls," Uchimura came to define true "liberality" in a Christian as "forbearance in all honest beliefs with unthinking conviction in one's own faith."[9]

Uchimura's health began to suffer, and although he was sad to leave, he started for New England to finish the last part of his studies at Amherst College. Shimeta Neesima had given him an introduction to the president, Julius Seelye. Uchimura showed up in his "old nasty suit, with no more than seven silver dollars in my pocket, and five volumes of [Gibbon's] *Rome* in my valise," and plenty of trepidation, but he found the large and genial Seelye both generous and welcoming. He was given a free room in the dormitory, but had to come up with

money for food, laundry, books, and fuel for the long, cold New England winters. He earned a little of this money speaking of his experience of converting from his heathen beliefs to Christianity, but much of his support came from the very generous pockets of one of his professors. He liked all his teachers, but he reserved his greatest admiration and affection for Seelye, whose helpfulness and sincerity of belief made a lifelong impression on him.[10]

In an odd footnote to his experiences with Mrs. Kerlin's Unitarianism, Uchimura discovered that he was drawn to the doctrine of predestination. This idea, the basis of Calvinism, was already going out of favor in the early nineteenth century, even among conservative New Englanders, but Uchimura was convinced that he was among the saved, and he believed that others who were saved would know it.

He had begun his *Diary* reflecting ironically on the label "heathen," and he ended it with a sharp critique of many missionaries' unthinking use of foreign converts as "tamed rhinoceroses," trotted out to satisfy and titillate Christian crowds. Referring particularly to a gigantic conference of 10,000 missionaries and interested colleagues, he noted that the missionaries asked the "rhinoceroses [to] tell them how they cease[d] to be like animals and began to live like men." They even asked them to "sing rhinoceros songs."

The missionary papers were "full of the acts of wickedness, the degradations, the gross superstitions of heathens [but] scarcely any account of their nobleness, godliness, and highly Christ-like character makes its way into their columns… The best missionaries," he argued, "are always upholders of the cause and dignity of the people to whom they are sent." Later, he said he loved Jesus and Japan equally and passionately. It is clear that he would have expected the best of missionaries to respect his love of country. Few missionaries would have fitted his definition of "best."[11]

Uchimura rejected missionary work and returned to Japan in 1888, where he remained until his death in 1930. In Japan he founded the Non-Church movement. He knew people needed churches, but he also knew that "liberal Christianity" could take many forms. Quoting the apostle John, he wrote, "I saw no temple [church] in the city [heaven].[12] Bishops, deacons, preachers, and teachers exist only here on earth. In heaven there is neither baptism not communion; neither teachers nor students." Uchimura knew that even the heathen without a church can be noble.

IN THE WORLD'S WHO'S WHO

W. E. D. WARD, Calcutta, India

William Earl Dodge Ward, Y.M.C.A. pamphlet, c. 1931

The Ward Family

Missionaries of the Future

Uchimura's criticisms of the missionary movement at the end of the nineteenth century focused on its cultural insensitivity, its lack of understanding of different ethical traditions, and its lack of respect for the national and political priorities of countries other than its own. These were problems that had persisted from the earliest days of the movement, but by the early twentieth century its success—as measured by its size, budget, and ambitions—made them more evident.

As Protestantism fought for significance in the radically altered American political and economic scene, the piety of the missionaries was recast and their energies channeled into projects such as social welfare, childcare, health and education training. In the United States, these fields were standardizing their practices, creating new professions and rewriting the country's social contract so that the state was now often a partner in projects previously left to the churches.

The upheavals caused by the immigration of ten million people to the United States over a period of about sixty years, along with the transformation of a largely agricultural country into the foremost industrial power in the world, had produced wretched urban conditions for many. There were unprecedented public health problems, massive and violent labor unrest, and greater class division than the country had ever seen. The belief that religious conversion could bring an end to sin, drinking, violence, misery, corruption and produce peaceful republics modeled on the antebellum U.S. had largely vanished. Many missionaries now saw the environment and institutions as needing reform as much as individuals needed salvation and Christian truth.

The growth of consumerism and the middle-class embrace of abundance, rather than productivity and frugality, further blunted the missionaries' personal radicalism.[1] Though the poor were even poorer, the relative material plenty available to the middle-classes increased opportunities and ideas of entitlement and diminished the need for thrift and unceasing labor. The expansion and wealth of the missionary empire and the growth of related N.G.O.s, such as the Red Cross, the Y.M.C.A. and the W.C.A., meant that missionaries and American aid workers abroad lived in comfort.

The Ward family, a sprawling missionary dynasty that included many Amherst graduates, followed some of the new paths that missionary work took in the next century, and the lives of some of its members illustrate the changes in

individual styles of Christian piety and labor. The family's interest in missionary work dated back to Lauriston Ward, a devout merchant from Massachusetts, who, in his later years, worked for the Treasury Department in Washington. His son, Langdon, born in 1828, married Laura Bliss, the Turkish-born daughter of Isabel Holmes Porter Bliss and Edwin E. Bliss (the couple who had accompanied the Van Lenneps to Smyrna), thereby uniting two active and dedicated missionary families. Langdon Ward worked all his life for the A.B.C.F.M. He and Laura Ward lived in Newton, Massachusetts, and had seven children, including twins: W.E.D. Ward, known as Earl, and Mark.

Paul Langdon Ward, Earl's nephew, in a memoir about his grandfather, recalled his father's early preparation for life.

> Whenever a missionary from overseas was expected, one of the
> children would be assigned to be his special host or hostess, to
> do the errands for the guest, make him feel at home, sit beside
> him at the table. In this way, each child came to know people
> from many parts of the world and to hear at first hand some of
> the thrilling stories of adventure, missing work and travel which
> they could tell ... Was it any wonder that every one of the seven
> children who grew up went to do Christian work abroad?[2]

Both Mark and Earl went to Amherst (1906). Mark became a doctor and medical missionary, while Earl opted for business. Missionary work, however, had altered to such an extent that when Earl protested he was neither a doctor nor a minister but a businessman, James Barton, the A.B.C.F.M.'s home secretary, replied that "the business side of the American Board is so large and so increasing that there will be ... a permanent place for you ... using your splendid business talent to the limit, and all in the interest of advancing the Kingdom of God."

Mark Ward and his eldest brother Edwin both served as doctors at the medical center at Harpoot in Central Turkey where, as Barton wrote, the mission college was enlarging its curriculum to educate students for their country's increasing commercial opportunities.[3] Earl, a sensitive and orderly man, worried that he was alienating both the missionaries and the "natives" by insisting on the need for business methods, aware that his imposition of them could conflict with "the great opportunity for Christian work." He discussed resigning with Barton soon after taking the post, but this was in conflict with his growing love for Dora Judd Mattoon, a hearty and cheerful, no-nonsense missionary stationed at Harpoot who talked him through his many frustrations and crises.

Dora, from a missionary family herself, was an indefatigable and fearless traveler, used to accompanying the missionary Rev. Henry Riggs on his horseback tours of small Turkish villages, sleeping in stables and getting lost in blizzards. She was becoming proficient in Armenian, the language of the Chris-

Harpoot, Central Turkey, photograph by W. E. D. Ward, c. 1910

tian minority in Turkey, and she helped teach in the mission's girls' school and run the orphanage. Part of Dora's job was to decide when the orphaned girls could take care of themselves and be sent away. "I expect by the time I get rid of them all I shall be the most cordially hated person in Harpoot," she wrote, "for sometimes mothers come weeping and wailing to our door and arouse the whole town on her behalf! However, it has to be done." (Orphans were defined as missing a father.)

Dora's piety was genuine, but it seems to have saturated less of her being than it did those of earlier generations. She was self-consciously "modern," one of a generation of educated and self-employed women who saw no need to marry. She praised a colleague who had found a nanny for her child so that she could continue to pursue adult activities. Over time, Earl changed her mind about marriage, but he agreed that she should continue to have activities and interests that were not homebound.

Once he was engaged, Earl returned to the U.S., leaving Dora behind to continue her duties while he established himself professionally. In Boston, he found gratifying work for the Y.M.C.A., which was at its most influential at this time. Dora stayed in Harpoot until World War I, when the aggression of the Kurds and the Turkish slaughter of the Armenians warranted the departure of most of the

mission. She left shortly after the beginning of the massacre of Armenians in 1915. On her return to the U.S., on December 3, she wrote:

> I wonder where all those dear friends are now? Many if not most of them killed, I suppose. How dear they all were, and how I loved and admired them! When I came away three of our professors and one of our teachers were in prison, along with eight or ten others of the prominent Armenians, and torture and massacre and deportation had not then begun. They came with full force later!
> In Diarbekir … things in the city were in an awful state. A reign of terror was going on and the most awful tortures were practiced in the prisons every night. Armenians were afraid to go outside in the city in broad daylight and of course were not seen in the streets after it began to get dark.

Dora reported that, on leaving, they had been warned by "everyone from the Ambassador down not to open our mouths" about what was going on in Turkey in order to protect the missionaries who remained. She speculated that one had been poisoned, others expelled. The missionaries' extensive work with the Christian Armenians made them targets. From Dora's letters it seems that her concerns focused largely on the missionaries, for whom she "trembled in her shoes ever since this publicity [about the massacre] began," not speculating that her silence was helping the Turks to destroy the Armenians without opposition.

A year after Dora left Harpoot, and a few months after their marriage, Earl took a job with the Y.M.C.A. in Calcutta. Dora, who had always worked, found herself a young married woman in India without a purpose. She suffered some kind of "breakdown." Earl forbade her to work "outside" for a year and limited her entertaining to one dinner or tea a week. She spent her time managing the servants, making dresses, baking cakes, and feeling inexplicably worn out. "I don't feel as if I were much use in the world. Earl seems quite content, however, to have me specialize on our home, and we do have such a good time together."[4]

Dora gradually began to work again in 1920, staffing a booth at the Child Welfare Exhibition and slowly taking on more work with the Y.W.C.A. In 1924, the Wards moved to Bombay to help establish a social services program run through the Y.M.C.A. Earl was to work in the "chawls," or tenements, where the 25,000 employees of the Empress Mills lived. He and Dora had to pull the program together from scratch with little training and less funding. They studied the models of British reformers, talked with missionaries working on issues such as temperance, and consulted with educational experts from Columbia Teachers' College in New York, trying to make sure their plans were up to date. Initially, they had no Marathi-speaking staff. Earl had to raise money to build a playground, and find rooms for schooling. He and Dora dreamed of hiring

Dora and Earl Ward's passport photographs, 1932

professional social workers, teachers and medical personnel. The government offered some land for the playground, but little else.

In 1924, they attended the "American Fellowship Party" in Great Britain, organized by Sherwood Eddy, longtime evangelist missionary to India and Secretary of the Y.M.C.A. Dora's description of some of the events show the growing breadth of her thinking on questions of labor, peace, and class struggle. She found it useful to see the U.S. as others saw it: "One gets more and more astounded that our people in America are so blind to what is going on," she wrote, alert to the growing resentment against colonialism, fears of economic instability and class division. She judged the 1919 Treaty of Versailles, with its punitive conditions on Germany, a "threat to peace" and wished Americans were aware of how much Europe wanted them to put their might behind changing its harsh terms. In a letter home she quoted the British journalist S. K. Ratcliffe, who was a popular speaker and a supporter of Indian nationalism, explaining that, "Americans are very much interested in India and Ireland, but when [Ratcliffe] mentioned Haiti and San Domingo and our own imperialist policy in the Philippines, no one knows [sic] what he is talking about."[5] The impressive company of pacifists and radicals made Dora tell Earl that she might "come out a communist!"

The Y.M.C.A. work in the chawls, however, was explicitly *not* communist, but funded—to the extent that it was funded at all: there were no professional teachers, social workers or medical staff—by the mill owners. The Wards anticipated their work in the mills "would be one step in the promotion of better relations between capital and labor," and they must "ensure the proper utilization of the leisure time of the workers and…be their friends at all times." Their faith in improved labor–capital relations had strong doses of naiveté and paternalism. They eventually hoped to offer, in addition to night school and children's activities, the production of Indian dramas, the extension of the Boy Scout program, and instruction in hygiene and thrift, which they thought would curb gambling. Dora had already noted that boy scouts "drawn from the depressed classes soon became cleaner and more alert."

Through personal contacts and ingenuity Dora found social welfare students interested in doing some volunteer work, and established a program of games and music for mothers and children. Earl started a night school, and the Wards were gratified later when a number of mill workers came to ask for a class in English. But money for the Indian children in the chawls was scarce. Two wealthy Bombay girls gave sweets as prizes to the children for sewing and other activities. There were fifty packets of sweets, but 300 children. Dora and others "had to open the packets, and finally ended up by having to break into two each piece of sweet. In order to prevent the children from getting more than one piece, we closed up all the doors but one and made them file past and out of doors."[6]

| Hindu in College. | Mahomedan on the Playground. | Parsi in Office. | Jew in School. | European in Business. |

YOUNG MEN OF ALL COMMUNITIES ARE SERVED BY THE Y. M. C. A.

Photographs from Y.M.C.A. pamphlets: young men from all communities (top) and Y.M.C.A. staff, c. 1920

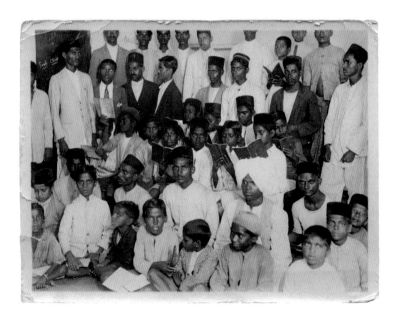

Wrestling in the chawls, Calcutta, India (top), a Y.M.C.A. class,
possibly learning English, Calcutta, c. 1920

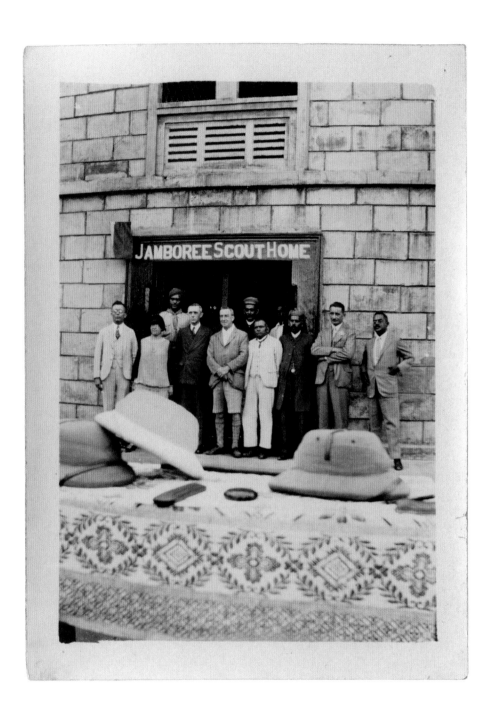

Jamboree Scout Home, Calcutta, c. 1926

The night school initially enrolled about seventy-five students, and the teachers earned four dollars a month. The Y.M.C.A. building fell down because of faulty construction, so Dora joined the committee to raise money for a new building. Meanwhile, in one of those jarring contrasts of global inequality, Dora wrote of a holiday they spent at the new Missionary Union in Kodaikanal, South India, a "fine stone building, which is as nice as the English Club." It had several verandahs, piano, reception hall and modern plumbing.[7]

An internal evaluation of their work in 1929 queried their plans as "opportunistic." It questioned their lack of Marathi and wondered if social workers could be of much use to mill hands.

But the Wards were not revolutionaries. In the words of their nephew, Paul, a missionary teacher and eventually president of Sarah Lawrence College, in New York State, they, like most American missionaries, were trying to "convey…many of the ideas and values that in fact lay close to the heart of American life." As Christians, Earl and Dora believed in charity, and as educated people of their time they reached out to Hindus, Parsees, Muslims, and representatives of other religious groups in India, largely abandoning the language of heathenism and savagery that had been typical of earlier missionaries. As representatives of America they accepted both their privileges and the superiority of their institutions.[8]

In 1932, the Wards returned to New England. They continued their work for the Y.M.C.A. in Massachusetts and engaged in extensive civic activity there. They had no children, but many of their nieces and nephews continued to work in new fields that their missionary antecedents had prepared them for.

Paul Ward, the son of Earl's older brother, Edwin, was born in Harpoot in 1911. Edwin practiced there for three years (overlapping briefly with Earl) before opening a clinic in Diyarbakir, in southeastern Turkey. His wife Charlotte, a graduate of Mount Holyoke College, worked as a nurse and assisted Edwin when she wasn't running their home and raising their five children.

Soon after Paul's birth, the family moved to Beirut, where Edwin took the Chair in Surgery at the Medical School of what became the American University. When World War I broke out, Charlotte took the children back to Massachusetts, returning at the end of the war. In 1926, Paul entered Deerfield Academy, went on to Amherst ('33) and got his Ph.D. in history at Harvard. He taught for a while before marrying Catherine Wakefield, who had grown up in China, and was, like him, the child of a missionary doctor. In 1942 he went to Washington to do research and analysis for the Office of Strategic Services, which became the C.I.A.

In 1945, Paul and Catherine Ward decided to move to China. They joined the missionary campus at Wuchang, across the Yangtze from Hankou, where Catherine had lived as a child. Paul taught and served briefly as treasurer of the university.

Bombay, India, c. 1920 (top); missionaries in Bombay,
with William Earl Dodge Ward seated right, c. 1916

Paul Langdon Ward, c 1940

After joining forces to repel the Japanese during World War II, the fighting between Chiang Kai-shek and Mao Zedong had resumed. In 1948, Mao and the communists won. Catherine and the children were sent to Hong Kong, where they waited for Paul to join them. In 1949, Mao declared the People's Republic of China. When Paul finally set off for Hong Kong, friends and admirers accompanied him along the train route from stop to stop until he reached his point of departure. In 1951, the whole family returned to the U.S.

Both Paul and Catherine Ward had thoughtful perspectives on the changing conditions and problems with Christian outreach in China. Paul Ward was acutely aware of some missionaries' dissent from American imperialist policies in China as early as the 1920s. His wife remembered from childhood how the Americans had segregated themselves, "setting [themselves] distinctly apart from the Chinese." These habits continued into the 1940s, when Catherine Ward thought them even more "offensive," than they had been twenty years earlier, as their Chinese colleagues, both men and women, were now largely western-trained academics who had suffered through a terrible economic crisis that left the Americans in China unaffected. Catherine also took up the issue of the astonishing material gap between the way most Chinese and Americans missionaries lived, and recommended that missionaries be rigorously chosen in part for their willingness to adopt a modest style of life more in harmony with that of the Chinese.[9]

Paul Ward had learned a lot in his time in Hangkow after the communist takeover, hearing from Chinese about the process of re-education—or what Americans called brainwashing—and later, in the U.S., when P.O.W.s from the Korean War returned home. Ward thought re-education produced obedience to the authority of the group, not genuine truth-seeking within. He felt the communists mistook their own goals—which he thought were mainly a desire for power—for Marxist ideology.

He compared re-education, ironically, to the conversion process of early Puritans, in which salvation could only come about by an individual experiencing his own limitless sinfulness, and could only be washed clean in subservience to God's wishes. As a twentieth-century Protestant, and an Episcopalian, not a Congregationalist, he obviously had no nostalgia for the Puritan conversion model that early missionaries had brought with them.

In 1962, Ward made a speech to the Mount Vernon Rotary club on the subject of President Kennedy's Peace Corps, which had been established the previous year, and which sent volunteers to help communities in foreign countries. Their two years' service offered young Americans the chance to learn about another culture and to introduce their own culture abroad. Ward thought the Peace Corps a welcome reworking of the project that missionaries had been involved in for several generations. In his talk he painted Christian proselytism as inevitably entangled with democratic ideals, and inescapably sustained by

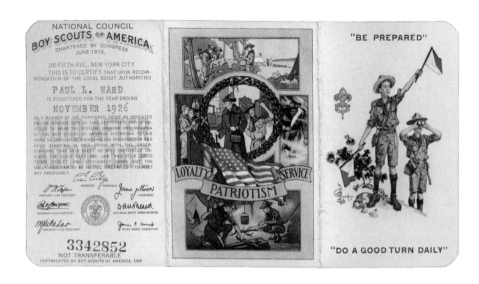

Paul Ward's Boy Scouts' registration certificate, 1926 (top), and certificate of service to the Office of Strategic Services (wartime intelligence agency), 1945

Western power and economic might. This mixture, he thought, was a strength, not—as Uchimura had seen it—the arrogant presumptions of a mighty power.

Paul Ward believed the *purpose* of missionary activity was the communication of religion, service, and democratic values. "We are not true to ourselves, and to our heritage of freedom, unless we try to communicate … our democratic way of life," he said. He thought this was better done by idealistic young people than by specialists and technicians who would have trouble communicating with anyone but other specialists. He saw a direct parallel between missionaries, who provided education and health care, with potential Peace Corps workers—"young

people ready to pay a personal price in hardships and strain in order to represent more clearly our idealism and our hopes for the world." Speaking from his Cold War experience, he pointed out that the communists were working hard to keep alive the memories of European and American imperialism—an imperialism that he thought was over.[10]

Ward never abandoned his missionary heritage of idealism. He spent many of his later years on Christian peace activism, working in the anti-nuclear movement at a time when it seemed quite possible that nuclear war might erupt between the U.S. and Russia and destroy the entire world.

In his view, men and women of missionary background remained the best equipped to carry what to him had become a largely secular idealism. Serving around the world, with a focus on democratic ideals, could take many forms, as the Ward family demonstrated. But Paul Ward believed that all service had to be embedded in the context of "tact and sensitive understanding of the realities of what non-Westerners call imperialism."

Westerners, too, call it imperialism now, and the distinction between it and American aid around the world—whether provided by missionaries, Peace Corps volunteers, the State Department, human rights workers, or anyone else—remains the crucial variable between giving and coercing.[11]

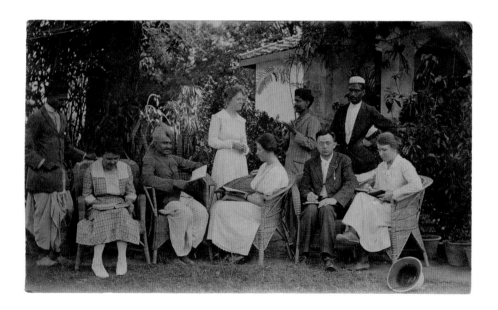

Missionaries in India, photographed by
W. E. D. Ward, late 1920s

Notes

Reuben Tinker

1. William Clark Durant, *The Life of Reuben Tinker, 1799–1854* (N.Y., 1921), p. 3.

2. Mary Zwiep, *Pilgrim Path, The First Company of Women Missionaries to Hawaii* (U. of Wisconsin Press, Madison, Wisc., 1991), p. 12.

3. Durant describes *Windham* as an "Old-fashioned long-meter hymn tune...more doleful than cheerful." p.4, n (1)—long-meter is eight syllables, like the first line of "Amazing Grace." Wikipedia, Daniel Read, accessed Jan. 20, 2013.

4. M.L.P. Thompson, *Sermons by Reuben Tinker with a Biographical Sketch by M.L.P. Thompson (New York, 1858)* p. 18.

5. Anne Boylan, *Sunday School: The Formation of an American Institution, 1797–1840* (New Haven, 1988)

6. *Ibid.*, 14.

7. *Ibid.*, 18.

8. "Embarkation of Missionaries," *Missionary Herald, Containing the Proceedings of the American Board of Commissioners for Foreign Missions*, Feb. 1831.

9. Thompson, *Sermons*, p. 26.

10. *Ibid.*, 30.

11. Durant, *Tinker*, p. 12.

12. Durant, *Tinker*, p. 10.

13. (*The Missionary Herald*, XXIX, 11, 339 "Extracts from a Joint Letter of the Missionaries at Lahaina," dated Nov. 20, 1833].

14. Thompson, *Sermons*, 35.

15. Durant, *Tinker*, p. 17.

16. *Ibid.*, p. 19.

17. Patricia Grimshaw, *Paths of Duty, American Missionary Wives in 19th Century Hawaii*, (Honolulu, 1989), 139.

18. *Ibid.*, 145.

19. March 1832, *Missionary Herald*, Vol. XXVIII, Number 3, 338-9, Sandwich Islands; "Letter from Missionaries at Lahaina."

20. Joseph Tracy, Solomon Peck, Elijah Mudge et al., *History of American Missionaries to the Heathen From their Commencement to the Present Time* (Spooner and Howland, Worcester, Ma., 1840), p. 284.

21. Durant, *Tinker*, 28.

22. *Ibid.*, 29.

23. *Ibid.*, 31.

Justin Perkins

1. Letter to Brother Philander Powers, Sept. 1833, Amherst Archives.

2. Henry Martyn Perkins, *Life of Rev. Justin Perkins, D.D., Pioneer Missionary to Persia*.

3. Amanda Porterfield, *Mary Lyon and the Mt. Holyoke Missionaries* (New York, 1997), pp. 72–87.

4. Justin Perkins, *Journals: A Residence of Eight Years in Persia Among the Nestorian Christians* (1843, NYC), p. 26.

5. Perkins, *Journals*, 21.

6. *Ibid.*, 33.

7. *Ibid.*, 40, 45.

8. *Ibid.*, 39.

9. *Ibid.*, 52, 53, 62, 63, 74, 149–50, 225.

10. *Ibid.*, 93, 96.

11. *Ibid.*, 143.

12. *Ibid.*, 179–181; Porterfield, *Mary Lyon*, 29; Rufus Anderson, *A History of the Missions of the American Board of Commissioners of the Foreign Missions to the Oriental Churches* (Boston, 1872), Vol. I, 182.

13. Porterfield, *Mary Lyon*, 73; Martha Saxton, *Being Good, Women's Moral Values in Early America* (New York, 2003), pp. 209–211.

14. Anderson, *Missions*, 214–215.

15. Perkins, *Journals*, 254.

16. *Ibid.*, 274, 288, 295.

17. *Ibid.*, 297.

18. *Ibid.*, 346, 345.

19. *Ibid.*, 396.

20. Justin Perkins, "Journal", Feb. 10, 1840, Amherst College Archives.

21. Porterfield, *Mary Lyon*, 72–73; Isabella Porter Bliss, "Diary" August 2, 1842, Amherst College Archives.

22. Porterfield, *Mary Lyon*, 72–81.

23. *Why Protestant Churches? The American Board and the Eastern Churches*, H. L. Murre-Van Den Berg, 107–8 in *Missions and Missionaries*, ed. Pieter N. Holtrop and Hugh McLeod, (Bury St. Edmunds, Suffolk, U.K., 2000).

24. Justin Perkins, *The Persian Flower, A Memoir of Judith Grant Perkins of Oroomia, Persia* (1853, Boston), 23, 124.

25. Perkins, *Life*, 32.

26. *Ibid.*, 85–86.

Henry Lyman

1. Hannah Lyman Willard, *The Martyr of Sumatra: A Memoir of Henry Lyman* (N.Y.C., 1856), p. 50.

2. *Ibid.*, 140.

3. *Ibid.*, 60, 61.

4. *Ibid.*, 249.

5. *Ibid.*, 258.

6. *Ibid.*, 329.

7. *Ibid.*, 303; *Chinese Repository*, Vol. III, 1834, pp. 321–2.

8. Willard, *Lyman*, 277, 294.

9. *Ibid.*, 293, 340, 349.

10. *Ibid.*, 356, 367–8.

11. *Ibid.*, 323.

12. *Ibid.*, 401–2; *Chinese Repository*, Vol. III, 309.

13. *Chinese Repository*, Vol. III, 310.

14. Willard, *Lyman*, 433.

15. Anderson, p. 368.

16. Willard, *Lyman*, 319.

17. W.H. Medhurst, *Christian Repository*, Vol. III, 309; Elijah Bridgman. *Christian Repository*, III, 324.

Henry Van Lennep

1. W.S. Tyler, *History of Amherst During its First Half Century 1821–1871*, Springfield, Ma., 1870, pp. 275–277.

2. Louisa Hawes, *Memoir of Mrs. Mary E. Van Lennep; only Daughter of the Rev. Joel Hawes, D. D.,* (Hartford, 1847), pp. 160–180, 191, 195.

3. *Ibid.*, 270, 266.

4. *Ibid.*, 341.

5. Henry Van Lennep, *Bible Lands, Their Modern Customs and Manners Illustrative of Scripture* (Harper Bros., N.Y.C., 1875), pp. 505–6.

6. *Ibid.*, 561.

7. *Ibid.*, 811.

8. *Ibid.*, 809.

Elijah Bridgman

1. Bridgman, *The Life and Labors of Elijah Coleman Bridgman* (N.Y., 1864), p. 1

2. *Ibid.*, p. 5.

3. *Ibid.*, 54, 49.

4. *Ibid.*, 64.

5. Frederick Wells Williams, *The Life and Letters of Samuel Wells Williams, LL.D.* (N.Y.C., 1889), p. 62.

6. Williams, *Life and Letters*, 57–8.

7. Bridgman, *Life*, 106, 108.

8. *Ibid.*, 105.

9. *Ibid.*, 79.

10. *Ibid.*, 120.

11. *Ibid.*, 128.

12. *Ibid.*, 135, 142, 140.

13. *Ibid.*, 42; Elizabeth Bridgman, *Daughters of China or Sketches of Domestic Life in the Celestial Empire* (N.Y.C., 1853), pp. 51, 77.

14. Bridgman, *Daughters*, 48.

15. *Ibid.*, xviii, 52.

16. Bridgman, *Life*, 143-4.

17. *Ibid.*, 155-6, 161.

18. *Ibid.*, 165, 170, 178.

19. *Ibid.*, 190.

20. *Ibid.*, 233.

21. *Ibid.*, 245, 248.

22. *Ibid.*, 255, 273, 276.

Shimeta Neesima

1. Arthur Hardy, *Life and Letters of Joseph Hardy Neesima* (1892, Boston), 4.

2. Williams, *The Life and Letters*, 214.

3. Hardy, *Life and Letters*, 442–3, 31, 38.

4. *Ibid.*, 60.

5. *Ibid.*, 89.

6. *Ibid.*, 92.

7. *Ibid.*, 121–2.

8. *Ibid.*, 142.

9. *Ibid.*, 164.

10. *Ibid.*, 165.

11. *Ibid.*, 169.

12. *Ibid.*, 200, 202.

13. *Ibid.*, 169.

14. *Ibid.*, 207.

15. *Ibid.*, 216.

16. *Ibid.*, 229.

17. *Ibid.*, 209, 288, 291.

18. *Ibid.*, 302.

19. *Ibid.*, 325–6.

Kanzo Uchimura

1. Kanzo Uchimura, *A Diary of a Japanese Convert* (N.Y.C., 1893), 11, 19, 21–22, 26–7

2. *Ibid.*, pp. 12.

3. *Ibid.*, 11, 12.

4. *Ibid.*, 59.

5. *Ibid.*, 140–142.

6. *Ibid.*, 143, 150.

7. *Ibid.*, 155.

8. *Ibid.*, 168.

9. *Ibid.*, 169.

10. *Ibid.*, 190.

11. *Ibid.*, 201.

12. *Revelation* 21: 22.

The Ward Family

1. T. Jackson Lears, "From Salvation to Self-Realization: Advertising and the Therapeutic Roots of the Consumer Culture, 1880–1930" in Richard Wrightman Fox and T. Jackson Lears, *The Culture of Consumption: Critical Essays in American History, 1880–1980*, New York, 1983, pp. 1–38.

2. Paul Ward, March 5, 1956, on the twelfth birthday of his son, John Chapman Ward (Ward Papers, Amherst College).

3. James Barton to Earl Ward, Jan. 15, 1909, (Ward Papers).

4. Dora to her family, Dec. 3, 1919; Dora to her family, Oct. 28, 1919.

5. Dora to her family, Jan 20, 1923.

6. Dora to her family, May 17, 1926.

7. Dora to family, July 30, 1925; Dora to family, May 17, 1926.

8. Paul L. Ward, talk, Mt. Vernon, 1962 (Ward Papers).

9. Paul L. Ward, Lecture on China and Russia; (Catherine Ward to Rev. Charles Long, Jr.).

10. Foreign Missions Yesterday—Peace Corps Today, Paul L. Ward., Dec. 5, 1962.

11. *Ibid.*

Part Two

Voices from the Amherst and Springfield Communities

Fazal Sheikh

Arline Wright

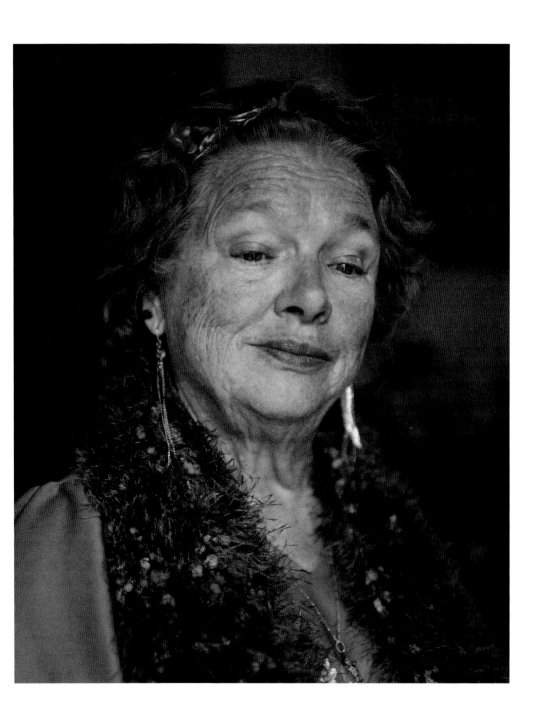

I was born in Athol on January 7, 1945. My great, great, great aunt Harlow was Native American, from the Mi'kmaq tribe up in Nova Scotia. In those days, with times hard and little for resources, they had to be sure to use everything around them, killing the buffalo and using all the parts. They knew how to make quilts and outfits that they could sell for money or trade. She even made dolls' outfits to sell. Her people eventually moved south and landed around Massachusetts. She's sitting weaving a basket in this picture. She was a strong woman, had many children. She lived to be eighty-five years old.

My grandma Starks on my father's side of the family was one of her descendants. Eventually she would be married eight times—once, even, to a bigamist—and each time she got married, she had two children with the husband, so by the end of her life, she had given birth to sixteen children. She was a tough lady and determined to make the farm she lived on succeed. She used to say, "If the stud-muffin don't work the farm, I'll have to get rid of him." Then, sure enough, if he didn't put his back into the work, she would move on to the next husband. Here she is with one husband, George, and then there she is with her last husband, Starks, who was the eighth. He passed away two weeks after she died. They say he died of a broken heart.

My grandparents on my mother's side, Frank Melrose Norris and Virginia Jane Avery, met in the fall of 1916. They were married in my great-grandmother's house before moving into a home in Pittsfield, in western Massachusetts. You can see her there on her wedding day, with the whole future ahead of them. Right up until the day he died, Frank couldn't read, and signed his name with an X. They were married for sixty-five years. I still have their marriage ceremony memorial with the pastor's greeting. The pastor inscribed it:

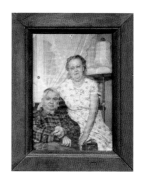

My dear Friends,
May God bless abundantly this new life upon which
you are entering. May health, wealth, and happiness be
yours. But seek ye first the Kingdom of God and His
righteousness and all these things shall be added unto you.

> *Most cordially yours,*
> *Harry C. Leach*

The father-parent—I can't bring myself to call him 'father,' he never acted the way a normal loving father should—had one full-blooded sister, Fannie, and fourteen half-brothers and half-sisters. There must have been something seriously wrong in that family because he was a man who was full of anger. Soon after his marriage, he became a minister in the Pentecostal Assembly of God. Even if he preached all over the state for many years, I still don't believe with all that he did to our family that he had a right to say he was a man of God. People like him, who smack children around and do even worse things, should be kicked out of the ministry.

You have to go all the way back to my early childhood to find the start of the abuse. They named me May, after—Let's call her the mother-parent. It's

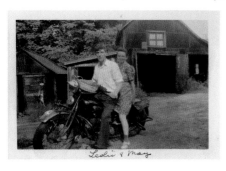

funny that they thought to name me after her. I just don't understand it, since she was such a cruel woman. She never loved us. And since I had her name, the father-parent would say he could treat me just like her. They both had bad tempers, and they took it out on us four kids. We were all hurt a lot growing up in that home. He was violent and abusive, right from the

start, but there was no one who would stand up to him, no one who would stop the abuse.

We used to sleep up in the attic on spring mattresses without the stuffing, just newspaper between the springs for padding. When we were kids, he used to cut a hole in the ice and make us bathe in it. He used to say: "Spare the rod and spoil the child. He that loveth the child chastises him with a rod." Then he would take a switch and beat us until he got tired, then he would rub salt and pour vinegar into the wounds. At the end of the beatings he would make us tell him that we loved him and that he loved us. The hardest part was saying that I loved him, because I didn't.

We never wore proper clothes at home when we were young, only when we went to church. I had the church dress on one day and I went to school and he came to the school and took my clothes off in front of the whole class. He brought a rubber hose to beat me with. He dragged me out of the school and beat me all the way back home.

If there was any way possible that he could hurt you he would do it. When I was eight years old, I said I wanted to cut my hair short. So he shaved me completely bald.

They knew what was happening at the school, but you have to remember that those were different times, when people were afraid to speak out, and they were certainly afraid of the power of the church. The father-parent's congregation also knew what was going on and the minister told him that it would have to stop, but they only sent him to another place each time it got too hot for them. We just kept moving around from parish to parish; at least seven times when I was [living with them] in the home.

The mother-parent, May, would make us oatmeal, and if we didn't eat it, she would put it in our sandwiches for lunch, and if we didn't eat it then, she would fry it up for dinner. I found a light in it because I could trade with a girl who had mashed potato sandwiches—and they were very good, I might add.

We were never allowed a party in all the years growing up. The mother-parent used to beat us frequently and for no reason. If a picture was taken of us and any of us in the photograph were not smiling, we would be beaten. I remember the time my sister Irene was beaten for not smiling as happily as the rest of us in a photograph. But in the marriage she did far worse things. As the father-parent was often away preaching, she had a tendency to go after other men. Several times during our childhood she got

pregnant by another man. What happened then might not happen now, but each time she got pregnant from some other man she would use a coat hanger to abort the baby. There were also unwanted babies that were born alive. There was a doctor who knew our family—there were many people who knew my father and wanted to help the "man of God" in whatever way they could. That doctor told them to make sure there would be nothing left that could be used later as evidence.

I found out they didn't name me until several days after my birth, since the father-parent was trying to decide if I was his, and if I should be allowed to live. If I had been the wrong color, or my hair had been too unlike his, it would have meant I wasn't his, and he would have gotten rid of me. The rules were real different in those days, especially when the clergy was concerned. There was a separate set of rules for them, and they didn't seem to be held accountable—at least not on this earth—for the violent physical and sexual abuse they brought to their families.

When I was old enough to understand what was going on, I tried to put a wrapped doll in the place of the baby. I wrapped up the doll real tight and placed it in the spot where the baby was to be buried. But they found out, and on that day I received one of the worst beatings I ever had. I never interfered again. It was things like that happening that kept us moving, so the parents could stay one step ahead of any trouble with the law.

My younger brother Frank was small, since they didn't give him enough to eat at home. Frank lived with the abuse until he couldn't take it any more. He hung himself in our barn in Windham, New Hampshire, in 1962 at the age of thirteen. I was always relieved that I wasn't the one to find him hanging there.

Many years later, when my own children were older than he had been when he died, I traveled with my sons Robert and Chris to the back-yard of the farm where Frankie killed himself. It was a bad place, where many terrible things had happened, and you could feel it in the land. I photographed them beside his grave. Later, when we looked up to the sky that afternoon, we could see in the clouds a face looking down on us, watching over us.

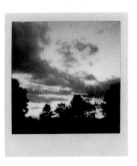

One day, when I went to school bleeding from a beating, they finally decided that what was going on at our home had to stop and they placed me with my aunt, the half-sister of the father-parent. I say that my aunt was my true mother, since she gave me all the love and comfort one could ask for in life. I called my aunt "Mom," because she was the one who saved me and showed me real love. Without her, I would have been completely lost. And that's why I wanted to change my own name. I couldn't stand to be May, and each time I was called by that name, it sent up a flare of memory of the woman who had abused us for so many years. So I changed my name to Arline.

That was just before Frankie killed himself. They said I was to blame because I wasn't there to take care of him like I normally was. The father-parent said so at his funeral, but Mom sent me to wait in the car and then slapped him and yelled at him and said never to come to her house again or she would call the police and send him to jail. He left the funeral after that, but as he walked past me in the car he called me a witch. So I guess I'm a witch now.

I was going to school all the while, but I fell so far behind by the time I went to live with Mom that it was impossible to catch up. I was in high school, even though I didn't know how to read or write, since the father-parent forbade us to learn. He wanted us to remain dumb and under his power. Mom came up with a plan and the teacher agreed to teach me orally, so that I could take my tests to finish school. At night, Mom would go over the day's work with me, so I would be ready for the next day's teaching. This way, I graduated from high school.

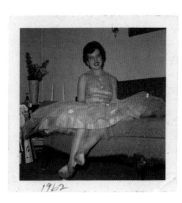

1962

Mom made this pink dress with apple-blossoms embroidered on it for my first prom in 1962. I had come to live with her only a short time before. When I was getting ready to head off for the night, she told me to wait, she had a present for me. It was a handbag with money to call home, lipstick, and a hand-kerchief inside, and as she gave it to me, she

said that's all a woman needs. I remember how happy I was on that day and how grateful that she had come into my life, changing the pain of those past years into hope and making it go away.

One time, in the days after I went to live with Mom, the father-parent came to try and force me to go home with him, but the police showed up right away—since Mom had known this would happen—and they showed him pictures that documented the abuse he had done to us and they told him they knew what was happening in his home and if he didn't want trouble then he better stay away. After that, he let me stay with Mom. She used to read to me and tell me she loved me every night. It was the early 1960s by now. Mom was Episcopal and still a real believer. I feel that she was trying to make up for all those years. I was lucky, since she filled me with love and would come to my bed at night, cradle me, and

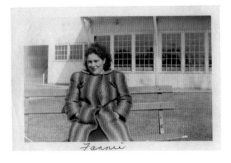

tell me she loved me. At Easter she would make us dresses that looked alike.

She passed away in 1969. I wear her necklace heart that says, "I'm an Episcopalian." It's going to go to Elizabeth, my granddaughter. It was supposed to go to my daughter, but Elizabeth calls me "Mom" so I guess she's going to get it now.

My older sister Irene ran away from home in the 1950s, because she had endured so much abuse. Somehow she blamed me. She left and went to work in what we called a "cat house." My older brother Leslie, who was born before Irene, was hit and killed by a drunk driver one night many years later, in the 1990s.

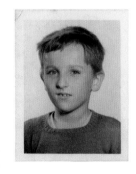

Eventually Irene went to live with our Aunt Fannie, the full sister of my father, who had the same parents. But she wasn't as lucky living with Fannie as I was with Mom, and I think she always resented me for it. Maybe it was because Fannie had more of her brother's blood inside her, being a full sister of that man. Truth is, Irene

Fannie

just went from bad to worse, like from the frying pan straight into the fire. Since my mom was only the father-parent's half-sister, she must have missed out on the evil part of the family's blood. It's hard to believe that after all these years, Irene has never made up with me. She can't even say she loves me and refuses to be touched. Sometimes I try to get in contact with her,

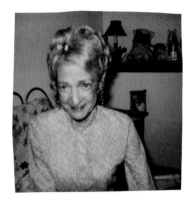

but she doesn't want me. Every Sunday at 6 p.m., I call her. She rarely picks up but I still leave a message telling her who I am and that I love her.

Virginia was the sister of my mother, May. The father-parent refused to allow my mother to see her, because she was sick. One day, I took my mother shopping and then took her to see her sister. I remember that my mother was afraid she would hurt me, but I said no, that I would be all right. She passed away soon after that day from cancer, because she smoked a lot.

It was then that my mother told me that my true father was Jewish. After that day I started to wear the Star of David around my neck. In fact, the only one who really belonged to the father-parent was my sister Irene. My brother and I had the same father.

The father-parent passed away in 1979, when he was 71 years old. After he died I wrote a letter about all the things he had done to us, and the pain he had caused his family, and when I got to the funeral home I walked right up to the casket and put the letter in his jacket pocket. I wanted God to have some good reading when that man was put into the ground. In the letter I told that man that one day he would have to atone for the things he had done. I wrote that if he was truly right in all that he had done to us, then he should sit up right then and there in his casket, and I would believe him. Of course, he never did.

Doesn't the Bible tell us: "Thou shalt not kill. If you do it to the least of these, you have done it to me?" The unrighteous shall not inherit the kingdom of God.

I put all the images of him away in a box years ago. Whenever I find things of his in the house, I get rid of them and burn sage to rid the bad spirits. If you keep those things in the house, they will affect the spirit of the house.

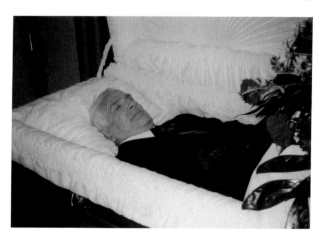

 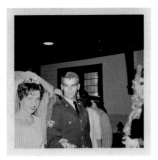

On June 11, 1966 I got married to my husband, Robert Baker, in the Episcopal Church in Athol, Massachusetts. It was four days before graduation. I was happy at that moment in the dress and the tiara that Mom had made for me. She wanted me to be given away by the parent-father, and I was refusing, but she kept prodding me, and since I knew it would make her happy and she had asked so little from me in life, I agreed and let him give me away. When we came before all those people, I introduced Mom as my mother, and she introduced me as her daughter. It was a perfect day. My husband and I said on that day that when we died in the years to come, that we wanted to be buried in the wedding dress and his military costume. We moved into his house in Athol to start our life together. Things certainly changed after that.

I soon learned that my husband wasn't really much different than the father-parent had been in my childhood. After all those years of abuse, and then following on those brief few years with Mom, I was now in another situation with my husband, a man who just followed his own desires and did what he liked, no matter who had to suffer to make him content. I tried to divorce him and they told me I couldn't, since he was in the service and I had no rights.

Coke and Mars bars were his way of apologizing for a beating. Can anyone believe that someone could abuse another person and then give her a candy bar and a Coke to make up for it? Imagine that. That doesn't mean that it didn't happen, or that it wouldn't happen again. No sir, it was certain to happen again.

Things started to get bad right away, but we began to have children and before long I had given birth to three boys. Robert was born at Fort Belvoir in Fairfax County, Virginia, in 1967, and Christopher was born two years later. My youngest son, Michael, was born in 1971 at Fort Leonard Wood, in the Ozarks of Missouri. After that, my husband was sent to Germany and the whole family moved over-

seas. But right from the start, the boys were treated terribly at the hands of their father and there was violence.

My daughter Cheryl Lee was born in 1973, while we were in Germany. My husband came home drunk one night when I was in the last days of the pregnancy and he beat me—and the baby inside me—severely. Cheryl Lee was born soon after that, alive, but she died two-and-a-half months later from the injuries. The army knew what had happened, but all I got was a letter of condolence in the July of that year, signed by my husband's Commanding Officer. It said that they knew the irreparable loss that I had suffered and they fully realized there was little they could say to help me and the members of my family in our bereavement. Is that all the government could do for me? That's all they did for Cheryl. Her father was never charged with anything.

We were all sent back to the States after that and Cheryl Lee was buried in Amherst. I just now had surgery to repair damage done to my internal organs like my ovaries and my bladder, and that damage came from the beating he gave me back when I was pregnant with Cheryl. So there was long-lasting damage. He said, "She needs to be fixed," and he fixed me all right.

As I kept raising the children, I had to find a way to make some money, since he refused to give us any. There was always the basic money for the things he needed. If I wanted extra money, I had to do abnormal sexual things to get the money from my husband. I am still afraid of men because of it.

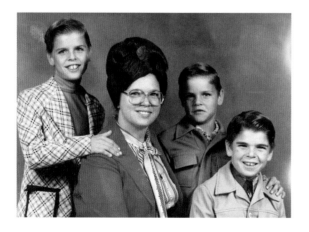

DEPARTMENT OF THE ARMY
Company C, 79th Engineer Battalion (Const)
APO 09360

AEUEC-XUX 12 July 1973

SFC and Mrs. Robert A. Baker
Company C, 79th Engineer Battalion (Const)
APO 09360

Dear SFC and Mrs. Baker:

The officers and men of Company C, 79th Engineer Battalion (Const) joins
with me in extending to you our deepest sympathy on the death of your
daughter, Cheryl Lee Baker.

We know the irreparable loss that you have suffered and fully realize there
is little that we can say to help you in this moment of sorrow.

Our heartful condolences are extended to you and the members of your
family in your bereavement.

 STEVEN G. HONZO
 CPT, CE
 Commanding

After some time, I got a daycare license I had studied for, so I could temporarily keep other children in the home under foster care. But I lost the license when the abuse in our home became public. Things unraveled in 1980, when a series of incidents finally changed our situation. One day Michael went outside the house and told a woman—who happened to be mandated by the court—what his father was doing to him. The woman told the child services what she heard. The next day, while my husband was at work, the police came to our home and a judge told me that I had two options: I could either keep my children or my husband, but I could not have both, and the decision would have to be taken at that moment. I told them that it would be the children who would remain with me.

The afternoon turned to evening and I prepared his dinner as usual and when he arrived for his supper, with the food already laid out on the table, the police came in and took him away. We sat down at the table—it was the first time we had ever done this—and ate his ham and butter sandwiches and finished the

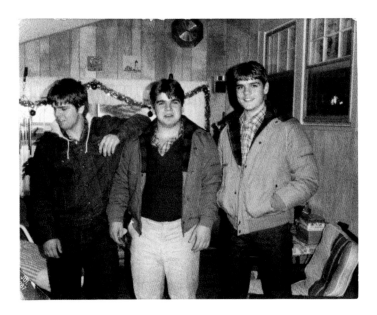

dinner before eating his cookies. The house was never without ham, butter, and cookies, but they were only to be touched by him. If his dinner wasn't on the table at six o'clock and laid just the way he wanted it, then we would get a beating. If there was anything left, we could eat that part.

After that day I got housing and fuel assistance from the government. Of course, I would never get back the right to have other children in my care and the court also appointed a therapist, Jerry, who helped me. "If you don't feel sorry for yourself, you can do something for yourself," he would always tell me. "It doesn't mean you can't change. Just because you can't read or write doesn't mean you

can't make something of yourself. If you can find a bit of good, then you have a way forward, no matter how bad it gets, God is always there."

Today, all my children are in their forties. My eldest son Robert has been in prison for child molesting. He has to register every year, and they can put him back in jail at any time. Christopher, the middle one, lives nearby with his wife and two children, my darling grandchildren, Elizabeth and her brother Joey. My youngest son, Michael, went back to live with his father. I couldn't imagine how he could move back in with that man. [Robert Baker died in 2013, after this testimony was given.] I should have gotten half of the money when I finally got divorced, but it didn't happen.

I praise Joey for doing well in school and I pay Elizabeth for getting A's. It's a kind of ultimatum to encourage them to do the things I couldn't when I was young. I want them to do well and to help them to be the best they can be and have the chances that I didn't have when I was their age. Once, we were at the cemetery where my daughter's buried, Elizabeth came up to me and said, "Mom, your little girl's right here." Oh boy, I cried.

At one point, when I was in the hospital, I stopped breathing and I saw my Mom and my daughter. Mom talked to me and said that it wasn't my time yet, that I had to stay for Elizabeth on her journey like she had stayed for me on mine. She said, "You need to go back." I didn't want to, but I had to for Eliza-

Somebody Special

beth. She's named after me and she's still young. But Mom said to me, "You'll go back in peace and want to make peace with people who have hurt you," and so I came back. I had a Do Not Resuscitate (DNR) order, but the nurse ignored it and brought me back. This week I am going with Jerry to change the DNR order, because it's not time for me yet.

Since then, I've been in a big white peaceful place. I've been feeling peaceful and relieved. I have to make a choice not to be around people who aren't peaceful and separate myself from those situations. I'm working on forgiving the unforgivable, but I don't know if I can. I'll keep trying but I don't know if I can do it.

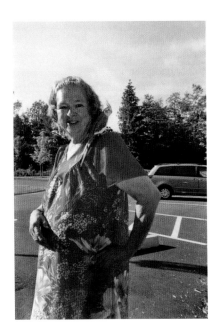

I have a bird named Gracie, who was supposed to be a girl, but who, it turns out, happens to be a boy. I named him after the church. He's a cockatiel. I don't shut him in the cage. He has his nightlight and doesn't like to be covered. He has a piece of licorice every day. I take him in the car with me sometimes. He used to come over to me at night when he was bored and ask me, "Whatcha doin'?"

It wasn't until I was an adult that I finally learned to read. Now I write poetry and have published two books. *Rainbows from God* is one of my poems, about the hopes and dreams I have for myself and my children.

I learned to read at the age of sixty by recording a message and my teacher would transcribe my words onto paper. Now I teach a class once a week for battered women in Springfield. I was even invited to read one of my poems for the mayor of Holyoke. I also go to church every week.

In the Springfield group I write with, we are only women, and we make a rule not to have any family members. They are like family and we support one another there, writing and listening. I try to be honest about the things that happened to me in my life, since I have learned to deal with them, and think that by sharing them with others, it may offer them my support, so they know that there is someone there who knows their feelings and has been through the hardest history and come out full of love.

Rainbows from God
by
Arline G. Wright

I woke up early as the sun crested over the mountain. The skies turned from dark to soft pink like cotton candy. The dew glistened on the life-veins of the leaves. Softly the sun warmed the dew, changing it to air, and it faded away. Then I noticed my tree had a new color. The green colors were touched by the Master's magic brush. They were no longer green, but yellow, red, rusty orange. It was like a rainbow, but deeper in color.

As I lay on my bed I thought of my own life that God's hand had so wonderfully touched and changed. I was always known as a dreamer, and rebellious. Now I see these colors of my life differently. The rebelliousness kept me alive and made me a survivor. The dreams always gave me new hope for tomorrow. When I was little I dreamed of being able to read for myself, and able to write what I thought. Now some of that dream has come true. Now I face the dream of my life.

I can only praise God for His rainbows in my life and His dreams in my heart and future. But most of all my hope for tomorrow is that my children may be able to dream, to hope, and to be all they can be. It's a brighter future with God's rainbow in view.

Carmen Rodriguez

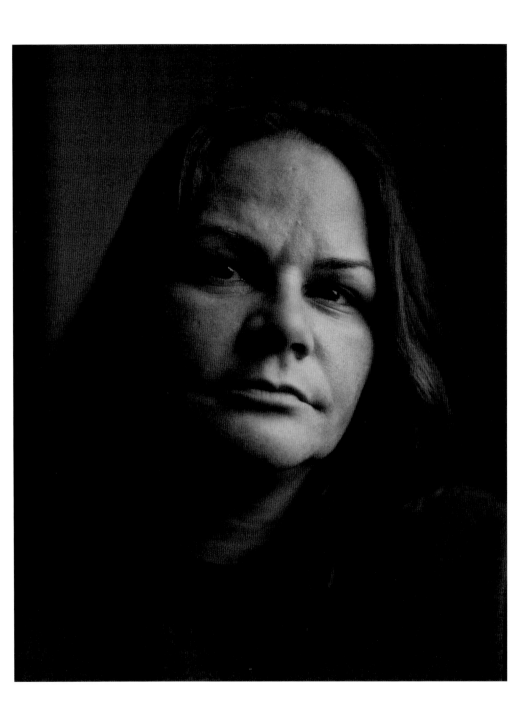

Ⓜy parents came from Puerto Rico to Westfield, Connecticut, in 1968, bringing their parents along in 1975, two years after I was born. I was the first-born: now I am the eldest of five girls at 40. I have three sisters and my father adopted another girl later.

When I was four, my father had an accident and soon after that my parents split. I don't know exactly how it happened, but somehow it was decided that we should stay with my father—so me and my sisters went to live with him. There wasn't a lot of communication between my parents after that.

When I was eleven, my father moved to Puerto Rico, and I was sent to live with my grandmother in Springfield for a while. But then I heard that my mother was around in Springfield, so I would go out looking for her. I decided I would walk to school just in case I found her or she found me on my walk, and it turned out she saw me first and yelled my name. When I turned back and saw it was her I was so happy to find her I didn't ask any questions. But when I returned to my grandmother, she punished me and sent the cops to my mother's home. The cops in those days used to ask the kids who they wanted to live with and where, and I decided I wanted to live with my mom.

So I moved back in with my mother. Then my father sent a ticket for me to go live with him in Puerto Rico, and since my mom was also planning on going back for a visit as well, she thought I could take his ticket and we would meet there. So I went. I lived with my father for about a year then joined with my mom again.

One day, when I was living with him, my father gave me a necklace. He took me to meet my mother's parents and told me that I was going to live with them from now on. They had moved back to Puerto Rico to help take care of me since I was so radical. I was too much for my dad. I was never listening.

I used to go to the school, but the school never seemed to make it into me. I started cutting classes. I used to play hooky most days. My mother was back in Puerto Rico by then and she had a bar and I learned from her and started to work at the bar to support myself. I learned about marijuana and cocaine. I was going out with people who I thought were my friends.

It was then that my father sent me the ticket down to Connecticut, so I could be in a different environment, away from that scene. I worked at McDonald's and lived at my uncle Luis's house. But I wasn't listening to him at all and he didn't want me after a while, because I was really disrespecting him. So they sent me back to Springfield. I was sixteen.

It went well for about a year. Then I started staying out and staying with friends. One day, it was snowing, and I stayed outside, under the bridge—I was already addicted by then; I was hooked on crack cocaine and marijuana. The crack forced me out into the streets, since the way that drug works is that you use and within no time you need another fix. Where was I supposed to get the money to support that habit? I began prostituting to make the money I needed for the

drugs. The more crack I did, the more I needed. It was just that way. This was in the 1980's and it would go on for days, or even weeks. I had contact with my parents in that time and at one point moved back in with my father. I was off it for about six months and my dad supported me. Then one day I met some girls and we went out together that night and someone at the party had some coke. I was hooked again.

When I was eighteen, I was with men, and by twenty-one I had my first child. I gave Marcia Lee to my father to take care of and then, again, when I was twenty-three, I had Chantal Marie, with another man. The second time I didn't know until I was four months pregnant that I was with a child. Then when the doctor told me I was pregnant, I told him I wanted help to get clean.

I stayed in the program and Chantal was born in the program and then my father kept her at home, bringing her each day to see me while I was under treatment. I had given the girls to him through the court so that they wouldn't be taken away from me. I stayed clean for a year. But I didn't have a place where I could have the kids live with me, and he wouldn't give them to me, 'cause he thought I was not trustworthy yet, and might relapse. He was thinking I didn't have enough clean time.

We never talked about it but since there was no way for me to earn money I started the process of prostituting myself again. I became pregnant with the youngest of my daughters in 1996. My youngest daughter's dad was using drugs and he supported me and gave me a place to stay. By then we were both selling crack cocaine. We were bringing it in from the Dominican Republic. He had shown me that I could support myself also. We were dealing big time. Then I got busted. I got arrested for possession, but I was pregnant and they gave me probation. I wanted the baby to stay with me, but we were still selling. Then we got busted again, this time heavily. We had eight balls of crack cocaine when we were snitched. The cops came into the house with a warrant and found our beepers, phones, the drugs, and money. It was a violation of my probation, so they put my daughter in the social services and put me in jail. But I wasn't trafficking, so they brought my charge down to seven-to-ten years. The last offer they gave me was for six years. I took the possession charge with intent to distribute and went into prison in 1997, with the expectation that I would be serving a sentence until 2003. I served in Framingham [Massachusetts Correctional Institution for women prisoners].

My boyfriend got seven years and was sent to Concord prison [MCI–Concord]. He said all along that he was going to go back to selling when he was freed. I see him sometimes now, but we don't talk. I know him and he knows me, but I don't want to get involved in that any more, so I stay clear.

One day, while I was still in jail, I woke up and couldn't get out of bed. My right side was paralyzed. They couldn't figure it out. Then they found out I had

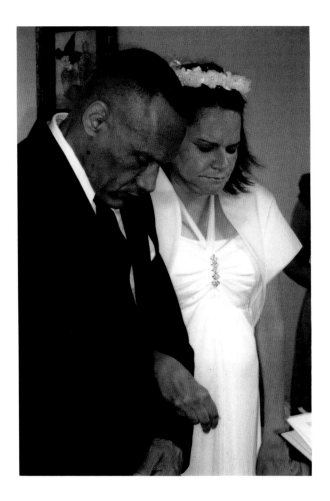

multiple sclerosis. That didn't change my sentence any, and they didn't give me any fairer treatment in jail.

When I was released in 2003, I went to Connecticut to live and then I met Edwin. It must have been a couple of months before 2005. Soon, I traveled to Puerto Rico so that I could visit my eldest daughter. She had come to see me once while I was in prison, and I decided to go back to Puerto Rico, thinking that things might be better for me there. I stayed for two years, but in 2006 I came back to Springfield, since in Puerto Rico money was a real problem.

I started slowly to use again on special occasions, like Valentine's Day. I was with my sister living in Springfield and was getting disability. Because of my record, I couldn't get an apartment of my own. We rented a room and lived there until last June when the tornado came and destroyed it. But we were lucky, since they gave us this apartment to stay in after ours was lost. I pay $450 a month here and Edwin lives with me. He and I got married in April and I got

him into the rehab program. My mother even comes up from Puerto Rico sometimes to stay with us during the warm months. I don't ask her a lot about the past and am just happy to have the time with her now. A couple of months ago, I was using money for drugs instead of paying the rent. I told them I was using drugs and asked them if they wanted to throw me out, but they decided to help me and accepted my relapse, letting me pay the rent and they supported us. That they didn't punish us, made a big difference to me. I was really afraid of being on the street again.

Right after paying the rent and them helping me, someone came here and gave me a word from the Bible that I had read the day before on my own. It was a kind of sign: when you pray to God and ask for strength. And with that prayer in mind, I spread the Bible to Philippians 4:13: "I can do all things through Christ who strengthens me." The next day that person arrived at my door and read me

that same psalm. That's when everything came, after we had been together for nine years.

My father had always prayed, right along, and I guess it was because of him that I started to pray and turn to religion. I had been starting to get really tired of everything by the end of 2009, and each day I would ask God to help me. This wasn't something I had felt so much before. It helped me. I just believe in God and the belief is what I now feel is going to bring me through. I don't feel that I am addicted any longer and don't go to the meetings of N.A. Instead, I have a close connection with the people from the church and go to meet them there often.

The church is the only way out for me. I don't think I'm an addict any more. Jesus did the work he had to do. I am not afraid of relapsing now. It's not risky for me, since I go to church—at the Pentecostal church on Main Street—three times a week. There are things that I can see now that I couldn't see before.

Christine Wells

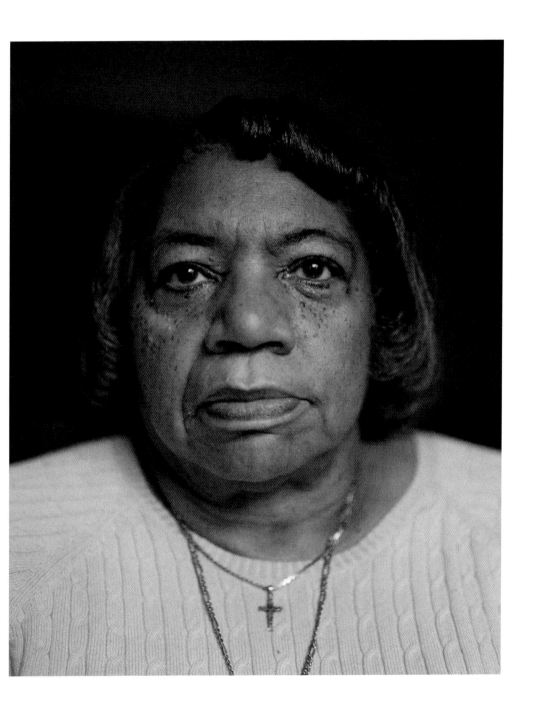

My daddy was a coal miner and my mama did homekeeping. He worked in the mine for more than twenty years. We were eight altogether. When I was about twelve years old, my father got pneumonia and had to stop work. Then he had a heart attack and he passed away and my mother took care of the family on her own.

Both my parents were uneducated, but my mother wanted us to go to school. She told me just to try it out for a while. It was rough for us because they started school desegregation right around that time. I went to school in Afton, Va., where there were more blacks, and the teacher told me, "Niggah, you ain't never gonna learn nothing." In that class, if I got it right, I got a beating. If I got

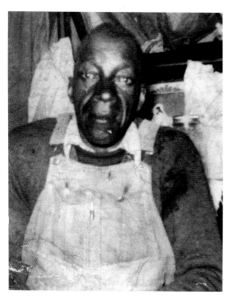

it wrong, I also got a beating. Then, when I stopped going to school, my mother started to beat me as well. I was the baby of the family. The older ones learned and were in the same class. We had a hard time, but then I refused to go any more. They wanted me to go to another school. Eventually, they gave up on me. I got a job when I was only nine years old: $7 a week to take care of an older woman; she was white, but she didn't have a problem with me being black.

When I was fourteen, I asked my sister Lola if I could come and live with her in Boston for six months. After that time ended, she didn't want me to leave. But I had told her it would only be for six months, so I said that if I could get an apartment, I would move out. But after a time, my sister's husband got a job back down south and so they headed off. By that time I had found an apartment of my own. I was doing home care and got a Patient Care Assistant (PCA) certificate, working in three or four nursing homes. But it was rough work, with ten or eleven patients to care for at any given time, and you had to get them all ready within that eight-hour shift. Now I do private work for part of the week, working half-days.

This is a picture of my father in his late fifties. He wasn't home much before this, but as he was already sick, he was at home most of the time. I used to dream about him but the memory faded. Now I don't see him any more in my dreams. God takes him away because he knows what we can't take in life.

I took this one in Boston, before I came out to Amherst. It was the day before Easter. I was working and it was made in the place where I lived with my

mother. She was on the first floor and I was on the second. But I guess she missed her home, for after three years she decided to go back to Virginia. She was over sixty at the time, and I was about twenty. This is my mom, Christine, and my stepfather, Rolly. They were happy together.

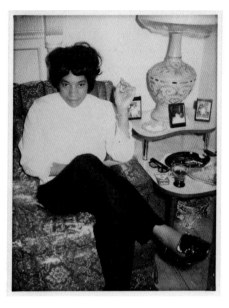

It was about fifteen years ago that I came to Amherst. I had been taking care of my girlfriend's mother, who had cancer, and she wanted me to help her in her last days. I used to come and work in Amherst at the weekend, heading back to Boston in time to be at work on Monday morning. It was a long travel. Finally, I heard about a job in Amherst working for a couple who lived on University Drive. They needed help. I got the job, living in their home. The husband had cancer and passed away soon after. The wife kept me on. I used to work from seven in the morning until seven at night, every day of the week. Eventually, it became too much. Her daughter Margie said she would help every other day. Margie did volunteer work and her husband Jimmy was retired from New York in a bank center job. After a couple more years, Margie took ill with pneumonia and spent some time in

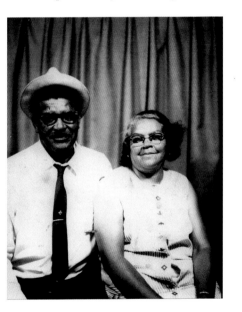

the nursing home. They found out she had cancer too, and the hospital told her there wasn't much they could do for her. I told her she had paid for her house and she shouldn't be in the hospital if she feels like being home. So she came home for three or four months more before she passed away.

Jimmy and Margie had said to the lawyer that if anything should happen to them, that I should have the house. I was thinking to sell the house and move back down south near my old home, but my sister took the family house and the land, so I had to stay here.

My boyfriend Lee used to live in England and he came to Boston to work. We

met through some friends. There wasn't much connection to it: he got off work, and I got off work, and he used to own a home but was living in another house. He was the closest I got to becoming a family. He passed away from a heart attack—it was about five years ago now. We were together for thirty-five years. He wanted to get married, but he had a couple of habits, like drinking a lot, which I didn't like, so I figured it was best to keep a bit of distance. It turned into a heart attack in the end; the drinking. Drinking is one thing, but over-drinking is not normal.

One day, he was in Boston and had an accident. He brought the guy who he had the accident with to me, so I told him to take care of it. He stopped drinking and was totally different then, watching what he said, and more kind. The doctor had told him that if he took another drink, he would pass away, so he listened good. But it was soon that he passed—only three or four years from that time. It was a hard life, working in the shipyard.

Two of my sisters are still alive. Lola lives in Boston and Rowena lives down in our family home in Virginia. I speak with the other one—the one from Boston—every day on the phone. She's back down south, too, but she also has trouble with our other sister.

When I told her I was going to come down and pick the piece of land to build my house, she asked me what land I thought I was going to build on? I told her it was the part of our parent's land that was left to me. She just said that I had no land; that my stupid ass and my dumb-ass other sister, should look elsewhere, 'cause we ain't gonna get nothin' from her.

Now I work in a kitchen and they give me a percentage of my tax. I go to church every week, but I don't have any friends around here. All those years working every day and being too tired at night made me stay mostly on my own. With work and visiting the Northampton church on Sunday, I had no time to do anything else, so there was no time to make friends. I know God is for me, but I don't feel as though I am filled with the Holy Ghost.

People are not nice to you all of the time. It was that way at the nursing home. So I would call on Jesus to help me through the days and nights. You take care of people as you want them to take care of you. In this way I was blessed. I could have been in jail. I could have been a hooker. After so many things happen, the way always weighs out. It's not God-like, but it's my life.

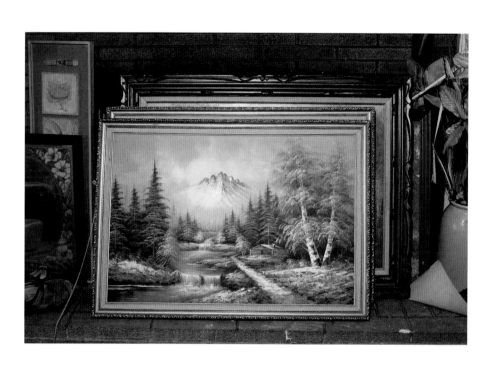

Jafet Robles

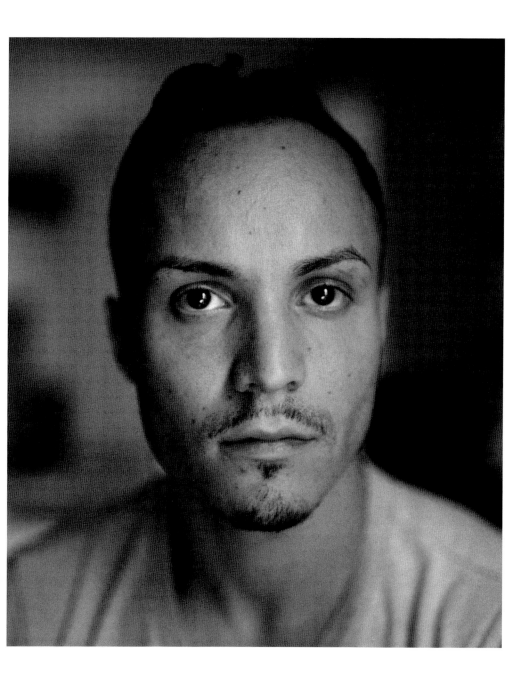

S oon after I was born, my parents, Nelson and Noemi Robles, left Puerto Rico and followed some of their family that had moved up to the United States, to Springfield, where they struggled to learn the language. This was in the 1980s. We lived on the east side of Springfield, in the projects, and my mom worked at a shelter and my father began to work at a substance abuse program. He progressed fast and my mother worked in the department of transitional assistance welfare program. They were lousy jobs, but they took whatever work they could get to bring in some money, hoping they would soon get better jobs that were more stable. At least this is what I heard.

Religion was strong for both of my parents and they were in the Spanish Second Iglesia Pentecostal Church. My dad started a program for addicts in Holyoke, taking them off the street and giving them a place to stay. He didn't make any money, but he saved a lot of people's lives with his caring. He called it the Agape program, which comes from the idea in the Bible that we must show love toward our fellow man. When I was growing up, people in the neighborhood would tell me that my father had saved them from a terrible fate.

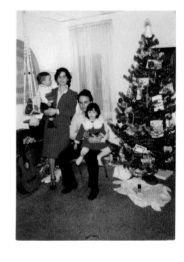

One of my earliest memories was of Christmas here in the U.S. and then the start of my time at the Lincoln school [Lincoln Elementary School, Springfield]. I was hyperactive in school and though I was smart, I was so overactive they wanted to keep me back for the year, thinking it would help sort it out. My mother refused, because she could see I was smart enough, it was just that they weren't directing my energy into the right places and she thought they were just holding me back because it was easier for them.

In school, I excelled at basketball and was on the team, which meant we traveled all over the East Coast. Those were the days of Michael Jordan, who was one of my idols. The school wasn't going well, but since I was always rewarded in basketball, it gave me hope. Then, in the fifth grade I was diagnosed with

attention deficit hyperactivity disorder [A.D.H.D.] and they gave my mother medication for me to take. When I took those drugs I wouldn't eat and lost all my spirit. Before long, my mom took me off the meds 'cause she could see how badly it was affecting me. That year my parents were arguing a lot and one day my dad sat me down alone with him to tell me

he was going to be away for a couple of weeks in Puerto Rico. He used an insurance settlement from a car crash—somebody had rear-ended him—to buy the ticket and left for Puerto Rico. He never came back.

I was hurt about that and I kept asking my mom about it, but she didn't have any real answers for me, since it probably affected her heavily. My sister and I were her focus and she gave us as much good guidance and love as she possibly could under those circumstances.

After my dad left I stopped playing basketball completely. I just didn't have the desire any more. Something had changed inside me, I guess. I started talking back and became rebellious, and soon I began hanging out with the guys in the neighborhood. They were angry at the world, and I was too, in a way. Many of these guys had mothers who were hooked on drugs. My best friend Joey was

twelve and his mom was a crack addict. Joey had a little sister, who was only eight, and since his mother wasn't capable, he had to look after her. As he was already taking care of his family, he had to find a way to make some money. Joey had an older cousin, who was about seventeen or eighteen, and as our fathers weren't around, he and his friends became our role models in the neighborhood. Because their fathers were also gone, they could understand us.

The older boys started using us to sell their drugs. At the bodega in front is where we used to sell. We had to do a lot of work for what was just a little bit of money; there was little reward in that time. When I look back, I realize that they were using us. The older guys made us feel we were part of something. That's how we started off in crime. We felt like we were special, the up-and-coming ones who were going to be as cool as the older boys on the block.

If I'd had a dad at home in that time, they wouldn't have approached me. It was always that way; the boys that had fathers who lived with them were left alone, because they knew that there would be a big price to pay if their parents

found out. It was easier with those of us who had only our mother in the home. Joey's mom was often robbing us of the drugs that we were supposed to sell and then we would have to work to pay off anything that wasn't sold. This was the end of the 1980's and the beginning of the 1990's, when the crack epidemic was the biggest. That was the start, and since my father never came back, it just kept progressing.

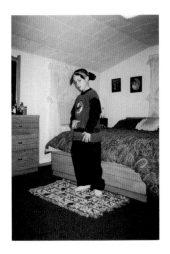

Rap was big at the time and we looked to those musicians and the gang-banger lifestyle of money as inspiration. Music was a big part of my life and the guys were sometimes using it to deal with the struggles in their own lives. There were some who were just talking about money and wanting to get more, but Tupac, Mobb Deep, these guys, they were saying things about how their fathers weren't around and how they were in the streets. We could relate to that with a kind of "fuck it" attitude, if you know what I mean. I was hoping that, in rapping, I might be able to have it lead to somewhere else. They even used to sing our songs in the neighborhood and I would spend a lot of time writing songs of my own.

Then, when I was thirteen or fourteen, I was hanging more in the neighborhood and was robbing cars—armed robberies, and selling drugs. We used to break the whole night robbing people. We were so neglected—it was a desperate time. We would go joyriding, robbing, breaking in, and vandalizing. At that time, I was in-and-out of juvie [Department of Youth Services, juvenile detention]. Before long, I had many things like distribution and robbery on my juvenile record.

I had the A.D.H.D., which made me a risk-taker: in the moment, I would forget about the consequences. But Joey was not so brave and his personality wasn't really in sync with the lifestyle. He was less daring than I was and afraid to do most things. He was more calm by nature and even had health issues. We had this other one of our crew who was homeless and without anyone and we took him in. We were like our own family and we protected each other.

In ninth grade, I dropped out of school. The older guys had been using me and were getting rich off the work I was doing for them. One time the guy who was "the connect" came to me and told me I was being used, that he wanted to cut

the other guy out. I agreed to it, since I knew it was somehow true. When this guy called the connect, he told him he would have to talk to me from then on. The connect was smoking crack and addicted and was anyway only a middleman. By that time I was dealing kilos and one particular guy was buying half-kilos at a time. After I had sold the drugs, I was supposed to send the money with a guy who would deliver it to the boss. But since he was an addict, there was this one time when he spent the money instead of handing it over. He lied and told them that I hadn't paid, blaming me for stealing the drugs from the bigger guys. Of course, those guys wanted their revenge, and I went into hiding. They shot up

the house and called my mother to tell her I owed them $20,000. I took off out of town for a time, not knowing what else to do.

Then I met Myra Lopez. Her father had died of alcoholism when she was five and her mother died a short time after that. Her brother was an addict and her sister was in prison, so as a child there was already no family left for her. When I met her she was living with a friend of hers who was also a friend of mine.

I hadn't had a girlfriend up until that time, and when I met her and heard her story, I kinda fell in love with her. The first time we had sex she got pregnant. I was ignorant at the time and thought I could take care of her and the baby. My mom freaked out, but since she was into religion, there was no choice in her mind but for us to have the baby.

My daughter, Destiny Marie, was born in 2000. Myra and I stayed together and I stopped robbing people. I naturally felt a change. We'd got an apartment when I was only fifteen and we were barely making it, but then I jumped up, since I had to cover $650 a month in rent and a new family. She was part of my obligation. After about a year and a half, I stopped hanging on the street

corner, and was organizing the sales on the phone, so I could be closer to the family. The guys who wanted me dead were still around and I knew that I would have to settle that problem if I wanted to go forward. By now my son, Jafet Jr. was born. I was still in the game, but I was sure to be home with my family at night to take care of them.

The dealer I was working for by then was buying 40 kilos at a shot from Puerto Rico. His crew was supplying New York. I knew that I had to clear up this problem with the stolen money and I went to the projects to see the guy who had lied about the money I had given him. When

I showed up at his apartment, there were four other guys inside. At that moment he could have easily killed me. But for some reason he decided not to and called the connect while I was sitting there. When the connect arrived, I thought it was looking really bad for me, since I was so outnumbered. But the connect told him that it wasn't me that hadn't paid the money, but another guy in Plainfield. He got me off the hook. A year later and I was on to bigger things.

In the neighborhood, no one ever called 911, because the police were always abusive to us. The only time when we would call them was if we needed an ambulance. Otherwise, it was best to stay away from the cops because they used to beat us for nothing. They just wanted to intimidate us. There was a lot of shooting where we lived and I saw my friend shot five times. Since the ambulance would always drag its feet when it had to come to that neighborhood, I decided to rush him to the hospital myself. He pulled through, and we wanted to retaliate on those guys who had tried to kill him. It was a power and territory thing.

The guy who did it had disappeared, so we pistol-whipped the guys who worked for him. Two months later, he rolled up on us at the corner, getting ready

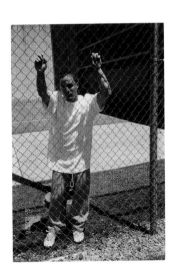

to shoot me for beating his crew. My friend was in the car buying at the time and his being there saved my life. He told me he would get me later, and rolled on.

Then one day, I got arrested by a local cop and was sent back to juvie. Myra moved in with my mother to stay with her while I was serving my time. Since we couldn't afford the rent, there was no other choice. Myra had started to change after our daughter was born and our relationship was already starting to be difficult. Myra was bipolar. I loved her, but she was often abusive, manipulative, and she was cheating on me often. A.D.H.D. made me always need to try and do something. Eventually my mom bought her own home, and we rented her old place from her. Myra would keep me from seeing the kids—lied to the cops about me hitting her, which I never did. She was cold.

Then we moved to the South End, where we could get housing in the projects in her name for $180 a month. The lease was in her name, since it was based on her money. It was a new neighborhood for me. It made the North End look like Hollywood. The place was so rough it even made me nervous. There were a lot of different crews but I made friends and started dealing horse with the guys who lived there. The users would shoot up right in my hallway. I was about eighteen at the time and never thought I would get caught. There was one guy running

the whole thing and the guys from Puerto Rico had muscled their way into the neighborhood and taken over. That gang told me to talk to the bigger money, the guy who was selling $30,000 worth a day. He had his spot there and I thought I had mine. They told me to talk to him and when I did, he said that if I was going to keep selling, I was going to get shot, but that if I wanted to sell, I could join him and work for him instead. I agreed and he would give me bundles and I would bag it and sell between five and seven in the morning, when no one else was around selling. I would make $300 or $400 for myself in that time and then be with the kids for the rest of the day.

In Vermont they were paying $40 for a bag of smack that cost only $6 in Springfield. They would come down to buy from me on a regular basis. Since it was such a rough neighborhood I was trying my best to find a way to get out. Suddenly, I thought that this huge operation might be possible and that if I could go to Vermont myself, I could make all that extra money. I told them I would travel up there instead, and sell for the higher price, which they agreed to, since they didn't want to keep coming all the way down to Springfield to buy. On that first trip up to Rutland, Vermont, I made $9,000. After that, I planned on a second trip and sold again.

Now that I was making these weekly trips up to Vermont, I was beginning to save some real money in the hopes of moving the family to another neighborhood. Myra thought I was cheating on her, so I finally agreed to take them up there for a trip one weekend. We drove up across the border into Vermont and met a friend and his wife. Soon after we arrived, the cops rolled up and searched us all and took us to the police station. I thought nothing would happen, since I hadn't brought any drugs on this trip. But they searched the guy's wife and told her they were going to make her take the rap. She was intimidated and told them she and her husband had been helping me for the past seven months. Since it was two of them giving the information, it made it a conspiracy—a conspiracy to traffic across state lines.

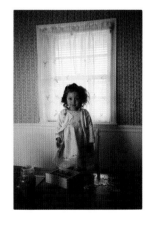

They arrested me and charged me, taking the kids and my wife away. There was a new law to fight drugs at that time, and they were starting to be really harsh. The cops claimed I was the ringleader and told me I was facing 40 years in the penitentiary. The Feds picked up the case and I took the blame, so that they would agree not to charge the mother of my children. But even Myra was willing to sign a document stating that I sold. More people kept getting arrested and each one of them mentioned my name. My kids were only three and one at the time, so I would do anything to keep them out of the mess I had put us in. My mother paid the bail for my

son's mother, which was $2,500. But my bail was set at $250K, so there was no chance I could get out.

My time in jail made me miss my kids so much. I look at them now and realize how much of their childhood I missed out on because of my mistakes. There were lots of white supremacists in the jail and the guards were taking advantage of the system, selling and making money off of the contraband they were getting into the prison. It was a corrupt and intimidating place. I was sentenced to 42–46 months and they flew me to Brooklyn on Con Air. On the plane, the women were on one side, and the men were on the other. When we landed, they put us on a bus to Allenwood State Penitentiary in Pennsylvania. When the bus was nearing the

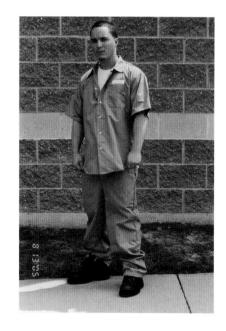

prison I was expecting they would take me out at the minimum security, since I had been dealing drugs and this was my first time in adult prison. But when the bus stopped and they called the names, mine was not among them. Then we drove on to the medium security, and again my name was not called. By now, everyone else was off the bus, and I was the only one left alongside a double murderer. I asked the guard if there had been some mistake, since I was in for a drug offense, and he said that there must have been an error, but that he didn't have any authority to change where they took me. We drove on to the maximum security, where the double murderer and I were put out into the yard and where we were surrounded by hundreds of men, 90 percent of them lifers.

When I arrived, the guard warned me not to take anything from anyone, because they would use that as leverage later. Some Mexican guys pointed me to the Puerto Ricans in the jail. They were introducing me all around and told me they would have my back, they would take care of me. They gave me all sorts of stuff, then they told me they wanted to see my paperwork: if I hadn't squealed then there would be no problem. Those papers show if you have ratted on anyone. Luckily, I hadn't co-operated with the police in any way and hadn't snitched on anyone, so it was OK for me and the Puerto Ricans accepted me into the group.

I was in a cell with a Native American who had been there for five years. In those first days he was describing his religion to me, which was strange for me to understand, since it was like nothing I had ever heard of before. We were going to work every day and coming back to the cell at night. In that very first week he was stabbed to death. Some other prisoners had a problem with him about their

religion and it cost him his life. In maximum security guys were getting killed all the time. In medium security it was OK, but in max, when things hit the fan, it got really ugly. The place was segregated by gang and also by state. There were Native Americans, Italians, and the Muslim Brotherhood, which was the biggest. I was with the one from Massachusetts. It was weird, because in Massachusetts, the blacks and the whites would never hang together, but in prison, when there was a gang dispute and violence, the blacks and whites from Massachusetts would come together to fight the others. It was hardcore there. There were many days when I thought it was going to go bad.

There was this one guy named Miguel Santiago, who was a tough lifer from Framingham. Most guys who are serving life still believe they are going to get out, that the next appeal will prove them innocent. But Miguel never thought he was going to get out and had accepted that he was going to be there for life. Guys like him were rare, but they were particularly dangerous, since they don't have any fantasy about a life other than the one in prison. He had been locked up since he was nineteen. He was a bully and everyone was afraid of him, but he took a liking to me and protected me. Whenever there was a problem, he would take care of me. If it weren't for him, I would have been in real trouble there and might not have survived my time.

After the death of my cellmate, the prison authorities admitted that I wasn't supposed to be there but even though my mom kept writing to them, there was no change. They didn't care and left me right there in maximum security. I later found out that they had taken all my juvenile charges and counted them as adult crimes, making me a repeat violent offender. Only at the end of my sentence were

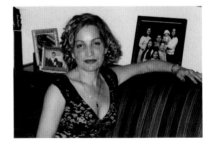

they getting ready to move me. I was lucky during my time there on many occasions and I sort of fell through the cracks. Later, after I left, many of the guys I knew got stabbed. There were big drug transactions in prison and lots of heroin. The guards were corrupt. We used stamps as money— you buy stamps and then use that as currency for trading. Weed was expensive, but heroin was easier, and guys who were doing life often started to get hooked.

My mom would have to spend about $1,000 each time she came to see me with the kids. If there was a lockdown she wouldn't be allowed in and would have made that long trip without even getting to see me. They would simply send her back home. My sister tells the story of one time when they were all turned back and how she was watching my daughter as she just stared out of the window at the mountains along the highway as they headed home. I think it affected them a lot; she had been promised to see me but there was nothing my sister could do to

convince them to let her in. People were often sent back for little reasons. Once my mom was turned back because they tested her hands and said that she was dirty.

Eighteen months I was inside. It felt like a lifetime. Then one day a friend of mine came to the prison and said he had seen a guy using my chair [at home] and bragging that he had sex with my son's mom. I wasn't sure if it was true and decided to call the house. The woman who owned the house answered the phone and I pretended to be the guy they said had been seeing Myra. When she put Myra on the phone and Myra realized it was me, and I was calling from prison, she lost

control and cursed me out, telling me I had never paid any attention to her, had always been on the streets and never with her. When she was done with her screaming she slammed the phone down on me. She was the only girlfriend I'd ever had and as I was in prison it was hard to take. I guess the days following that phone call were the toughest time in my life. I still had as much as two years on my sentence without good behavior.

After that, we didn't speak for more than ten months. Then, on Christmas day, I called to wish my kids Merry Christmas. She answered the phone and cursed me again, telling my daughter—who was listening in the background—that I hated her and all the while my daughter was protesting, saying I was her daddy. Myra told her that the other man who was living with them was her daddy now.

I couldn't believe there was a guy living there with them already. I had been hanging my hopes on having the family when I got out of prison, so this came as a real blow. She wouldn't let me speak to my daughter and hung up on me again. I had to go back to lock-in with depression and deep pain.

Right before I got out, Myra tried to kill herself. After getting pregnant with this other guy, who was just out of jail, she found out he had a crack addiction. This was 2007. The Department of Children and Families were going to take the children away from her, so Myra agreed to let my sister Rebecca have custody. I guess she knew that was her only chance to see the kids. And anyway, maybe somewhere she knew that Rebecca would be good to them, since she was the most stable person. My mom was on a missionary trip to Nicaragua at the time, so that wasn't an option. If it hadn't been Rebecca, then they would have put the

kids in foster care. When Myra lost the kids, she went back into her old routine. Now, my son visits her sometimes on the weekend. But there is no consistency and when she doesn't want them she lets us take care of them. We try not to antagonize her. We know she is unstable, so we try to put up with it.

Now, the second man she had a son with is having trouble, because she got together with his brother who is involved in that lifestyle. Later, she had a kid with him as well. For my daughter to know this is really troubling, since I feel the mom has a big influence and I don't want my daughter to make the same mistakes we made. When I was in prison, the one thing that hurt me every day was the fact that my kids were growing up without me. I got a tat on my arm by one of the lifers for $20. They know how to do good work there, because they have so long to practice.

I got out of prison early for good behavior, and when I came back to the North End I was determined to turn my life around. But when people found out I had a criminal record they didn't want to hire me. My parole officer kept giving me violations because I wasn't working. But then I got hired by this store in Northampton, and the parole officer showed up to confirm I was working there, so when the manager found out I was on parole I lost the job.

All this time I was living at my mom's house and trying to establish my own apartment for my kids. I tried to get a license to become a personal trainer. On the day that I took the test, I found out that my grandfather had died and the distraction shifted my focus and I failed the test by one point, and so I lost the $800 I had spent on the registration.

I was so frustrated that I returned to selling drugs, this time to dealers rather than users. I was smarter now. I knew not to sell on the streets. I still had the illusion that I could make enough money to buy a house for my kids. I made money this way until two bad events happened. First, my best friend, Johnier, who I used to be into rapping with, got caught in a drug bust and they sent him to the state prison. It was a big case that made all the papers. I would have gotten busted too if I hadn't have been with my girl at the time. She didn't like gangs, tried to live a normal life. She caused me to slow down with the selling. Then my

friend Melo—Carmelo—was chased down and shot on my street in Springfield. Melo had borrowed a friend's car, and the guys that chased him thought he was the other guy, the owner. They had some issue with him, probably over money. They chased down the car, shot it up, and ended up killing Melo. His death and Johnier's bust, those things convinced me to turn around my life for good.

When I realized that I couldn't get a well-paying job to support my kids without more education, I decided to go back to school. Right now I have to work several jobs—as a personal trainer, car salesman and custodian—but my goal is to mentor teenage boys and teach them about the dangers of gangs and drugs and show them the importance of an education in life.

It started out with Project Coach [an after-school sports and mentorship program for youth in the neighborhood]—that was my first time trying to do a speech for kids. I remember sitting back and thinking, putting it together; I did it and I did all right, I did good. I kind of had the energy for it. With my hyperness I was a little funny. I wasn't really prepared as much but I think it went pretty well and that made me want to keep doing that.

With Voices, our community group, that really had a positive impact on me, just feeling like what we were doing was important. And it kind of made me feel like it was something that I was good at, 'cause I'm social. It's, like, going door-to-door, you gotta have like courage to talk with these people, and you know, I have that courage. I'll speak up with what needs to be said, whether people want to hear it or not.

So basically the job thing was a struggle with me, with trying to find jobs, 'cause every job would shut me down. But I stayed persistent, 'cause I felt like looking back at my life, all the mistakes I've made and everything I've learned from those experiences, if I can share those experiences with youth, I can make a difference and help someone not make the same mistakes as I did. So I stayed persistent and drove every agency in Western Mass. crazy. I was going in there suited up like I was a lawyer, just really polite, just kept following up, coming with letters of recommendation, I was flooding these people with letters. They were like "What're you doing, man?" But I just needed something to be able to show up with, just to have a reason to bug 'em.

Gandara [a mental health services agency] told me that because of my record they couldn't hire me to work with kids but that they could hire me to do my speeches once a week, every Tuesday. So that was my opportunity kinda to show them. So then I really took that serious and presented a different... I kept it real professional, I didn't put on my crazy revolutionary ways, I kept it professional with life skills, conflict resolution, job applications. And I learned that with youth, through organizing, like engaging them and having them come up with ideas and involving them in the whole process of what we were doing. And then eventually after working there I went to Cheryl Rivera [the Democratic State

Representative from the North End], I called her and asked for a letter of recommendation. And when I got that one I went to Holyoke Community College studying human resources. I got all my grades. I've completed all my classes like Child Psychology, all the classes that pertain to that.

I'm in my third year now and I hope to get a master's degree so I can get a real job that will allow me to provide for my kids in another way than selling drugs. It's hard for a convicted offender to get the trust of the society. But just this week I found out that I am far along in the interview process for a job working with teenage gang members. My family is strong and they are helping to support my chances and those of the kids.

I went back to the guy who gave me the speaking job, and I was venting. I explained to him that I was almost going to finish school, and I had been sacrificing doing all this schoolwork, taking away from my community work, doing all these reports and projects, hoping to get a job in the field, but I told him that every place I went had told me I wasn't going to be able to work, even with the degree. I told him that even though I love kids, I could never work at a school. I know most of the bones in your body and I know nutrition, but I could never work in a hospital. And I explained to him about being a single dad and wanting to provide for my kids so that they could have certain opportunities. After venting, he told me, "It is what it is, keep trying" and stuck to his guns. But later that day he called me back and told me I had a position. Now I got my foot in the door, the ball's in my hands now. It's all on me.

My daughter got accepted into a charter school by a lotto: it was fifty people out of eight hundred and her name happened to get picked. It meant the world to me because the Springfield school system sucks. My son will be able to go there just by her going there, when he turns to sixth grade, so that's a plus. So right now, just making sure—make them know to be hard workers, respectful people, that they're in that stage... trying to shape them to be that way so that they can survive; know the importance of education, no excuses, no self-pity, those kinds of things.

That's about it. I'm happy! Enjoying life, raising kids, I love them, I think it's going to be a fun ride, watching them grow up, go to high school, sports, vacations. I'm excited about the work we're going to do with Voices. I think we've got a strong team. Everybody has their strengths.

Rona Thompson

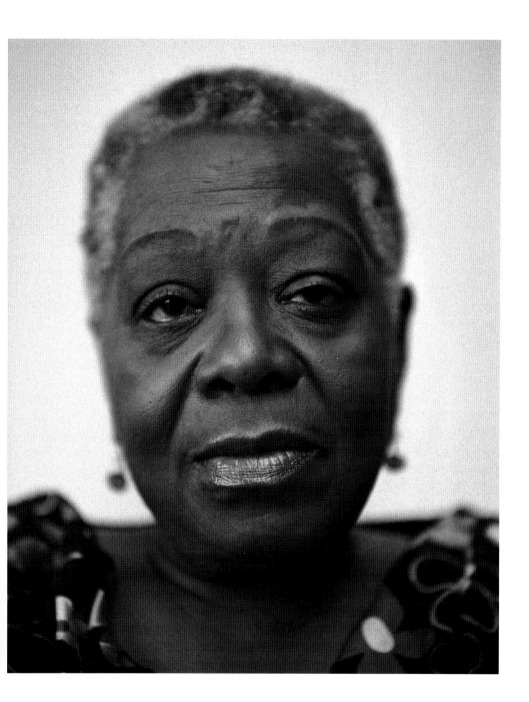

My father's mother, Sarah Antoinette Braithwaite, was born in Barbados in 1869. When she was seventeen, she was attracted to a man named Earlston Sobers, who was vacationing on the island. He was a tailor by trade and owned a shop in Chicago. Sarah fell pregnant with him and had a son, who he gave his own name, Sobers, and took responsibility for the child. But they didn't stay together and Sarah began raising the boy on her own.

Before long, she met a young Barbadian her own age named John Trottman. Sarah was his first experience of sex and he immediately fell in love with her and asked to marry her. His mother and his friends asked if he was sure that he

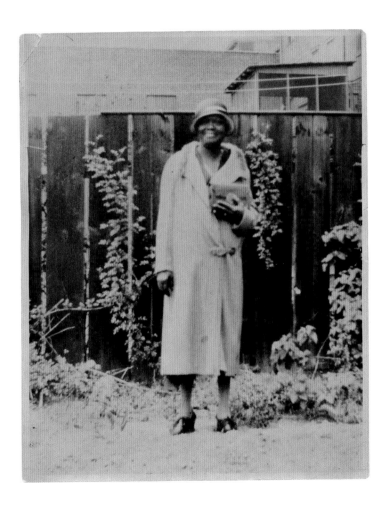

wanted to marry someone who already had a child. But he said yes, he loved her. They were married on July 4, 1889, and had two daughters, Juanita and Elise.

John couldn't manage well financially. He couldn't find work in Barbados, so the family decided to go to Panama to help with the building of the Panama Canal. My father, Ellis, was born there in 1910. That is also where Juanita became sick and died.

Sarah was an excellent cook and she decided that she would cook for the prostitutes in the red-light district. These women were making their money fast, and they were living just as fast, and they gave Sarah big tips. You know how Barack Obama's wife Michelle is always there behind the doors, taking care of things and running the show? This is the way with our women and Sarah was like that.

In 1915 the family finally came up to New York. Sarah kept on cooking and working hard when they were living in the city. Her husband took on work as a carpenter. Sarah started investing her money in the sou-sou [local savings' scheme] to keep her man's business out of the cash and so that she could get one big lump sum of money every few weeks to spend instead of a small pittance every week. She had a grape arbor and used to distill her own wine. You can see the photograph of her dressed in all her finery in front of the vines in her garden. In those days there weren't no black folks lookin' so fine and so full of life. Later in life she got the diabetes and when she was sixty-five they had to take off one of her legs because of it. She died in her own home in 1947 and was buried at the Evergreen Cemetery: 1869 to 1947: seventy-seven years—not a bad life for that strong woman.

My grandmother on my mother's side, Clarissa Clark, was born in Barbados when they still had arranged marriages. She wasn't nothin' but a wee four-foot eleven and she married a slave master. In those days, if the slave master passed away, then the slave went free. So when he died, she was freed, and went to college and eventually became a teacher. She got married to a man who had also been a slave and they sailed to America, coming through Ellis Island and then on to begin a new life in Harlem. My grandfather was not too sharp and maybe the plantation was happy to get rid of him. But he fathered four kids: George, Alfred, my mother Evelyn Clarissa Clarice Trottman, who they called 'Sis,' and Sammy. When the war came, my grandfather didn't want to fight. My grandmother was hired by Jews to clean their houses and even if it was low work she could make some decent money doin' that job.

My mother was born around that time and my grandparents moved to New Jersey so they could build a house. But eventually they were forced out of the neighborhood and moved back to Brooklyn. Their son Alfred died at eighteen, and after his death his father wanted to purify the earth by burning down the place. The authorities came and put him into the mental asylum for that crazy move, leaving my grandmother to take care of the children on her own.

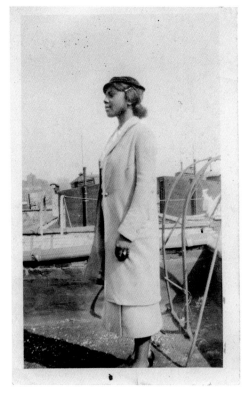

Alfred had been my father Ellis's best friend. As a player-player, his eye was always on the mark, and he quickly spotted a girl who was at home without a father in the house and a mother who was always away working. He had a perfect chance to pluck this ripe young thing. In this photograph my mother was about eighteen. They all used to hang out on the rooftops. Before long, with all of his carrying on, Ellis made her pregnant. But my grandmother forced him to marry her and take responsibility for making her pregnant. With little choice he married her, and when I was born they sent me to live with my grandparents from my father's side of the family, since they could take better care of this new child.

In those days all the visitors to the house were from Barbados. Sarah kept right on cooking for people on the side, making extra money. They were happy people. Hard workin' people. Money-makin' people. Money was always comin' in pretty good, so things were lookin' up for them. I grew up in that environment and was surrounded by all that love.

My Aunt Elise had a deformed right foot, which kept the men away. She lived with my grandparents all that time and didn't get married. But James used to come to my grandmother Sarah's to play the sou-sou. When his wife died—and since he knew that Elise was a fifty-five-year-old virgin—he was right in there at the plate, loving the idea of having another bride at his age who was a virgin. My father Ellis told James that if he was going to take his sister, he'd best treat her well, since the whole family loved her dear heart. I think my love for her came partly from how much my father cared about her. He always told me to look after her and I always remembered that.

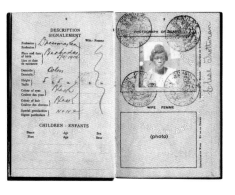

This photograph from her passport is one of the earliest images I have of that dear woman. It was taken in 1922, when she was only about eighteen. Elise would be closer to me than my own mother in the years to come.

James, anyway, must have been thinkin' to himself, "I'll take this younger virgin instead of one of those old biddies at the church." Here he is with my grandfather, John, who lived to be ninety-six and died in 1968. Now here's an image of two real players.

James and Elise were married and moved into the house at 652 Herkimer Street in Brooklyn in June 1961. I was born in that house and spent a whole lot of my childhood living there with Elise and James. Bedford Stuyvesant: "Bed Stuy—do our die," yep, the greatest neighborhood.

With the whole family around me, you can see that I was a child who was loved and treated well. Here I am at Elise's house. And that's the one where I am dressed up for my graduation from Junior High School. Those white gloves, can you imagine? I graduated from High School at Franklin K. Lane in Brooklyn when I was seventeen.

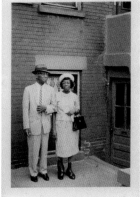

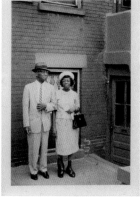

My father was too busy with other women. Here we are at a party in the Seventies with his friend Ray. My dad's the one on the right. That night my father tried to put the moves on one of my girlfriends and I just laughed when he asked me, in that knowing way, who that young girl was across the room. He kept that up right through his life. You can see him in this picture, with one of his other girlfriends. He just kept movin'. When he died, he was sitting in a car with one of his friends drinking rum in the JFK parking lot. It was August 1978.

My mother Sis lives in Maryland now. I called her the other day and told her I was sorry for being such a bad girl. I know that I gave her a lot of trouble and not much respect when I was young, because I was spoiled by everything that

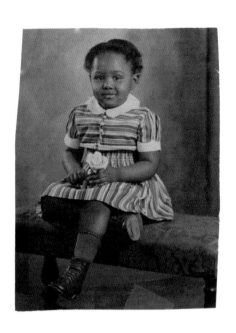
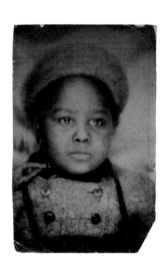
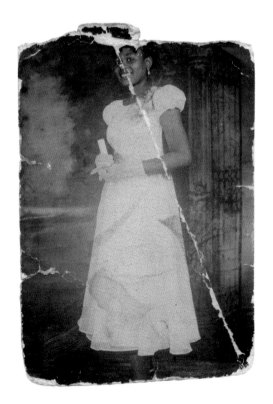

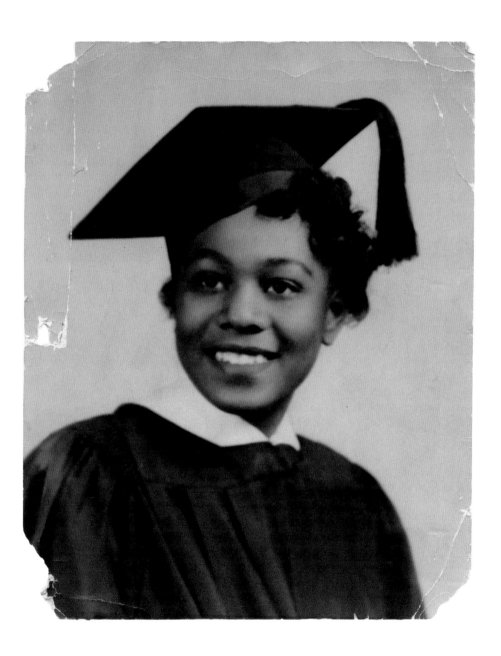

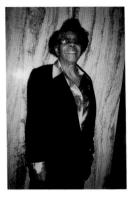

was going on around me. She is a good person, even if she's manipulative. She's one of those "Do as I say, not as I do," kinda women. She was quietly envious

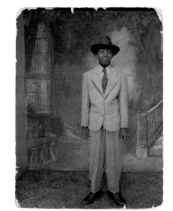

of the love I had from the men I had in my life. I had my father, my uncle, and later my husband. Her own man didn't have any time to give her the love she needed. She came up real poor, since her mother was working so hard, and she was often left alone with a lot of responsibility.

There's a photograph of my husband, from when he was around fourteen years old. But you can see he was a player-player too. A trickster, bless his

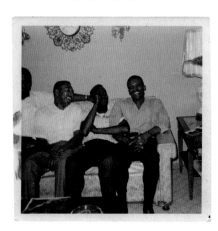

heart. After we split up, I started seeing George. He's there with the big smile, sitting on the couch with his brothers-in-law at his home on Willis Avenue in the Bronx. He's such a mild-mannered, gentle person. Like they say; it's not about men in your life, but the life in your men, and George has a whole lot of good life in him.

That's us with my Aunt Elise in around 2000. Living so far away from him up here in Amherst, I miss

the boy. I called him the other day and he told me he was getting even thinner as he gets older. I'm going in the opposite direction, so I hope he doesn't lose too much weight.

We had our children, Janice and James in 1956 and 1957. Baby Dawn came later. I live with her up here in Amherst, though it isn't as exciting as those times in Bed-Stuy, since this place is quiet and there's no action. In this image I must have been around thirty, sitting with a beer and a cigarette—not bad. And in this one I don't know how old I was, but I

can tell from the eyes that I was feeling no pain and a bit high at the time.

They were good kids and filled me with a lot of love. James is in the picture with his wife, Anne. He died soon after that picture was taken, in 1997. Their daughter Rona is seventeen now and their son had twins, so they are my great-granddaughters. It's a big family and getting bigger every day. So I'm glad James left behind some good love when he went.

My daughter Janice and her husband had her boy Wade. There they are in Bed-Stuy. Wade's a good boy, turned into a man now and married. He's got cancer and we are all thinking of him.

James's first-born, Shirley, had her son when she was seventeen. I told a friend of my daughter's, who had a child very young and was left by the father without anything, that she better make sure next time that she gets at least a social security number before letting a man ejaculate inside her.

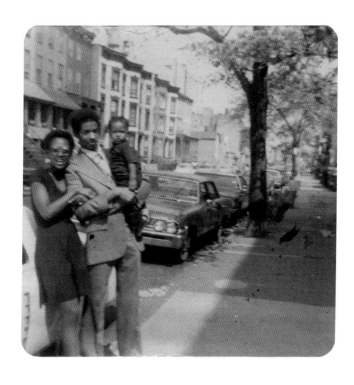

Luis Manuel Perez

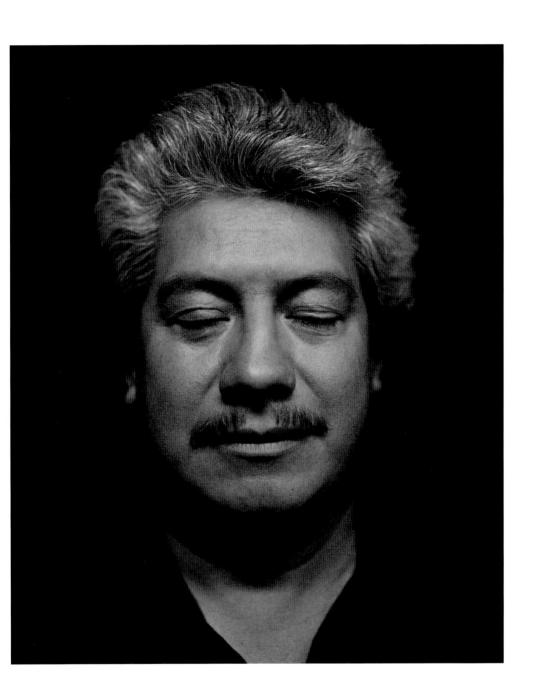

I was born in Mexico on October 3, 1966, at the Soledad ranch in Mapastepec, Chiapas, the son of Sabino Perez and Carmela Hernandez. They got to know one another because my father had lost his first wife and was working away from home as a farmer, planting for himself and for others. My mother was living in one of the colonies of Alta Mira. My father already had four sons, so he had a big life. I was the first of their family, for better or worse. Ultimately we were ten children—seven sisters and three brothers. I was in school for six years, but then my father was sick and with so many children I had to leave my studies and take responsibility for the family. I was only twelve, but this is the way it works with our people. At least I was able to learn how to read and write. Most of the children didn't really have the chance to go to school. We were very poor. In our home the wind, rain and sun came through holes that were everywhere. My father never had the chance to build a better house. There was no time and no money.

When I was sixteen, I got to know the mother of my children, Irma Zunun. I loved basketball and we had a team and traveled to tournaments. We were called the Tigers and were the best in the region. We were proud. We were to play another team and they were running us down, saying they would win easily, but when we started, the other team realized that their trash talk was premature. Our switching strategies confused them and caught them completely unaware. They started to realize we were pretty good. We thrashed them that time and after the game my good friend from the team asked me to go out to do a little dancing and find some girls.

When we got to the dancehall, we were talking and I told him that I had seen the woman I knew was for me. She was across the room and I pointed her out, but before I could make a move, he headed over there ahead of me and started talking to her. After five minutes, they left together and I was furious, thinking he had taken my love. I later learned that he and the girl had a terrible time, which offered me some degree of consolation. It was actually a good thing, since after he left, I saw that there were three other girls next to me and I asked if any of them wanted to dance. Irma, the girl who would become my wife, was one of those girls, and I later learned that she was only there by chance, since her family was so strict that they didn't usually let her go out. On this day, her aunt had come to visit and had convinced her parents to let her go out with her friends for just the one night. We danced, and before long she was gone.

The next morning, I went to visit a friend who lived in the same town. I was there for an hour when my friend's wife invited me into another room. As I entered, I saw Irma—at least, I thought it was her, but I couldn't be sure, since I had only seen her briefly in the dark of the dancehall. But I sensed it was the girl I had seen the night before. I guess she was trying to escape when she realized it was me. I learned that she lived next door to my friends and it had been a real

coincidence to visit so close to her home. Seeing her again, she got flustered and left quickly. She was extremely shy. I went after her, and my friend stopped me, asking me what I thought I was doing.

On that day, I was only sixteen, and Irma was fourteen. It turned out she was studying in secondary school and she was to go to her family's second house in Tuxtla Gutiérrez. She was afraid to tell her parents about me, so for a year and a half we had to see each other secretly. We lived so far apart, but on the second visit I asked if she would be willing to be my girlfriend. Then they moved: I showed up at her old house and the friends that we had in common said she had moved away. I was sad for the next month. I had started drinking at fifteen and now I was sixteen. After two months more, I went to visit my friends again and this time there was a card from Irma. The letter had her work address. As soon as I heard, I took off for where she was staying. I went to the address on the card and the woman at the house told me there was no one there by that name. I was heartbroken. The taxi driver took me back to the place I had just left. By then, I didn't care any more, since we had already lost each other.

When her father went away, she asked the neighbors to give me the correct address. I would go every month to visit her. She was studying to be a nurse. On the next visit, she took me back to her home and introduced me to her mother. Her mother let me stay for the night. She said the problem would be with her husband. I asked Irma to marry me, but she told me she needed to finish her school first. She had two more years to go and I was impatient, so I said it was too long and she had to choose between me and her schooling. The problem was that I had no money to support her. She said she wanted to be with me and to marry, but I told her I didn't have enough money and wanted a companion. She was wary and thought her father would be livid if we suggested to him that we were going to live together without getting married. It was on March 21, 1983, that she told me we should go to her father and speak with him together. We went with my parents and a family friend and we surprised him. The father exploded in fury when his wife told him that Irma had a boyfriend and the boyfriend and his family had come to ask for Irma's hand. He went storming out of the house.

When he came back, my parents and the neighbor arrived at the home again. They asked to speak with him and apologized for arriving unannounced. He said that we were both kids. What could I offer her with no job? But I had been a big help at home—even Irma didn't know I had these habits. I knew I had been supporting the family all my life—I even knew how to do the women's work. After two hours her father was still not convinced. But just as we were getting ready to leave, he stopped us and asked Irma about marriage and she said that she didn't want it. Her father was very Catholic, but in the end he accepted our wish. He put her in my parents' hands. It made my mother very nervous. We went and got drunk in celebration.

Irma said her faith was strong and that she would stay in our house for a week. The next month we came back to her parents to visit and her father gave me the work of chopping up a whole of a tree with its roots to make firewood. They had a huge farm, with steep ravines, and there were many trees that he could test my resolve with. After a week of heavy abuse, I earned their respect. I was used to

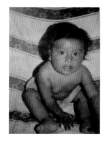

living loose with drinking and smoking and basketball, but we lived together for a year and then I told her I had nothing, but if she wanted me, we could marry. I built her a simple little house and we started our family.

I said to her that if we were to make it, we could get ahead with hard work. Every two years we had a child, but we kept going for a girl. In the end we had five sons. I had built on my father's land and I had worked with him planting coffee, beans, and corn. In December and January we would go to Toluca to col-

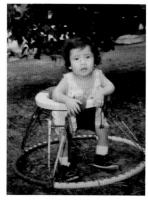

lect coffee. This was around 1990. She was taking care of the family. The two eldest sons, Alex and Luis Miguel (the others are Daniel, Francisco, and Jose Conception) were working with me as I had worked with my own father. They were all able to go to school but they helped on the farm when they were not in school.

I didn't want my own kids ever to have to go through the same deprivation I had lived with as a child. I have had things in this life that I never thought I would have. We were the first in our family to have a phone. One of the reasons I did well was because I listened to my parents who told me that stealing and drugs would only

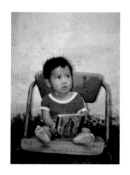

bring bad for us. It took me three years to build my house. When I want something, I am able to get there.

For one year after my son was born I worked for the police, and then for three years I was in the army. I decided to go into the military because I thought they would take care of us, but the reality was different. There were some things, like new shoes, clothes, and arms, but no real money. I had thought I could save money there, but you

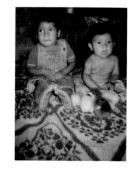

have to buy all sorts of things that I hadn't expected, so I couldn't save anything. I had three children at that point, and there was a depression in the price of coffee. When the prices fell, many farmers abandoned the crop. A few opted to convert their coffee fields to cattle land. Others sold their

land very cheap. Some even gave their land away, because nobody wanted the fields, knowing this crop required so much work. It was in this way that the great coffee hope came to an end.

But my children were in school, so I was thinking about what to do next, since I didn't have any money. I talked to Irma and we thought about how I had dreamed of going to the United States. The fact of no other options made me want to go. But she was afraid for me to go, having heard all those stories of men who go away and then within no time are with other women. She had heard of many men who had arrived in the U.S. and then left their families behind. In the end, she had to agree, because we had no other choice.

It was April 23, 2004, when I said goodbye to my family with a deep sadness in my soul. I did not know if I would ever return. I remember the desert as if I were living it again. Those memories I am never going to forget.

At that time, there were famous coyotes [guides] who were taking people across the border at Sonora, walking for two days and nights straight. I talked to a guy I knew in Chiapas and he agreed to take me for $2,500, the whole trip. But they don't take responsibility for you if you can't make it physically. I had a sister and brother who were working in Florida harvesting tomatoes, so I had an idea of what to expect. Twelve of us walked for two days and nights. We were all from the same village, except two, who had already come the distance from Guatemala.

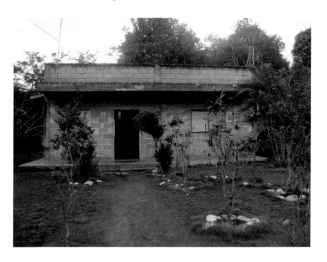

We took the bus for four days to get to the northern part of Mexico, along the Sonoran desert, where there were small houses. The coyotes were vigilant and always traveled with us closely. They even knew where the sensors were in the desert floor. They knew everything about what was happening around them, and when we arrived at the border town, they made us wait in hiding for three days until they felt it was a good moment to cross. They have spies checking on the

route. The only money we had to carry with us was $50 to pay for the van to get us from the small village to near the border. It was a short distance, but it was dangerous, so the price was high.

We left at two in the afternoon to get near the border and then we were dropped and we waited until after eight at night to start. At the fence, they told us to start running across the road. Then we had to keep walking fast, and quiet, and since we were moving fast, we had to be careful not to get lost, because this is what happens in the desert at night, and it's almost impossible to find the group again. You have to keep watching over your shoulder to keep sight of the next person. You know that when you are lost, the coyotes will leave you behind and you may have to be rescued by the border patrol. But since the coyotes are only paid when we reach Phoenix, they are also trying to make sure you don't get lost, or caught.

The agreement was that we got to Phoenix and then would contact our families to release the money. In some cases people pay in advance, but that's dangerous, since you can be tricked and left in the desert on purpose. I was paying to get all the way to Florida. If you failed to pay the $800 for the journey to Phoenix, they could leave you where you couldn't escape. If you don't pay the coyotes lock you up until the debt is paid. Often people paid off slowly, only getting a bit from their check to live on when they had already arrived at the farm that had contracted for them. This was a kind of indentured servitude, because the coyotes would come on payday and only leave you the bare minimum to eat until the next paycheck.

Our route went across from Altar Sonora to Phoenix, to the area known as *el brinco*, the crossing, where there is a spot before you get into the city called *el levantón*, which is the pick-up spot. You have to hide from everything when you cross. You have to watch for police, planes, always looking out for everything. There are points in the desert where the immigration police put water, supposedly to help the people, but the coyotes know that this water should only be used in an absolute emergency, since the border patrol monitors those areas and going to them heavily increases the chance of being detected and caught. In our case, we had to go to one of them because we didn't have enough water. I decided to go and was lucky, even though they warned me it was risky.

On the second day the nineteen-year-old girl who was with us from Guatemala couldn't walk any more and the coyote was ready to leave her. It's true that the walking was very difficult and we were all exhausted. She was a bit large and her feet had become so swollen that her shoes were extremely painful. I couldn't agree to leave her and gave her some of the medicine I had brought along and took her things from her so she didn't have anything to carry. Within a couple of hours, she fell and couldn't get up, so we decided as a group to each carry her for ten minutes, then the next one would carry her. With eleven of us, we could

make some progress. I gave her some more pills and tequila and told her to take her pants off, but she was nervous, and I told her she had to trust us. I rubbed Vicks [menthol rub] all over her legs and we rested there for a while with her feet up in the air to let the blood drain. By now we weren't so far from *el levantón* and thought we could make it by 2 a.m. if we kept traveling. But the coyote told us at this pace it was going to take us until 9 a.m. We shamed the coyote into helping and we all had to take turns, including the coyote, to get further. I told him that he would be making money with her, so it was to his advantage to take her. Finally, late the next morning, we arrived at the safe house. The girl was so happy. She tried to give us money for not letting her die in the desert. We told her that the money should be sent to her parents in Guatemala better than giving it to us. When we were in Phoenix, the coyote and I became good friends. I was dropped off last, because he wanted my company along the way. The girl still calls me often and asks for my address, but I refuse each time to have her with me.

One person had not paid for his journey and was being held for two months. The coyotes were not planning to let him out and would only bring him basic food until he paid the $1500 they were demanding. It was twice the price, but they were saying that he had cost them money by not paying the first debt of $800, so this was the new amount. I went back to see him with the coyote who was now my friend, and we crept up to the window and asked him if he could get out. He told us to break down the door and we were able to get him out this way. We had left the car nearby and so we got him out and ran away. He didn't know who we were, but he came with us because it was better than staying there. When we got to our final destination, the guy offered to have his family send money to us, but we refused. If we were all in such a bad state, how could we take advantage of each other at this moment?

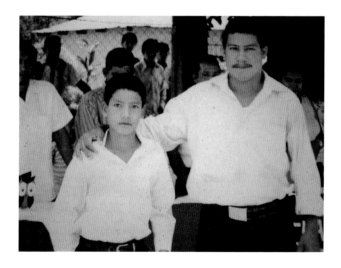

On that first journey I stayed for one full year, picking tomatoes in Florida, then decided that I had to go back to see my children. We returned to Mexico on a public bus, but on the Mexican side they asked for my papers and when the immigration official went inside his booth to check, we ran away. We were afraid the police would try to steal our money, though we had sent home nearly everything we had in case something like this happened. It was common for us to get robbed by the Mexican officials when coming home. I used to send the money by something like Western Union, called Vigo.

I stayed for six months in Chiapas. But within no time there was again not enough money, and with my son studying I had to leave the family and come back. But on this crossing we got lost in the desert and it took more than four days to reach *el levantón*. The border patrol had become much more active by then and it was extremely difficult to get across and around the immigration. The coyote took us in an extremely long route to stay away from the patrol. It was the same coyote from my home village who had brought us before. When we were in the van, we were all worried, since the police know how to look for cars that are riding as though they are carrying a lot of weight. My nephew and niece went in the front car and were stopped by the border patrol on their return. For me it wasn't so bad, since I had family to go to, but for many others, who don't have anyone, it's a horrible journey.

My brother came to collect me in Florida. My brother and sister were looking for a new kind of work, since the work in the fields for tomato picking is extremely difficult, and the pay can be really bad, particularly in the late part of the season when the tomatoes aren't so easy to find on the vine. When there were lots of tomatoes, we could earn $80 to $100 a day, but in the lean times, you had to bend down for hours to look under the bushes for $20 or $25 in a whole day. Then at the end of the row, when you wanted to stand up, it was impossible and you had to lie down for fifteen minutes just in order to be able to stand again.

They had buses to bring the workers to the farms. The main problem for us was the immigration police, since they knew where the buses would drop us off and they would come and catch people then. But our boss would check and was treating us well, so we were lucky in that regard and never got caught.

Then my brother Juan found a job in Massachusetts working for a landscaping company, earning $8 an hour, and that is when I came to Springfield. I passed two months without any work in April 2003 after that first journey, but now I have been here in Springfield and working for the last eight years without a break, and without going home to visit my family. The situation along the border has become much too risky to cross now and it's complicated. I am here since it is the only way that I can offer some kind of future to my kids.

When my children have accidents, or are ill, the pain of being so far away from them is tremendous. Three months ago, my second son had an accident

playing football and he was kicked in the head and almost died. He was the goalie and had caught the ball and was on the ground and was kicked by mistake in the chin, near the neck. He was lucky, since a bit lower and he would have been killed. The doctors weren't sure if he would recuperate, but thanks to my family's intervention and the friends that we have, he is OK. They brought all possible medical people to see him, thank God. We can communicate only by telephone and I don't want any of them to come here, since I want them to stay in Mexico and not to abandon the family and their studies. My hope lies in the education of my sons.

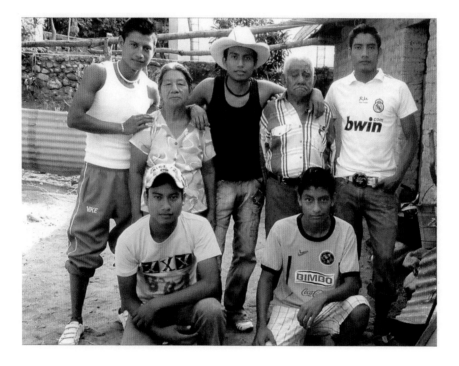

For most of us who are undocumented workers, life in America is incredibly oppressive. I am here so that the family can prepare themselves for a profession, and so that they won't ever have to make the same sacrifices for their own families. I never want them to come here and live like I do now. In the time since I left they have abandoned farming and are living off the money that I send. I give my wife Irma all the money and then she decides how it should be used.

My children don't understand why I don't come back, but if I leave, there is a strong chance that I won't be able to get back here. And the kids realize that if I came back, we would not have enough to live on. Now I send back $300–$350 a week, and without it they certainly wouldn't have a chance to sustain themselves. Irma complains that there is not enough money and she has weeks when she

doesn't have enough to eat. I wake up at 4.30 a.m. and work until 6 p.m., so by the weekend I am exhausted, and anyway, I don't have enough money to go out, even if I wanted to go somewhere. We are both suffering in this way, but that is the way we must stay. I basically started with tobacco and harvesting. Six years ago I got a job with a landscape company, so although the job is difficult, we have the chance to work, even if most of us are illegal here.

On some occasions we are treated badly. In the first company where I worked, they used to keep us from the bathroom, and wouldn't let us have water. We spoke up against the foreman sometimes, but the bosses now are OK. The foreman still takes every chance to abuse the immigrants. But the truth is that the owners prefer the immigrants, because we cost the company less and we work harder. The Americans don't know anything about the work. The boss says, "The whites don't understand this work. If a white guy isn't doing it well, give the work to one of the immigrants."

But it's very sad for people like us, because we are hated, treated badly, exploited, mocked, discriminated against. Everywhere we go we find racist people who treat us like criminals. But in reality, our crime is working very hard—in construction, in fields harvesting tobacco, growing vegetables, in factories, stores, restaurants, laundries, hotels, etc., and all in order to give something to our families to eat, to allow our children to go to school.

Also, we are the people who grow the economy of this country, and for this reason we're persecuted under the law, persecuted by criminals, who rob us in the streets, in our homes, who hit us, who stab us to the point where they send us to the hospital, or kill us. If we call the police we are not heard. They discriminate against us in very ugly ways. But also of course there are some good police officers who do their work in the way they should.

While I have been here I have been given the opportunity to meet a group of Americans who seek to work for the immigrants in Springfield. In 2006 I helped create a program that provides food from November through March, primarily for people who work in the fields, as it's very cold in this region then. Also we started a program called The Little Clinic in order to give medical services and medicine free to the immigrant community. In this way there has been an improvement in the health of immigrants. We help victims of abuse, victims of domestic violence or victims of abuse at their job, abuse from the police or from any authority. We have gathered together hundreds of students from different colleges and universities to talk to the children about the importance of education. They tell them how they should take the opportunity of being in school, and that the transformation of this world depends upon them, that they have to fight against the slavery of poor people, the slavery of inequality.

This is a legacy that I would like to pass on to my sons, and I give thanks to God because it appears my dreams for my children are coming true. Alexander

has already graduated from his studies in business administration and two more will graduate soon. The other two are in preparatory schools and their goals are for a license in law and a license in physical education. I want my children to prepare for a profession so that one day they will be able to help the most poor and marginalized people. Because in twenty years I have realized this is one of the most important and beautiful things someone can do in their life.

This is how I have lived my life and how I live it today. With this work I am seeking a change in the lifestyle of immigrants in Springfield, because I can assure you that millions of immigrants live in the way I have done, many of them even worse. I just want people who don't believe, or don't know immigrants, to understand the reason we are here in this country, so that they can put their hands on their hearts and accept us as any other human being and give us the opportunity to live in freedom.

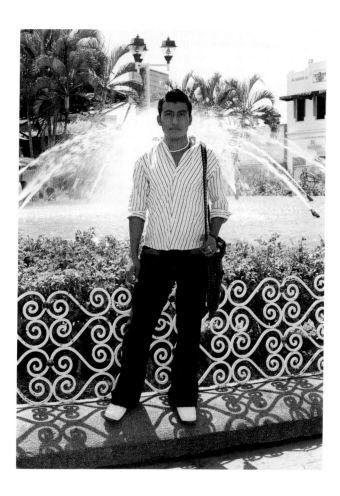

Margarita Albelo

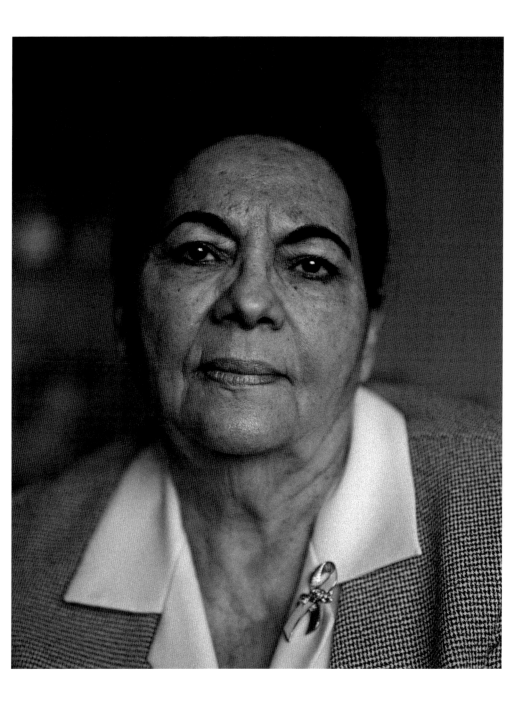

I was born in the small town of Cordoba, Puerto Rico in 1937. We were seven children—two brothers, and four sisters—and I stayed with my parents on the island through high school. Our life was extremely hard, with my father working in the fields. As children we didn't really have much, but because of that we appreciated everything we had with one another. There were so few jobs and many of us wanted to come to the United States. As soon as I graduated, I came to New York to stay with my aunts and my oldest sister. There was a large Puerto Rican community here and

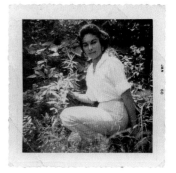

much greater opportunities compared to what we had at home. My older sister Jostina had a place in the Bronx where she lived with her husband and baby. One of my fondest memories of being there was that we were so near to St Mark's Park, where we could go out and be among nature. It reminded me of home in Puerto Rico.

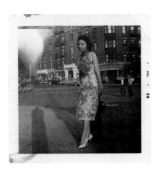

As soon as I arrived, she was able to get me a job in an underwear manufacturing company in the city. There were many young people coming to the United States, and they often stayed with us in the first days after their arrival. We had only one bathroom, and the apartment was always packed, but our time there was so much filled with love and respect. My younger sister Carmen was the next to come live with us. She was married before long and moved out to live with her husband. One time, in 1959, when we were living in the Bronx, and we had all gotten together during a visit from my youngest brother Juan, who was living in Puerto Rico, I wanted an image of us all, since it was so rare for us to be all together in one place. So we arranged with a studio to have it made. There is my brother Juan Alvelo, the twins—Carmen

and Jania, Federico, Me and Anna, the eldest, who passed away from cancer when she was seventy-six, and then Jostina, who lives in Queens today.

My brother-in-law was also from our village in Puerto Rico and his aunt came to visit one day. I was twenty-one years old at the time and she insisted that she wanted to introduce me to her son Jose Hernandez. In those days I was more interested

in the outside appearance of men, and so I wasn't so impressed by him, but I really should have been looking at the inside. After a year of dating, Jose asked me to marry him and we were married in the Saint Cecilia Church in Manhattan. This was in 1960. My maid of honor, Leticia, was my best friend from childhood. We had lost touch, but we met again by chance in New York on the subway one day and easily fell back into our close friendship. I introduced her to our friend Gilberto, who she would eventually marry, and who was Jose's best man at our wedding. Leticia married in the same church the year before, and I used the Castillo Photo Studio to make our wedding portfolio. Many years later, Gilberto and Leticia would divorce and she would move back to Puerto Rico.

After we married, my husband and I found a place together in Spanish Harlem, on 115th Street and Third Avenue, on the ninth floor of the projects. Since he didn't have an education, Jose could only get a job as a janitor at a children's center. But the truth is that he was never ambitious, and as long as he was comfortable in his job, he didn't have any further goals. After a year, I had my baby Josephine and my mother-in-law would take care of her while we were at work.

It was a pretty rough neighborhood. I remember very well one Christmas Eve, I was in the elevator with another woman about to go upstairs when a black man came in; he had a switchblade, which he put to my throat. I gave him all the money I had, while the other woman was completely paralyzed by fear. I told

him he could have everything we had, but I begged for him not to harm us. He left without hurting us, but the experience has made me afraid of the confines of the elevator, and of moments when I see intimidating men like him out on the streets in front of our house. I would panic during such moments and found it difficult to enter the building.

One time I went to the police to tell them that there were men outside my house and I was afraid to go inside. The police station was nearby and one of the police officers came with me. Since he was a black man himself, he thought I was afraid of these men simply because they were black. I think he must have told them something about my fear, because they were always intimidating us after that. In the months that followed, the fear grew so intense—I was not able to get into the elevator without panic—that I told my husband we would have to

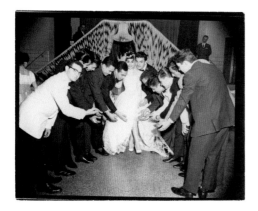

leave the building. He didn't want to leave, but I eventually convinced him to move to the Bronx.

Soon after our move, my sister and brother-in-law bought a grocery store and I started to work with them in the store. Over the next years, many other members of our family came to New York looking for a better life. Everyone knew that on the island there was no real chance for a proper job and

future for the children. My son had been born in Manhattan and my daughter was soon born in the Bronx, and I remained at the grocery store between 1967 and 1980. During that time, my sister decided to move back to Puerto Rico and so I was able to buy the store from her. My husband would work in the day as a maintenance man for New York housing, and in his off time he would help out at the store.

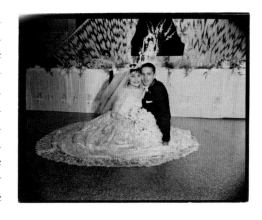

Things started to go badly between us and in 1968 we were divorced. I kept the store and one other sister would help with the kids while I was as work. It was hard, but I was able to earn enough money to support us. After we divorced, my husband eventually moved down to Florida and bought a house for his retirement. But before long he grew sick. He passed away one day when he was sitting on the toilet. They only found him several days later when my daughter arrived to take care of him. Since his whole family was buried at Saint Raymond's in the Bronx, we decided to bury him there.

I was helping my parents financially, and since I was a good daughter, it was not difficult. My sister, who eventually bought a house in Queens, and I would take part of our salary and send it to our parents. We wanted them to come and live with us and one time my father even tried to come and stay, but my mother would come only when she needed medical treatment. Before long she told us that she couldn't stay in this country because she needed the feeling of her homeland beneath her feet.

My daughter also supports her husband and three children, because her husband is sick and unable to work. She works for a finance company and though the job is good, she has to travel more than two hours to get to work. It means that some days she travels for more than five hours during her commute, and if her boss decides he needs something done urgently, then she has to stay longer and miss her bus. Even though she was working hard, the house was put into foreclosure and she started to sell the contents of the house in an attempt to

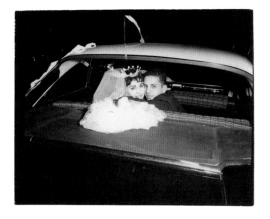

raise the $5,000 they owed. When she couldn't pay the bill, the bank tried to sell the house. But when there were no buyers, the bank decided to offer her a new agreement and they were allowed to stay on in the house.

In 1980, I married my second husband and sold the store. We had met many years before, during one of my visits to Puerto Rico, when we were both married to other partners. He had a good job in transportation there. When my husband and I were divorced and his wife died, he started visiting me in New York. Eventually, he asked if I wouldn't come to stay with him in Puerto Rico as his wife. We bought a house in my name, since I was afraid not to have anything if the marriage went wrong.

In 1992 he retired and we moved to Orlando, but after a few years we moved back to Puerto Rico, because he said the people in Florida were too unfriendly and the heat was too intense. It was difficult for my daughter, she was unhappy because my husband was so strict. Back in Puerto Rico, we lasted for another five years before the breakup. Actually, he was too friendly with other women and it made me mad. I was confused and when I found he had someone else, I decided

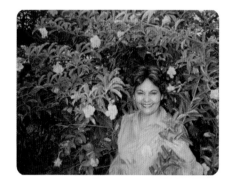

slowly to leave him. That was 2000. Since he was supporting us, we were not as free as I would have liked, but when my daughter went away to college at Colgate [in upstate New York], I decided it was time to move on and I went back to the U.S. He didn't want to let me go and though the life with him had been comfortable, I realized that it wasn't worth it any longer.

When I finally got divorced, my daughter was truly happy. I lived with my family until 2005 and eventually decided to move up to Amherst, where my sister was living and where she said I could apply for subsidized housing. I was lucky to get an apartment quickly, since the waiting list is usually for many months. It was better to be here than anywhere else, because I could get by on my social security check. Now I am in my seventies, the family helps me and takes care of me while I am back here in the apartment.

My brother Juan was living in Florida, and his son, who lived in Georgia, had back surgery and was always in great pain. We think now he was buying drugs through email and a lot of money soon went missing. He went to bed one night

and never woke up. It was devastating for Juan to lose his son, who was only forty-four. And this was only a year after his wife passed away. He moved back to Puerto Rico and we try to get him to come up to live closer to us as a family, but he continues to refuse.

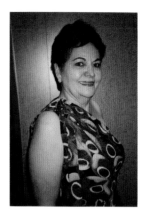

Juan's other son was always away traveling. He told his father that he was taking holidays, but all the time he had been traveling for drugs. It was the pictures that finally got him in trouble, since he had been taking photographs of all the places that he visited to get the drugs. Those photos were perfect proof against him. It turns out that he was always traveling through New York, but never contacted us, so we didn't know what was happening. Since it was my brother's son who was in trouble, and he needed money for bail, we decided to put our home on bond, because I couldn't see my little brother in that state. It was twelve years ago and we were living in Puerto Rico at the time, so we came to the U.S. and got a lawyer and put the house up on bond. We were eventually able to pay the bail.

When I had to go see my nephew in the jail, I felt like the whole building was on top of me. They told me to take off my jacket, that I couldn't take it inside. But when I took it off, they told me I need a long-sleeved shirt, so I had to go out and get one before I could see him. He was convicted of trafficking and they told him that if he pleaded guilty, he would get ten years with the possibility of an earlier parole. Eventually, he served three years of his sentence in New York, New Jersey, and Pennsylvania and got out on good behavior. After his release, he traveled home to Puerto Rico, where he still lives with my brother Juan.

I belong to the first Christian Spanish Church in Amherst. I was born to parents in the Christian Church, but I stopped going in my teens and then when I was in Orlando in 1992, many years later, I felt more connected to the church. But my second husband was not interested, so I took it up again after we parted. I'm coming back to the church as I get older, now that I'm living on my own. We are trying to have our own place to worship together here in Amherst. There aren't too many places we could have the church and we try to have it in the basement of one of the houses nearby. We share it with the A.A. and other groups. The pastor comes from outside the town. It's a small group and in our belief we are doing in our hearts what God tells us to do.

During my childhood, since our father was not a believer, it was hard. It took me to get old to understand my relationship to the church. My sister and brother-in-law go to the same church. They are good believers. My ex-husband, the second one, was not.

With my first husband, the families were close. I loved his mother dearly. My son was ill and had breathing problems and my mother-in-law was taking care of him. My mother-in-law prayed so hard that it took his illness away.

Lately, I have been having dreams of my grandson, who is having a bout of laziness. They are taking him to the psychiatrist, because his father's sickness is affecting him. He doesn't want to tell his father that he isn't interested in some things and that he doesn't want to play sports, because he is afraid to disappoint him. I ask him in the dream why he was acting this way.

They are mixed-up dreams really. Sometimes I dream about the grocery store I used to have and see an image of me sitting behind the counter. I dream a lot of my sister Anna, who passed away, because I feel guilty that I didn't do more to help her in that time when she was ill. She was hiding the cancer from us, but in her last days she told us. Finally, I was able to go to her in New York, in the Bronx, but she was in the hospice by then. I was with her for the last two weeks of her life. She knew she was ill and that she would pass away. I stayed with her until she died.

My nephew Edwin, the son of Carmen, was working in a metal work factory in Yonkers. He lost the tip of one of his fingers in an accident one day at work and it took them two attempts to re-attach it. They used too much anesthetic, which affected him adversely, and he had difficulties when the company he was working for went bankrupt. They didn't give him the $80k that was owed him.

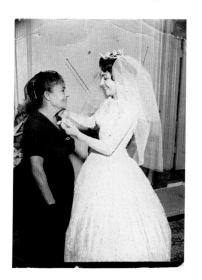

He had to go back to his mother's family to live. Essentially, he went back to Puerto Rico. In New York he couldn't work. They gave him his social security, which is $1700 a month, and that's what keeps him going at home. Nothing else. He divorced his wife early, for it was a failure, so the life can be difficult sometimes and bring things that are not expected.

My mother, Librada Cruz, died in 1965. Though he had never abused me, my father was extremely abusive to her. He was violent often, and others would tell her that she should leave him, but she refused, saying she needed to stay for the sake of her children. When she was older and near death, she made us promise to stay together as a family. She started having severe headaches and we brought her for a check-up in the U.S., but my father didn't allow her to be away for long and wouldn't give money for her to get proper doctor's attention. She would pray, asking God not to take her away before she

had completed her job with the children, and since Juan was the last born and still at home, she was dedicated to him.

In 1965 she had a stroke and my mother-in-law took care of my son while I went back to Puerto Rico to be with her. I was the first of my siblings to be at her side in the hospital. When the others arrived, we decided as a family to take her home, since it would be best for her to die surrounded by us in our private place. She passed away soon after.

When I look at the image and think back about her life, my biggest memory of her was the suffering and abuse she had at the hands of my father. The abuse he inflicted on my mother impacted us indirectly, because we could see the way it was affecting her. If he had been drinking, we used to stay near her, since we wanted to protect her. It was a lot for her to handle, taking what was happening without fighting back or complaining. She put up with a great deal in order to raise us and her dream of finishing that job before she passed away became a reality. God granted her wish to stay on this planet for her kids until her job was done, since she lasted until my brother went away to the army.

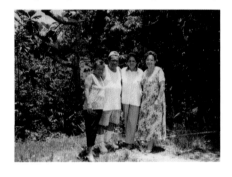

On the day of the funeral, my father, who had always been a quiet man, didn't want to go to the cemetery. When were getting ready to go, I remember him just standing there at the window looking at all of us leaving. After that day, he started to have epileptic seizures, which he had never had before in his life. I think it was brought on by the loss of his wife. I remember that he loved us a great deal and worked hard for us. He used to take us to the shelter during the storms that hit Puerto Rico frequently, and I remember on one day in particular when the storm was coming and he was trembling, afraid that we might not make it to the shelter in time. He was afraid for us, more than for himself.

After my mother's death, my father came to live with us and married for a second time in 1979. Then, in 1985, when I came back to New York so my daughter could get ready for school, he stayed in Puerto Rico. In 1985, at the time of his death, he was staying in Sostina. We always respected our father and my sister took good care of him, even letting him take some beer when he wanted in later years. He was surrounded with a lot of love and we were all together at home with him when he passed away. We all went to bury him in the Aguas Buenas Cemetery where my mother is buried. Often, when I travel home, we go back to the land where we lived as children. It has a rich beauty that is missing here.

My biggest treasure is my family. My family is my everything. I will do anything for them.

Parvin Niroomand

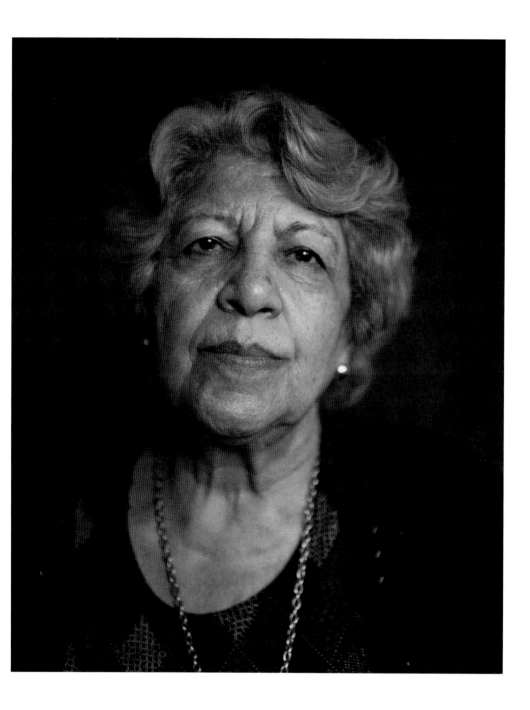

I am from a good family in Iran. My maternal grandfather, Mirza Dawoud Khan, was a judge and the head of the court in Tehran, as well as a leader in the parliament. There is an image from 1902 in which he is seated on the left side of the frame, a samovar prominently displayed in the center, along with his two sons, Mohammed and Hassan, who is sitting at my grandfather's feet. As they were a respected and wealthy family, instead of going to the photo studio in Tehran, he used to call the photographer to his home once a year and the man would arrive with the backdrop and all his equipment for the day's work. On this day he was photographed with one of his relatives and colleagues from the court. Years later, he would marry one of his daughters to one of the richest men in Tehran.

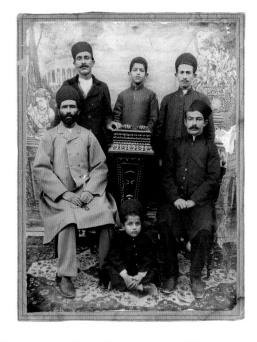

My paternal grandfather, Hajj Mohammed Ibrahim, was a prominent copper merchant in the bazaar. Before long, he owned half the bazaar, and as his skin was light, they used to call him

the "white hajj." He became so well known that the other businessmen selected him as a member of parliament for Tehran.

There is an image from 1906–08 of him with the members of parliament that was held in Tehran and created by the first constitution in 1906. In that photo, my grandfather is on the right side, six down from the top. He used his wealth and renown to care for the people who worked for us and for his colleagues. When any of his children married, my grandfather would insist they stay in his house with his wife and the rest of the family. Although he passed away at sixty, my father was always very proud of him.

My grandfather fell in love with my grandmother, Messchi, when he saw her from afar at a religious gathering. It was a

time of arranged marriages, but he was in love and insisted that his parents seek her out. They allowed him to marry her, even though she was four years older than him, which was quite a rarity. Messchi was an extremely open-minded woman.

There is an image taken at their home during the engagement party of Messchi's cousin, Muluk. My grandmother is there, seated at the center wearing sunglasses. Muluk is on her left, and Muluk's fiancé is standing just behind. The homes in those days had two yards, so that when one would enter the first yard, the women would go into the second yard to be away from sight and secluded. There were more than fifteen rooms in that house. There she is with all her relatives. At the end of her life, after her husband's death, she lived with my parents until the age of ninety, taken care of wonderfully by my own mother.

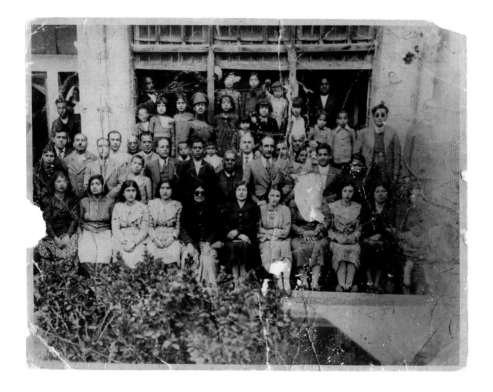

My father Ismael Niroomand worked with his father for many years in the bazaar. After he married my mother, he learned Russian and went off to start a successful business in Tehran importing samovars. He also owned a travel agency and was doing business with America, selling tires and Chrysler cars during the 1920s and '30s. Samovars became very popular in Iran. He was successful until

the Second World War began. He owned thirteen houses in the city and three villages outside it. This image is from that time. He is seated on the right, holding a rosary, which was customary for men of respect and wealth. He had a manager who he trusted completely. This was one of my father's greatest qualities—that he could give complete trust to a person: it was at once his gift

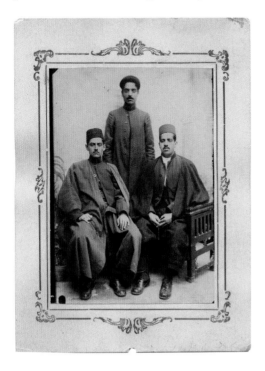

and also perhaps his downfall. He lost the business during the war, when the trade from the U.S. stopped. We had to move to Borujerd, in southern Iran, and by then my father had lost most of his wealth.

I was his third daughter. I was born in 1934. We had a large mansion in Borujerd. We were only five in the family, but we had fourteen servants. I told my father it was too many, but he said my mother had decided that we must keep all of the staff. He was proud of what his wife was doing and he respected her as the lady of the house. I have been thinking about this image of my mother, taken when my parents first moved to Boru-

jerd. Here she is with me at the age of six and the woman who used to bake the bread. This must have been taken in 1940. I had my own little dress on and, since I needed to copy my mother, they put a scarf around my head like hers. She had asked the woman to help her make a costume that was from the region. She was kind to such people and had insisted on the photo, which meant that the photographer had to be called to visit the house. She knew it would please the people of the south, to see the owner's wife in their local dress.

The war hit him hard. He found out the Tehran manager had cheated him and had sold two of the villages without telling him, keeping the money for himself. There were more than eighty families in one village and more than a hundred families in the other. My father had set up boarding schools for the children. He was a truly trusting man and this was his weakness. It was the villagers who came and told him that the village was sold. Now, because the manager had borrowed so much against the rest of the businesses, my father was forced to sell the third village to cover the debts. My oldest sister was sent to

boarding school in Tehran and my second sister to an Italian boarding school. People were shocked that he had sent his daughter to another country to study. At that time in Iran it was almost unheard of.

When my oldest sister, Malli, was in ninth grade, a man came to ask our father for her hand in marriage. Although the man was Iranian, he was living in Paris, where he had gone to study for his master's degree. His eldest brother was my mother's doctor. His whole family came to visit my father. This was an educated man and my father thought he would take care of his daughter well. The marriage was OK and they stayed in Tehran while he became a teacher.

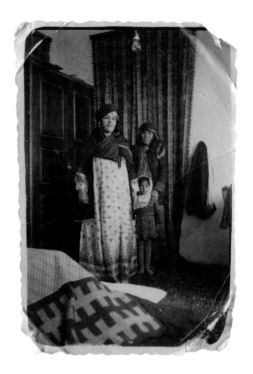

Four years later, when she finished high school, my sister Ghodsi was married. This was also an arranged marriage. Her husband, Mohammed Guran, was in medical school. Both my sisters continued their studies after marriage with the support of their husbands. My younger sister went to London to study and became a midwife.

I was married to Ibrahim when I was twenty-five, and though it was a bit late, this was also an arranged marriage. My parents never forced me, but my father wanted Ibrahim as my husband because he had studied in Europe— in the Netherlands. I believed that men respected women, so I agreed, even though we never searched into his background very carefully. He was from the north of Iran, and when we married I moved out of the main house and into his house, although my sisters had stayed with my parents. Three years later my husband got a scholarship to do research in the U.S. and I was left at home with our daughter.

By then I was a teacher, and since his research fellowship was only for a year, we decided that I would stay in Iran while he studied. But then he was accepted for a Ph.D., and so he summoned me to Iowa, where he was at the State University. This was in 1963. I wanted to go to school as well, but he refused, since I had to support him in his studies. He told me I had to work, or ask my father for the money. I had already had my second daughter by this time and so I decided that I couldn't ask my father for help. I was hired at a factory where

they were making instruments for the satellite program. They asked me to work on an important government project. I had been an artist all my life and was used to painting miniatures in an extremely precise and intricate way. So I was quite good at what I was asked to do. I worked from six in the evening until two in the morning. They never told me exactly what it was for, this work.

Then after two years the boss called me to tell me that they would be closing the place down. I said would he finally tell me what I had been working on all this time. He said that the instruments I was painting were used in satellites for the U.S. space mission. Now the government had decided to lay off the workers in order to start a weapons' manufacturing plant. They fired us all, even my boss, in accomplishing that goal.

By this time, Yuri Gagarin, the Russian cosmonaut, had orbited the earth and the American Neil Armstrong had gone to the moon. I remember sitting in front of the television at the house of my husband's math professor, who insisted we must watch as a man from earth goes to the moon. We called all the children and watched together breathlessly. My husband was studying nuclear engineering. I was doing all sorts of odd jobs. I even worked in a company that was making sweatshirts for a couple of years, putting designs on the shirts. Eventually my husband got his Ph.D. They asked us to stay on at the university, but my husband decided to go back to serve his country. So we went back to Iran and lived once again in my father's house.

As soon as we got back, my husband told me he wanted a divorce. A month later, my father passed away, so we stayed on with my mother. During that period my husband was arguing all the time—I was a woman from a city and he was a man from a small town. One day I received a letter from the court asking for the divorce. My sister spoke to my husband, but he insisted he could not stay with me, since he claimed that I was always correcting him. Finally I agreed to the divorce. My mother was very upset and I consoled her.

We went to court, but the court allowed the children to stay with me, albeit with very little financial support from my husband. My mother's friends, who were supporting me, said that I should tell him to take care of the children and see if he thinks we can survive on such a meager amount. But I knew he was stubborn and so decided to accept the decision and divorce him as he wished. I even forgot about the dowry money he had in safekeeping for my daughter.

I had lost my teaching job when I went to the U.S., and because I had been away for more than five years, I spent a whole year fighting just for the opportunity to start again at the lowest level. They refused to reinstate me to the grade I'd had before, even though I was qualified, and had left only at my husband's insistence. They said I had been laid off for not getting official governmental permission for the leave of absence. Finally they put me in with those who had no experience—I became a teacher of English as a second language.

I was worried about my children and one night my husband came to say he had decided to send them to England. This was before I had won the job back and I had nothing. I talked with my sister, who thought it was a good idea. I agreed and promised to send the clothes for them and everything else they needed. So he took Paddy, who was nine, and Mitchka, who was then only five, to England. He didn't even tell me where they would be. The girls were crying the whole time as I was packing their clothes, but they never asked me where they were going, and I was afraid to ask them how they were feeling. As I took them to the airport, I told them that they would be educated and that they would become ladies of whom I would be extremely proud. In the months after they left, a family I knew agreed to visit their school. They found that the place was not suitable, and I managed to force my husband to move them. In the following years, they would come back to Iran once, or at most twice a year, but I was only allowed to see them infrequently—at most once a week, since my husband insisted upon taking them north to be with his family. During those fleeting moments, I could see that they were not as happy as ordinary children. But I could do nothing to change the situation.

Mitchka finished her 'O' levels in 1979, and since our country was in the midst of the revolution, it was decided that children in lower education needed to come back. But I knew that if she came home, she would not be permitted to go to school, and she would waste away simply working at home. I had a nephew, who was a doctor in Boston. He agreed to have her and we sent money for her to travel to America. Paddy, since she was older, was able to stay on to get her Bachelor's degree in mathematics. By this time her father had remarried.

When Paddy graduated, I was able to make the journey to the United Kingdom and convince her to go to the U.S., as there would be more opportunities for her and she would be away from the revolution at home. This was one summer in the early 1980s. The girls lived together in America, and Paddy started graduate school at UMass, Amherst. Mitchka studied Asian Arts in Boston. For eight years I couldn't visit them, because of the Iran–Iraq war. It was a terrible time for us all. Mitchka finished her art degree and Paddy got her Master's and Ph.D. I got a letter of visitation for her graduation and in Kuwait I got the visa to come to the U.S. I got on well with the ambassadors in Iran and they had helped me, since I had been teaching their wives. This was 1991–92. Paddy has her own company now.

When I arrived in the U.S., Mitchka was laid off. I told her to study nursing and she went to get a degree in nursing and moved to Florida. She saw that the nurses were not really taking care of the patients and grew sick and angry, watching the patients ringing their bells as the staff ignored them. Then she went to London and got a Master's and came back to the U.S., where she was accepted at Harvard and moved back to Boston.

Before the revolution, I used to talk to open-minded people about religion. They accepted that I was different and that for me it didn't make any difference if someone was not like me. But after the revolution, with the ascent of Khomeini, Muslims had to report their own neighbors. Because of this, many people were killed. People are closed-minded now. Since the revolution, good Muslims don't want to talk with these people who claim to be religious scholars. They are like a piece of driftwood, taken this way and that by the ocean.

Three years ago, my sister back home was having some family problems with her niece, and it was making me anxious. At the time, I used to take my car and drive to other towns to visit people in the nursing homes. I thought I should just come to be with them for a time and to show them love. It gave me a good feeling to be useful and make others feel that they are somehow still wanted. Then, one day after visiting the nursing home, I was on my way driving home, when I hit a cyclist. It was a young girl. I couldn't remember what had happened and when they took me to the police station and told me that the girl was dead, I started screaming uncontrollably. I told them in the midst of this hysteria that since they have guns, they should take one and shoot me right then and there. I couldn't believe that I had taken someone else's life. The pain was too much for me to carry.

The girl passed away from the injuries. When they told me that she was dead, it was the most painful moment in my life. The family came and supported the girl's father, who heard the story and even witnessed the police video of my arrest. When we were in court, they showed that video and I couldn't watch. He spoke up afterward and told them that he forgave me for what happened. I could only cry, since he was so gracious. He was like a piece of gold to me. Even though I am a foreigner here, many people from the community offered their condolences to me for this horrible accident and loss. They supported me. Even people who didn't know me sent me condolence cards. Women from Pennsylvania and Connecticut sent me images of Jesus Christ, knowing that I am a Muslim, and they said that they respected who I am and that they were praying for me in this time. I could hardly believe this outpouring of emotion and support for an old woman.

My mother used to tell me, even in my early childhood, that I am different. I am thankful that God has given me a good heart. My father used to tell us, "You

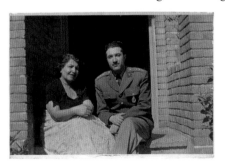

cannot educate people. You have to forgive." I am so fortunate for this family forgiving me for all that has happened to them and all the hurt that this accident has caused.

This image of my mother was made in 1955. She is seated beside my brother-in-law, Mohammed Guran, who was studying medicine and married my sis-

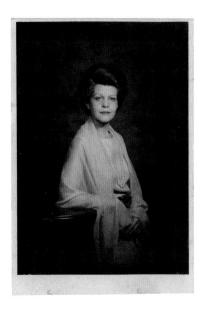

ter. He was from the north, like my mother. We were in high school at this time and she was heavily involved in the family. This one is of my sister Ghodsi in 1978, not long before she passed away. I remember that she looked at that picture, saying that she was glad it had been taken, so that people would remember her beauty when she got old. She didn't know that she would soon be diagnosed with cancer and die soon thereafter.

And this is of my mother in Tehran in 1995 when she was eighty years old. It was just after prayer time. I feel one can see the kindness in her face. Always a housewife, she took care of the family. I think she must have been very open-minded. I think of how the workers in the house insisted on coming back with us to Tehran. She made the arrangements for all of them to come with their families from that small village and I often think of how shocked they must have been by the experience. It makes me proud of my parents, to see that they insisted on having more people to work for them than they really needed. Since they had enough, they were helping to share with others. When we ate, meals were prepared for the whole family and the servants would sit together and eat the same thing that we were served. I remember my mother used to fight with my father, because he was always giving his things away. When he came home one day without shoes, and we asked him what happened, he told us that he had given them to the lawyer who had been cheating him. My mother accused him of being too trusting.

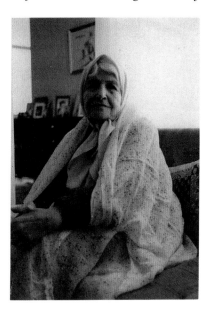

If I tell this to my daughters, who were raised here, they will not understand. But I think they are just like my father, and easily cheated. I often wish the whole world was more trusting. I don't let anyone take advantage of me. But I also try to give whatever I can.

Paul Vasconcellos

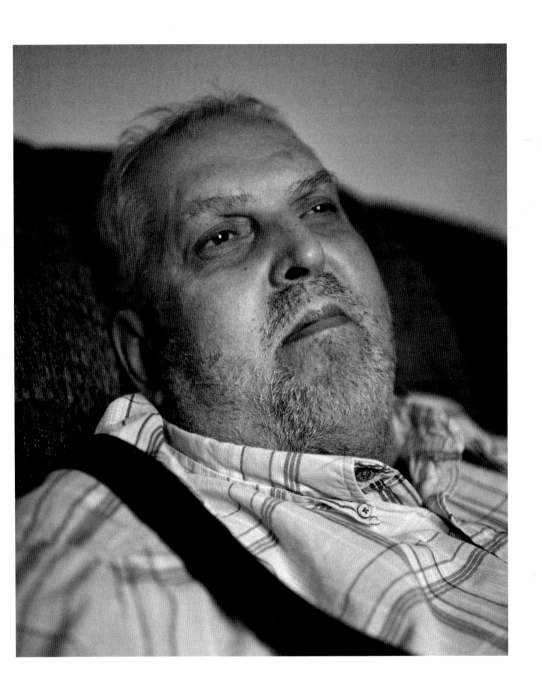

I was born in 1948 to a Portuguese father and my mother, Mary Carlew, who was part Scottish and part Portuguese Protestant. At the time, there was a booming factory business and fishing as well as agriculture in New England. In our family some of the aunts and wives lived in New Bedford and Fall River.

My grandparents on my father's side came from the Azores among a wave of immigrants at the beginning of the last century. My grandmother Isabella had nine children, two of whom died right away. Soon after they arrived in America, my grandfather left her. Because of the separation we were never allowed to meet him. All I know is that he went on to have four black children from a second wife, who was part-Cape Verdean and part-Portuguese.

My mother, who was an alcoholic, stopped working after I was born and became agoraphobic over time. She abused me from an early age, both physically and sexually. My two older brothers—they were much older—may not have had it happen to them, but I don't know for sure. In any case, they certainly never spoke with me about anything like that happening to them. She threatened me pretty well. Another part of her mental illness was that if she wanted you to do something, to laugh, or to cry, then you better do it. She was very controlling around me. I don't even know if my father was aware of what was happening, but since he had disengaged from her and probably was seeing other women, it didn't seem to matter to him. Maybe his neglecting of me had something to do with his own shame. Parents are supposed to protect their children, but they often offer the opposite.

I was eleven when my mother died of a stroke at the age of forty-one. She had diabetes, which was never properly diagnosed, and she drank cheap port too heavily. Because she had converted to Catholicism, and because she didn't go to mass, we had to pay $250 just for the right to have her casket resting in the aisle of the church. They refused to allow us to rest it on the pedestal. She had become immense at 250 lbs and only five feet tall.

After she died, my brothers quit school early at my father's suggestion and were married off at sixteen and eighteen. From that point on we didn't see each other often and only exchange cards sometimes. But though I was the youngest, I was convinced by education and determined not to quit school. After their marriages, both my brothers were out of the house, so it was just me and my father at home.

Two weeks after my mother's death, my father already had a new girlfriend— which makes it easy to imagine that he had been seeing other women all along. He had, in any case, always neglected my mother and me. As he never bought my mother anything during the years she was alive and he bought this woman everything, it made me dislike her immediately. It may not have been her fault in reality, but what does a young boy know about such things? Yet there must be something in my character that made me refuse to take on that anger for very

long. In looking back on my life, I feel as though a generosity of spirit has kept me going through some really difficult moments.

My father was so neglectful in those days that the protective services would come to the house just to see that I wasn't left without food or was in a difficult situation. They thought it was important that I stay with him, so they made a plan to have the other members of the family take me after school. This way, I would have some stability and would be looked after.

There's a picture of me in the second grade. It's an interesting thing that school was my safe place to go. We lived in a two-story house and the woman on the second floor was kind and that was a similarly safe place for me to visit. If

it wasn't for those two things, it's hard to say if I would be here today. I'm glad for this image, because it reminds me that, despite the fact my childhood was hellish, I can look at that picture of myself and say that I was definitely innocent.

Our neighbor Florence and her daughter, who lived upstairs, did the kind of things with me that were supposed to be done with a child. Their patience shows. For the longest time, when I kept everything in, I was sick, and thought I was the

worst thing in the world, but then when I see that image, it shows my innocence. After many years of therapy as an adult, I finally came to the realization that I was not responsible.

I have had many deep experiences, many chances to create an alternative reality to escape what was happening in our home. I would create a scenario in which things were good. I would think, if I could only be somewhere else, things would be different. The woman upstairs had a phonograph, which was quite fancy for that time. I would sit in front of it atop a hassock in my underwear and T-shirt, looking so intently at the record going around and listening to the music. It was a sense of complete safety. I could lose myself in the moment and be taken away. I would just sit there listening and watching the record go round and round. When the record was done, I would put on another, just to keep up that soothing meditation.

The determination to stay in school was mine, and if I had not fought for it my father would happily have taken me out of school and put me to work. But for me, it was clear that I would stay and graduate. When the time came for me to finish high school, the guidance counselor tried to convince me not to take the route to college. I don't know if he had been influenced by my father in this decision, but as I was a good student, I knew that I could make it, given the right chance. My father refused to fill out any of the financial aid forms for Brown University. But even though I had to live at home, I got a stipend on my own.

I started college in 1966 and was politically active almost immediately. It was the time of demonstrations in the U.S. and we did a lot of protesting against the war. The president of the university at the time was a military person and new recruits were hired only when they were pro-war. Our protests convinced the school to remove him from his post.

When I was twenty-one, I was married. It was the happiest day for my father. When I graduated from high school with honors, he never cared, but this made him really content. Maybe he was worried that I was gay, or maybe he wanted my wife to take away his guilt about the way he had neglected me in my childhood. Maybe it was some way of thinking that life might work out for me in the way he expected. I was even thinking it might work, and probably I was deluding myself; convincing myself that I could will it into existence. But the marriage soon failed. When I got divorced, my father was very upset and told me that I had embarrassed him. After that, I didn't speak to him for almost fifteen years.

Soon after my divorce I left school and began working. I was always paid the least, since I didn't have a degree. I did some volunteer work, social work, and worked at restaurants, as well as at the Provincetown drop-in center.

I was twenty-four years old when I moved to Provincetown and worked for Bill Dawson, who owned a small guesthouse and would become a real mentor in my life. He was one of the first to get AIDS, and during our time together he

helped me to be "out." I was lucky in that I had a sense of myself and was secure. I was young and could easily have fallen prey to the wrong people, but Bill took me in, acting as a protector to me in the best way possible.

He helped me get settled and find my way. He gave me a place to live and a job and I took care of the guesthouse until I found a full-time job at the Provincetown drop-in center, where I counseled people and helped them with their illnesses. Soon after I got the job, I moved out and lived on my own. Bill had been an alcoholic and he was difficult to work for. I was associated with him from 1974 to 1976. He was an example of someone who was really different, but who still had a common ground. We could always tell that he had come from money, and when he got really ill years later, his mother came and took him back home, where she cared for him until he died.

Provincetown—they called it "the last resort," the only place for people who had nothing else. Although it was a happy place for some people, Provincetown was an extremely unhappy place for others. During the season, it was teeming with tourists, and since the people who lived there knew the winter would soon be returning, they decided to party and have sex as much as possible while the going was good. As I worked at the drop-in center, I would see people who would come to be treated for gonorrhea, and I would tell them not to drink or have sex for at least a week, but then I would see them later that night, out in the bars, doing the same old thing, because in the winter period there would be nothing, and many would be left with only sadness. They were desperate to take full advantage of the moment during the summer, regardless of the consequences—at least, I don't know how much they considered the ramifications of their actions.

I was trained by the state to test for syphilis and gonorrhea, and realized that there were many people who thought so little about themselves that they didn't even care about their health, and worse still, that they couldn't think about the others that they were hurting, and would be willing to make others sick. Most of us wouldn't dream of such a thing, but there were some out there who I met that were acting really recklessly.

It gave me an incredible sense of accomplishment, helping out and offering people support. We were a small group, but we worked well together as a team and even supported one another, which was heartening.

When you are young, you have all sorts of ideas of how things are going to be perfect; like a relationship. I had a dream I was walking with Bill on Commercial Street, and we were talking and then across the street we went into a doorway that had a stairway that descended from the street level. And suddenly, I could no longer see as we went down and I lost sight of him. I was calling out to him, but he never answered. I woke up and had a strong sense that something had happened to him. Within a couple of days, I got a letter from his mother. He had died the night that I had that dream. She wrote about how he talked about me

frequently and how I respected him for who he was. As the AIDS progressed, he had become blind. She wanted me to know that, and to give me a sense of the closure. He must have had me in his thoughts when he died. It is kind of amazing for me to imagine, but he must have passed with me in his mind.

I realized that I needed to go back to school and I was admitted to the University of Massachusetts at Amherst, where I studied until I received my degree in 1979. I went on to graduate school, at the school of Education at UMass, [to specialize] in counseling psychology and social justice. I eventually rose to be the dean of the students' office. By my mid-fifties, my health started to deteriorate badly and with heart problems and other complications I was soon relegated to using a walker, power scooter and a wheelchair. Although it was only shortly before my retirement, the school pressured me to give up my job because of the health issues.

In January 2008 I retired at the age of fifty-nine. I moved to Holyoke and Providence Place and in the July of 2009 I moved here to Amherst with a personal care assistant. Before I retired, I had lived in an apartment that wasn't accessible [for a wheelchair]. It was that I would have to move out. The social workers who helped me suggested I apply for housing here at Anne Whelan House in Amherst. The insurance helped with my health-care provision to an extent, and I was lucky, because I had taken the precaution of putting in for long-term disability insurance, which helps me support myself here. In order to get in, a person has to have under a certain amount of money. And when your income goes down, your rent goes down in relation.

I was recently quite ill and spent weeks in the hospital and then at a rehab. But the possibility of getting home made all the difference. It made me suddenly grateful when I realized that I could go home and not be in a nursing home. It was a depressing time, and I thought about giving up, but then I had an epiphany, about the generosity that has been given me and how so many people come to visit me when I am ill and help me; how they are there for me and how much I would be letting them down if I ended my life. I decided to work hard, and finished three weeks in the hospital and a further three weeks in the rehab before I was strong enough to come back home.

Many years ago, one of my brothers called and told me that my father had fallen down the stairs in his home and had lain there with a head injury for twelve hours before he was discovered and taken to the hospital. He was par-

alyzed—which was tragic, since the thing that brought him the most joy in life was dancing.

We stopped in Providence en route to Provincetown to see him. My two brothers were also there. My father looked so vulnerable at that moment and was in a state near death. I mustered the courage to tell him that we had had our differences in the past, but that I wanted him to know that I loved him because he was my father. He said that he felt the same about me, and I think he was grateful for my forgiveness for all the things he had done to me in life. In those moments, I thanked God for allowing this time to happen.

Ten days later, I dreamed he and I were walking down Summer Street together where I grew up in New Bedford, and where he had a cobbler's shop. We walked together and then turned into his shop doorway and it got dark and I couldn't find him. I got up from the bed after the dream and put on some music, because I had the sudden feeling that he had died. Within the hour, my brother called to tell me that my father had passed away. My middle brother, who had been closest to my father, didn't have any kind of experience before the death. I guess my father was making some sign to me about forgiveness. In that hospital room, we gave each other a gift. I could still love him, because he was my father. I never had that peace with my mother though; her abuse was too unforgivable.

I never had the chance to confront my parents when they were alive. If I had, then they would have turned it against me. I think they had issues already about the fact that I might have been gay, and then my mother had done these things to me when no one else was around, so how could I possibly convince anyone that I was telling the truth? They happened when I was sick from school, or in the hours after school, but before my father came home. If I was sick, she would use that as an excuse to sleep with me. When I was between six and eight, she used to take baths with me. I could, with the help of therapy, only get to the moment of being in the bathtub with her before I would scream and end the session. I hit the moment when I would see and feel what was happening, but I immediately blocked it out. She died early and there were times when I wished her dead and I still find that difficult. As I age, I have more empathy and realize that she was really sick.

Today, if there were such a case, they would probably be careful to look into it. And having a spiritual life has helped to heal me a great deal. I developed a trust with others, as I have with you, so I can speak about these things more openly, more freely. From the work you are doing, we see someone, but we have no idea what that person has really been through. You look at the surface and then delve beneath that surface to listen to what the person holds within them.

Sellou Diate

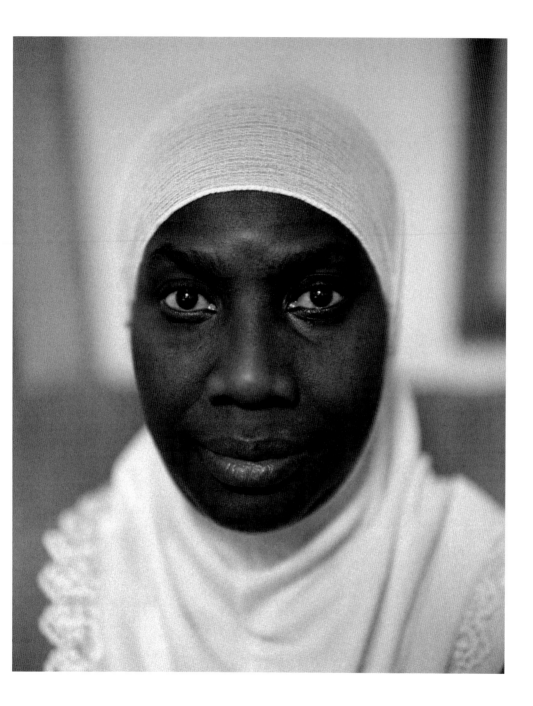

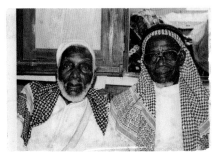

I was born in the town of Bignona, Cas-
amance, Senegal. My father, Osman,
was well respected. He had been mayor
and head of the parents' association. My
mom had eight kids, of which I was the
youngest, and my father had another
eight with different mothers, so there
are sixteen of us altogether. I went to ele-
mentary school in Bignona until seventh
grade, at which point I went to Dakar to live with my mom, as she was sick and
needed to be there for her treatments.

Our house was full of people when I was growing up, there was never a
quiet moment. All kinds of people—strangers and even those who had sick-
nesses like tuberculosis. The men ate together and the women ate together and
the children ate together. There was something about
sharing the same dish and eating communally that in-
stilled in us the sense that we must learn how to deal
with one another.

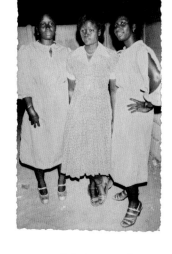

My father was extremely generous. If we had eaten
one day and on the next day someone came to the
house hungry, my father would give them money for
groceries because he would say that we had eaten the
day before and this person should eat today. We lived
in a community and it wasn't just one person raising
us. We all had to help out in the house. My job was to
help prepare the rice.

The last-born is always the most spoiled, and al-
though we were all supposed to do things, I would
wait until I was forced. We wouldn't eat if we didn't

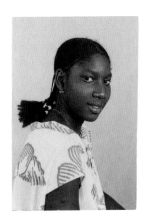

do our chores so I would go to my uncle's house—he
was the Imam—because he would always feed me no
matter what.

I was bright in elementary school, always in the
top ten. We used to get up at five in the morning and
refresh and go to the madrassa [religious school]. At
seven, we went to the regular school. But school didn't
mean a lot to me after that. I didn't really have any
interest in studying. One year I went away on vacation
and refused to go back.

After that I lived at my mom's home in Dakar,
where my older brother worked for Air Afrique. When

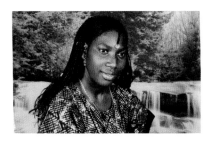

he was transferred to Abidjan in the Ivory Coast, we stayed in Dakar and went back to Casamance every year for vacation.

In Dakar, my sister had met a man from Burundi and they had become friends. So I was surprised to see him one day in Bignona, when I was on vacation, standing on the street with a friend—the man who is now my ex-husband.

It was a love marriage. He was a student so he had no job and could not support me. By chance, our families knew each other and I remember my parents allowed me to do as I wished, but warned me not to come to them if it didn't work out. My father had insisted on choosing the husbands of my two older sisters, but they had grown dependent and never went to school. So he had learned from that and sent the rest of us to school before we got married so that we would become more independent financially.

But we convinced our parents and we were married in Casamance. It was a hard marriage. The region was in the middle of a long rebellion because the people of the Casamance region wanted independence. We were in an area that was full of different cultures: Mandingo, Djoula (which is my ethnic group, but my mother is a Fulani); that is why we can all speak many languages. But the struggle for independence became very violent. The rebels wanted to burn our house since my dad worked

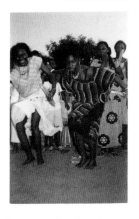

for French colonialists doing trading and commercial work. My ex-husband was one of those who wanted to get something done, but he was targeted. So to get away from the fighting, we went to France.

We came on to New York and we asked for asylum. We had some family there and could stay with my sister for three months. The first year we were undercover. [At home] my husband had been in construction, working on the road, running a crew. Here, he was a dishwasher, and I braided hair to make some

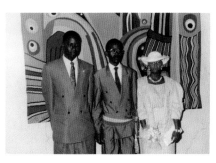

extra money. In less than two years we got permission to stay. With the papers, my husband got a job as a security guard. We lived in Bed-Stuy, Brooklyn. I opened a salon and we had customers from all over New York.

One day, I braided the hair of a woman who was a student in Springfield. Other women in Springfield liked her hair and asked her who did it, and that's when they

asked if I would come up to Springfield if they bought me a ticket. So that's how I first came here. The woman who had invited me had arranged other customers, and for two days and nights I was braiding non-stop. I got back in the train and fell asleep for the first time in 48 hours.

We moved to Springfield in 1997. Since my son Ahmed was twelve, it would be better for him to be away from the big city. I came here with him and then three months later my husband moved as well. After that, I went to Springfield Technical Community College and took a course in computer engineering technology. When I graduated I went to work as a repair technician with a phone company.

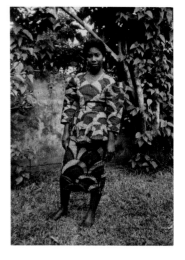

We had bought a house in 1999, and then in 2006 we saw this house and decided to buy it. Two years after that, my husband's sister got cancer and since my husband was the main source of support, we had to pay for her treatment. We had to pay the doctor before he would see her and for all the chemotherapy and drugs before they would treat her.

We started to have our own troubles during that period. We had built a big house for the family back in Senegal. We asked the bank for a modification on the loan because we had missed a couple of payments. The rent we got from the other house was paying the mortgage. I wasn't dedicated to sending money back to my family. I only did it when I could—I'm the baby, remember, so most of my siblings worked, and I only contributed sometimes. But in my ex-husband's family he was the only source of income and he had to support his relatives.

These financial problems started to weigh on our marriage. My husband refused to help me. My main aim was to save the house and to be responsible for

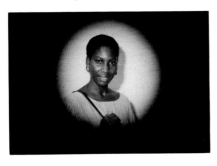

our own actions. We consulted an Imam who told us each our rights and duties. Then my ex-husband wanted us to leave the house and go live with his cousin. But his cousin is not *mahram* to me—not family. Islam prefers that two people who are not family don't live together or have a close relationship because it could lead to adultery. So I said no. And the Imam

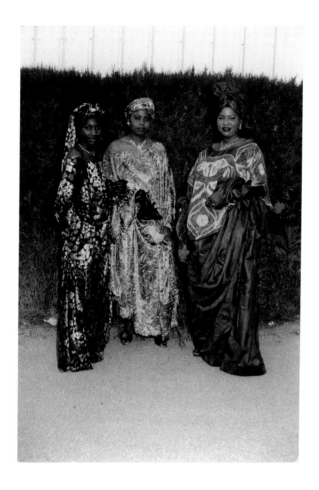

said it wasn't appropriate to do it. So I stayed in the house. But communication between us didn't go well. My ex-husband told the Imam that he would contribute to the house, but he didn't, and then he left for Senegal on vacation without telling me.

When he returned, my room was locked. I was furious that he didn't take his responsibilities seriously, so I had locked my bedroom—didn't lock the house or change the keys to the house, but I locked my bedroom. He tried to open the bedroom door, then took a shower and left and never returned. He went to live with his cousin for two months but they didn't get along so he had to move out. It was hard for me, but it was a blessing, though.

The bank still would not agree to modify the loan. By 2009 my husband was already out of the house and out of the process. I found a place to give us property counseling. They set the modification for $1800 but said that for six months

we could try to pay $1100. I paid the $1100. Then we received a letter saying that agreement was cancelled and now the mortgage was to be $2,250. My husband had kept this information from me. He told the Imam, but he kept it from me. By the end of the year, he was back in Senegal. I missed some payments after working for a few months, and since both our names were on the deeds, if my husband wouldn't sign, they wouldn't modify the loan. He didn't help me. He wanted me to be kicked out. This went on for a full year and I finally got tired. In December of 2010 I found [the tenants' rights organization] No One Leaves.

The movement is helping people who have nowhere else to turn. We got invaluable help from those who were helping us in this struggle against the banks. My kids gave me strength to fight. I was no longer afraid of what would happen to me. I had lived somewhere else before this house, and although I really love it, I knew that if I lost it, there would be something better for me in the future. My life wouldn't end because of this. Even if one gives up, you can still fight for the others.

I met other people who told me their own stories of trouble with the banks and their attempts to keep their homes. There were many things I didn't know about my rights when I went to the group. The banks were intentionally misleading us, keeping us on a string and telling us to accomplish all sorts of tasks and send in all sorts of forms without ever acknowledging when they were received. Or they were keeping us waiting endlessly without answer, until one day we get the notice of foreclosure and eviction. It's a cruel way to break people down, to the point when they no longer have the strength to fight. They take advantage of our weakness and throw us out on the street.

We had been married in Senegal but I filed for divorce here in the U.S. The bank said that in order for them to modify the loan, my husband had to sign the Quit Claim deed to hand over the house to me, since he was not interested in it. But he refused. He was being vengeful. Under foreclosure, to modify your loan, you first have to pay back the amount you owe before they'll accept any other payment. They refuse to accept whatever you have.

While I was in the middle of this fight, I was so worn down that my children got me a ticket to travel home to be with my family in Senegal for the first time in years during the time of Eid. I was to leave on October 30, but then on October 20 I suddenly got the letter telling me I would be foreclosed upon on November 9. I said to myself if this was going to be, then let it happen. The people from No One Leaves—people I barely knew—asked me if they could protest on that day, even if I was going to be away in Senegal. I couldn't believe they would offer me such help.

When the day came, I was in Dakar, and they all came to the house in Springfield and set up loudspeakers. I called them on the phone and they had me lead them in the chanting. We protested as one group. I was so loud that

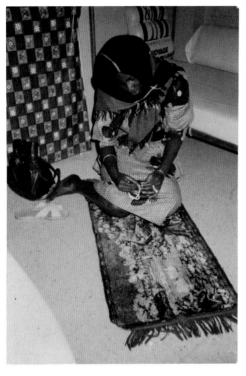

my brother came and asked me if all was fine. Later, when I told him that we had been protesting with dozens of others who were carrying out the protest in my name, he was amazed that Americans could do such a thing. To my great surprise, another bank was convinced to buy back the home and give me a new mortgage, one that I could afford.

I hadn't been home to Senegal since 2007. Now I was there at the time of Eid, which was an added blessing. All I had been wishing for came to pass. It only happened because of their good will. We were just asking for a little help, not a bail out. In those two weeks I visited every member of my family, which meant traveling all around the country. My sisters and brothers had passed away since I had been back, so it was important that I be there to honor them, even if it meant losing my home. But they were all paying so much attention to me in the U.S. The Boston Community Capital Bank [B.C.C.] made an agreement with me and I didn't have to deal with Fannie Mae any more. They sent an application and told them that they wanted the owner who lives in the house to be able to sell it back to them. Luckily they said yes. It was bought for $110k and sold back to me for $143k and they also hold the mortgage.

There's still exploitation but they don't go beyond your needs. They'll ask you, "Can you afford this?" Whatever you can afford, they go by that. So they give you a way to stay in your home. And I'm grateful for that. It kept my family in our house. I wouldn't be able to get another mortgage if it wasn't for B.C.C. They are still making money off of me, since I am vulnerable, like most of the people they can exploit. Still, it's half the price of what it could have been if I paid the bank, and they will also share in the profit if ever I sell the place in the future. If I sell it for more than the mortgage amount, we will share the profit. If I moved out, I wouldn't be able to buy another house, so I'm happy with this solution.

My sister also lives in Springfield now. She has two kids who are seventeen and eighteen and they live with her. Our children here contribute to the family. If they are young, they should cook dinner for the others. It's the way we raise them: to contribute. It's like that in Senegal. We start to work at twelve. My

niece contributes and takes care of the home. The boys have to be asked, but they do it too.

Since I started to get involved with No One Leaves, which is a group of mixed races, religions, even economic levels, I started to feel that my community is standing up to injustice. But many of the members in the community look at me as though I am mad. They think I am putting myself and my family at risk. Even when I invited those who are educated to come and speak to us, they won't come. I tell my kids that they have the opportunity to speak up and act, but my kids don't get involved. They call me an activist and prefer to accept the discrimination that exists here. They see how things are changed, but they still don't want to fight. That makes me sad.

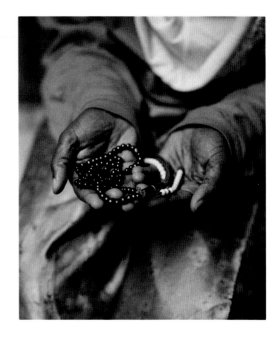

Being a Muslim is very hard in this country because we are targeted for a lot of things—singling us out. It's a funny thing that the black people are thanking those who look more Arab for taking the burden off of them for once. They are so used to being the main suspects, they don't mind sharing that space with others. In the Muslim community it's worse on people that are Arab or look Arab, like lighter-skinned people. I never was targeted, I think, because I don't look like an Arab. So although I wear a hijab, the fact of my being black also makes it a bit better for me than for people from the Arab world. I don't know if this antipathy can ever be fixed. The Imam of my mosque would warn us what is happening, and he would also tell us how we should use non-violent resistance. The police, if you call them, are not there to help us, because they may not feel sympathetic to us.

Because our kids are black they are often targeted by the police. My nephew Julius was driving and they pulled him over and cuffed him by the side of the road and searched his car without his permission and without a reason. It was just because he was a young black man driving along the streets. The children these days in my area have to get used to such things, but it must breed some real animosity when they have to continually swallow and put up with what is essentially an injustice. As immigrants, we don't want to have anything to do

with the police, because we are afraid of being shipped home on some made-up story. We don't even think to find out what our rights are, since they can simply create a story against you that you may not be able to disprove. It's often fabricated against you, so you just stay quiet.

I think it was around September 11 that I began to feel I wanted the hijab to be part of my identity. I had started wearing it earlier that year. It was a religious step forward. We were treated with such prejudice here in America after September 11, as if we were the ones who had brought this great devastation on the country. So I wanted to embrace this part of my identity because I felt that what was happening was unjust. Of course, I was cautious at work, since I was worried about losing my job, but I did it slowly, until I could wear the hijab and my boss understood. It fortified my faith.

Members of the community had asked me in the past to wear it, but when they saw that I had decided for myself, they treated me differently, with a degree of respect. They are proud that I cover myself, but I needed to wait until the feeling took hold of me and it was my choice. My husband didn't care much either way. In Senegal, we tend to follow certain European traditions, but we shouldn't be afraid to make a statement and follow our identity if that's what makes us feel content. Allah is stronger than anything and can protect me.

I am very thankful to have been able to make hajj in the company of my son—to have accomplished the fifth pillar of Islam. Oh my God, it was incredible. So many people. We were among, I believe, four million people. It was so nice waking up at two o' clock in the morning and going to *haram*, to the mosque. You know we walk around the *Ka'aba* [the sacred house in Mecca] to make *tawaf*. I think it was like 100-and-something degrees, but walking barefoot around the *Ka'aba*, you won't even feel it because it's cold at the bottom. So that was a very, very nice experience.

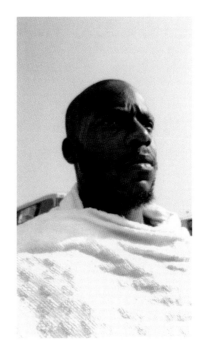

It changed my heart. I don't feel that material things are important to me any more. It makes you understand a lot of things. It shows you that in this world we're only here to visit. When you are there and you know everybody is working for the same goal, your belief gets stronger and you want to do more deeds, instead of just trying to get something for yourself. So it really changed my life. Now if people want to fight

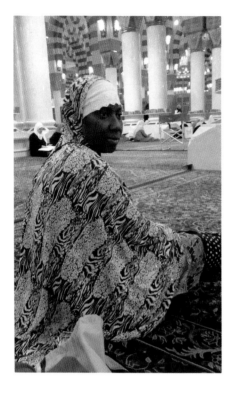

I don't get mad. I just look at them and laugh. I'm, like, "Okay"—because it's not worth it. I asked Allah to make my heart easy and I think I am very easy now. If I get mad I just do two prayers and I ask for forgiveness and then Allah forgives me.

He'll forgive us, so why can't we forgive each other? And then be more patient. Because when you're there [Mecca] you really learn how to be patient. I think I was patient before but now I'm trying to be more patient.

Before I went to hajj, I have a friend in Milwaukee and she said, "Oh Sellou, I have this friend who's looking for a wife and he wants me to introduce him to you." I said, "I'm going to hajj. I don't have time for anything else." But when we got back, my friend called again, saying, "Sellou, my friend just called me, he said he wants to marry you."

I said, "How can he marry me without even knowing me?"

"I don't know," she said. "Can I give him your number?"

I said, "Sure." So he called and said, "Hi, *salaam, salaam*," introduced himself. I told him about my hajj and how I have friends I met there here in America, and

how that's really nice. And the next time he called, he's, like, "Okay, if I want to marry you, who should I send my parents to?"

I was, like, "Are you okay? I don't know you!"

Because that's normal at home, but I'm, like, "Uh-uh. I need to know who I'm talking to first. It's not just me. My son also has to meet you, and my family."

And he said, "Okay, I'll come."

So then he came down. I asked my son to drive down with all the kids. He met my family and I let my son talk to him. My son thinks he is a nice guy, and so we continued to talk, and I was waiting for my heart to say it was okay.

At that time, though, there were two other people who wanted to marry me. I guess [because of] the hajj, just, *boom!* One is in New York and the other is in Senegal.

I had asked Allah to make me meet someone who believes in Him, who is more religious and who has faith in Allah. Because in Islam it says it's preferable when you are married. So when I told my son about him, he said, "Oh my god, Mom, Allah accepted my prayers. That's what I prayed for!"

And I was like, "Really?"

And he said, "Yeah!"

So I thought, okay. So we talked.

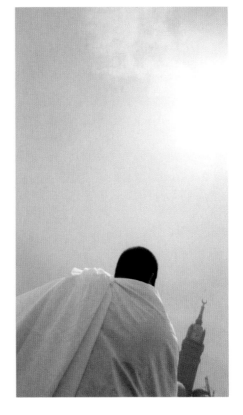

We kept talking. And more and more I could feel the faith in him. He understood [about] having a wife, what his responsibilities are. I thought about it and I said, you know what? Okay. He's single. He has kids, which is good because I'm not looking for more kids, unless Allah decides in a blue moon, but only Allah knows.

And he was patient. I called my brother back home and said "So-and-so wants to marry me. This guy, this is his criteria." So we narrowed it down. But the last word was gonna come from me. He told me what he thinks and finally I made my decision. And when I called Musa, I said, "Okay, now you can call your parents."

So he called his dad in Mali, and his dad called his uncle in Senegal, and his uncle called my brother right away.

The other guys—they're married, so me being a second wife would be a no-no; it just adds problems to problems.

With Musa, the belief is stronger. When we talked, he said, "OK, I'm looking to marry you, but [only] if Allah wills it. If Allah says that we will be married, we will be married. He'll make it easy. If we're not married, it's none of our faults. It's just: 'Allah said.'" That's what he said: "Let's leave it up to Allah."

Then the second thing, I said, "Well why do you want to marry me?"

He said, "It's because of your belief." He said, "I'm a man, I can probably date anybody I want, I can probably go home and find anybody that I want, but it's that belief that I'm looking for." So at least there's something pointing to Allah. Because right now, like with material things, I don't see anything that anybody can give me what I never had. Plus that's no longer in my needs. I don't want anything else. But anybody that can help me strengthen

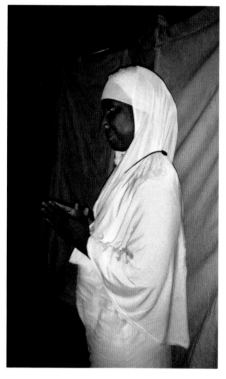

my faith—that's what I was looking for. And I think he's that. And him, too: he's looking for somebody that can help him in his faith. So that's how we found ourselves going back, being recommitted.

When I was struggling, I would often dream of my parents and I knew they were watching over me and on the mornings following these dreams, I would wake up with a renewed spirit. After the first pre-dawn timing for prayer, there were days when it was too cold to get up and I would convince myself that it was OK, but I would ask forgiveness and go back to sleep. Every time I dreamt that I was in the mosque and praying.

Now, when I go back home, I remember that sense of sharing. My father used to go to the post office to cash his checks, but by the time he came back home, much of the money would have already been given away. Eating together out of one communal bowl gave us the sense of sharing with one another. You couldn't sit with your own plate, the way people do here. Here we sit each with our own plates, and it gives the children a different sense of their community. We started to adapt, and it becomes natural not to share.

Back home we grew up with things being this way, and it's almost like a religion for us, this social sense. But here, we don't eat out of the same bowl, just like many of my friends in New York. My kids understand sharing, but it's a bit different for them, as they have learned the American way of selfishness.

Allah puts you through things to test your faith. When I get depressed, I do *salat*. I'll ask Allah if keeping this house is good for me and my family. If it is, let me win it back, let us stay. But if keeping this house is not good for us, then let it go. That was always in my prayers.

Because I might win the battle and then something really bad could happen to me. That way I would be trying to force something that is not good for me. So that's why that prayer is very, very, important.

Fazal, you have to keep praying for me, so that I can stay in this marriage.

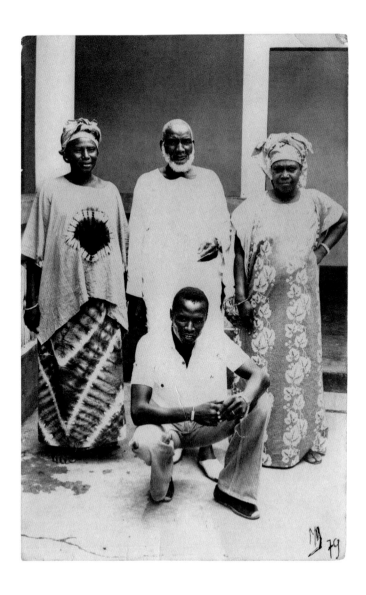

Appendix

Molly Mead

A Problem Shared
Working with the Amherst Community

The Center for Community Engagement at Amherst College had its grand opening in the fall of 2007. We were established to put leadership and resources behind the college's commitment to "educate men and women of exceptional potential from all backgrounds so that they may seek, value and advance knowledge, engage the world around them, and lead principled lives of consequence." This excerpt from the college's mission statement makes a clear connection between knowledge, engagement and the hoped-for outcome for every Amherst alumnus—a principled life.

Even as we were established with great fanfare (Deval Patrick, Governor of Massachusetts, was the keynote speaker on our opening weekend), we were aware that Amherst's commitment to community engagement has been a part of the college's purpose since its very beginnings. It was a core assumption that an Amherst graduate would make a difference in the world. In the early days the college educated "indigent young men of promising piety." Today the college spends more per student on financial aid than any college or university in the country, to ensure that no man or woman of exceptional potential is denied the opportunity to attend the college because of limited financial resources.

But at least some of the values that underlie community engagement today are quite different from those that motivated nearly 150 Amherst alumni to become Christian missionaries in the past. There are some core assumptions that animate the Center for Community Engagement today which challenge the very idea that our graduates would travel around the world spreading religious beliefs for which no one was asking.

The CCE's mission statement is: "to ensure that an Amherst College education provides graduates with the knowledge, skills, experiences, and civic commitment to be engaged citizens". To accomplish this we do the following:

- Foster intentional, reciprocal relationships with community members and organizations, creating the context for challenging, meaningful engagement.

- Build a community on campus and beyond that works together to address some of the most vexing public problems.

- Support faculty to engage the community in their teaching and research.

- Build student leadership skills by providing a range of leadership opportunities, training and reflection.

Since 2007 we have provided financial and educational support for over 1,000 students to take part in a summer public service internship. We have supported the faculty to teach almost a hundred different courses with a substantial community component, and organized three-quarters of the student body to become involved with a local effort to address inequality and create fair and just communities.

A set of core values informs our activities. The first, and perhaps most important comes from the understanding that the communities themselves hold key pieces of knowledge. About some things, they know more than we do. On the other hand, there are things that we, Amherst students, faculty and staff, also know—that perhaps they don't. What is often overlooked, however, is the kind of knowledge that is embedded within the community groups with which we collaborate. So all our work always begins with this question: What do the people we are working with—whether to address hunger, improve public education, lessen our negative impact on the environment, explore ways the arts can uplift the human spirit, and so on—what do they already know about their circumstances, and what do they already know about how to improve them?

Another core value comes from understanding that you almost always need to get to know people before you can work with them to improve their circumstances. For both these reasons, we prefer the term "engagement" to "service." Engagement implies working with, rather than working for; and getting to know people, not simply giving them something they didn't even ask for.

Most of the activities of the Center for Community Engagement involve a partnership with a local organization. We help students and faculty get meaningfully involved with the Amherst and Holyoke public schools; with adult education programs based in the local library and other nearby locations; with wonderful after-school programs including Girls, Incorporated and El Arco Iris; and with the local food pantry and hot meal program. We work with the Survival Center, a place that treats everyone who comes through their door with the utmost dignity and respect; with Big Brothers, Big Sisters, a mentoring program that asks our students to make a two-year commitment to being a steady presence in the life of a young child; and with the Amherst Senior Center, a place that values the older people in our community and helps give them a meaningful connection to others. In each of these partnerships we know that we get as much as we give.

Ultimately, we believe our fates are inextricably tied together. The motto of the college is "Terras Irradient"—"Let them give light to the world." In the nineteenth century many Amherst graduates interpreted this to mean they should bring light to people and places that did not, themselves, have light. Today we think of that approach as containing a fair amount of hubris. If we from Amherst can create light, it is only done in close connection with others. Perhaps in two hundred years time this will seem as shortsighted and culturally bound, though well intentioned, as the actions of the early Amherst graduates. The words of philosopher Hannah Arendt must guide our every step: we have "to think what we are doing."

Molly Mead is Director of the Center for Community Engagement

Directory

Amherst Senior Center

The town of Amherst opened the Amherst Senior Center in 1968. A multi-purpose department, it offers a wide range of programs and services to elderly people in the greater Amherst area.

The center serves as the community focal point for the provision of services and referrals to the elderly, while also offering a wealth of Senior Center activities. It works to initiate, facilitate, coordinate, and provide services that, in the broadest sense, enhance dignity, support independence, maintain health, and promote the involvement of Amherst's elderly in the general community.

The center serves those aged 55 and older, as well as their families. Increasingly baby-boomers even younger than this are taking advantage of some of the center's services.

The many services available include: assistance with basic needs such as housing, income, and food; assistance for people with hearing or vision problems; guidance for people with questions on health care; assistance for people caring for their elderly parents; help with questions concerning Medicare, housing, health, social well-being, and community services; assistance with transportation needs; community information about safety issues, and funding for immediate health, housing or other emergency situations.

Senior Center activities include: senior lunches, continuing adult education classes, trips, outings and social clubs.

Maura Plante, Program Director/Services
plantem@amherstma.gov
Bangs Community Center
70 Boltwood Walk
Amherst, MA 01002

Springfield No One Leaves/*Nadie Se Mude*

Springfield No One Leaves/*Nadie Se Mude* organizes tenants and former home-owners who are living in recently or soon-to-be foreclosed homes to stop evictions, protect Springfield's housing and communities, and mobilize residents to resist the major lending institutions and banks that are tearing our communities apart.

SNOL believes that financial institutions should rewrite loans at real market value and fixed interest rates; accept rent from occupants; or sell the homes back to occupants at real market value.

SNOL makes the following demands on financial institutions, including major banks, lending agencies and investors:

1. End no-fault evictions after foreclosure:
 a. Banks should accept occupants' rent money and stop evicting tenants and former homeowners for no fault,
 Or:
 b. Sell back the home at real market value to the former home-owners.

2. Reduce principal:
 a. Because banks created a financial crisis and subsequently got bailed out from it by the federal government, they should reduce the principal balance of underwater mortgages to the current market value to prevent families from being displaced.

3. Turn vacant bank-owned properties over to communities to be used for long-term affordable housing.

Springfield No One Leaves organizes for these demands using a two-part strategy model. The first requires community action: encouraging residents to stay in their homes and making their stories public, SNOL organizes blockades, vigils, protests, rallies and other actions to exert public pressure on the banks. The second depends upon a legal defense: SNOL informs bank tenants of their rights and works with legal services and progressive lawyers to use aggressive post-foreclosure eviction defense to win the dismissal of eviction cases, earn large move-out settlements when appropriate, and pressure the banks to reconsider foreclosure evictions.

A member of the regional network NEW ROAD (New England Workers and Residents Organizing Against Displacement) and the national coalition, Right to the City, SNOL members also participate in campaigns for national policy change both locally and in sites around the country. Most recently SNOL members participated in a successful campaign to pressure the Obama administration to replace the acting director of Fannie Mae and Freddie Mac, the majority-publicly owned housing lending agencies. In January 2014, an Obama appointee, Mel Watt, became head of the Federal Housing Finance Agency, which regulates Fannie Mae and Freddie Mac.

http://www.springfieldnooneleaves.org
Malcolm Chu and Roberto Garcia Ceballos, Community Organizers
413-342-1804
info@SpringfieldNoOneLeaves.org
29 Oakland Street,
Springfield MA 01108

Voices of the Community/*Voces de la Comunidad*

Voices of the Community/*Voces de la Comunidad* is a made up of residents of the North End neighborhood of Springfield, a predominantly Puerto Rican inner-city community. Our volunteer-members work to improve the neighborhood of the North End. We do this by providing information to residents and listening to their needs; seeking alternatives and solutions to community problems; making our voices heard; acting as advocates for North End residents; organizing the community and building relationships between residents; holding our elected officials and community leaders accountable; providing hope and motivation; and demonstrating that we can be heard.

We believe in social justice. We believe that the growth and improvement of the North End is possible. We believe that the North End is full of leaders and opportunity just like in any positive community. We believe that there are good people here with great skills and capacity. We believe that, if we work together with our community, we can make ourselves be heard. We believe that the people are committed to seeing a better future. We believe that in unity lies our strength. We believe that if we educate the community about changes, improvements and possibilities, we can realize our goals.

From 2010–2012 leaders from Voices of the Community organized to pressure the City of Springfield to repair the Gerena Elementary School building, which was long notorious for its health hazards and poor environmental conditions. As a direct result of resident pressure, during the summer of 2012 the City of Springfield invested over $2 million to repair the building. The US EPA then chose Gerena Elementary School as one of two sites in the United States for a pilot Health Impact Assessment—again the result of community pressure. The EPA study is currently underway.

Currently Voices of the Community is also organizing in response to the proposed casino in Springfield, security needs in the public schools, and the high rates of youth incarceration in the neighborhood.

Jafet Robles, President
413-363-4824
roblesjafet83@yahoo.com

Ivette Hernandez, Vice President
413-328-4141
ivettehernandez33@hotmail.com
27 Newland Street,
Springfield MA 01107

Just Communities / *Comunidades Justas*

Just Communities of Western Massachusetts is a regional membership-based community organization fighting for immigrant justice in Western Massachusetts, as well as on the state and national level. The mission of Just Communities is to mobilize, educate, and empower members of the immigrant community. By bringing together the immigrant community alongside union members, faith leaders, and students, we win on issues of immigrant justice and shift the course of local and state politics. Our efforts to expand and defend workers rights in Western Massachusetts are driven by leadership development, direct action and community organizing. A key principle of our work is that it is led by the communities most directly affected by issues of immigration justice.

Bliss Requa-Trautz, Community Organizer,
(413) 306-3483
bliss@comunidadesjustas.org
640 Page Blvd #101
Springfield MA 01104

Editorial note
Collaborative Art: the theory and practice of working with communities

The transformation of this world depends on you is the third in a series of three collaborative art projects hosted by Amherst College in which an artist is invited to work with students to explore the relationship between the college and the local community and to produce artworks that bring the two communities closer together.

The first project, *Who Am I in this Picture? Amherst College Portraits*, led by the California artist Brett Cook in 2007–8, resulted in a campus-wide exhibition of banner-sized triptych portraits that explored divisions and internal tensions between student, staff and faculty communities. A book of the project was published in 2009.

The second, *Exchange/Value*, led by the architect and conceptual artist Rick Lowe in 2009, explored the exchange of time and work between students and seniors. At a time when in-care services for the elderly and disabled were being drastically cut, it helped students to learn new skills and seniors to retain services they had lost. A series of newsletters documented the exchange.

The third project, published here, grew out of Fazal Sheikh's collaboration with the students and with members of the wider Springfield community, many of whom were experiencing economic and social hardship. The students were encouraged to look beyond the campus and consider lives very different from their own.

List of illustrations

Against All Assumed Authority

pp. 12, 15, 23, Amherst College Archives and Special Collections (A.C.A.S.C.)

A Wake Up Call to God

p. 28, A.C.A.S.C.

p. 31, Portrait of Noah Webster courtesy of Yale University Library, A.C.A.S.C.

Reuben Tinker

p. 32, *Sermons*, by Reuben Tinker, with a biographical sketch by M.L.P. Thompson, New York, Derby & Jackson, 1856, A.C.A.S.C.

p. 35, A.C.A.S.C.

p. 36, Courtesy of the Herb Kāne Family Trust

p. 39, A.C.A.S.C.

Justin Perkins

pp. 42/46, Justin Perkins Papers, A.C.A.S.C.

pp. 47, 49, 50, Henry J. Van Lennep, Sketches and Papers, A.C.A.S.C.

pp. 53/54, Justin Perkins Papers, A.C.A.S.C.

Henry Lyman

p. 56, A.C.A.S.C.

p. 59, Henry J. Van Lennep, Sketches and Papers, A.C.A.S.C.

Henry Van Lennep

pp. 62, 64, 65, 66, 68, 69, 71, Henry J. Van Lennep, Sketches and Papers, A.C.A.S.C.

Elijah Bridgman

pp. 72, 76, 81, Elijah C. Bridgman biographical file, A.C.A.S.C.

Joseph Neesima

Joseph Neesima, c. 1870

pp. 82, 84, 85, 87, 89, 92, Neesima and Uchimura Collection, A.C.A.S.C.

Uchimura

p. 94, Neesima and Uchimura Collection, A.C.A.S.C.

The Ward Family

pp. 98, 101, 103, 105, 106, 107, 109, William Earl Dodge Ward Family Papers, A.C.A.S.C.

pp. 110/112, Paul Langdon Ward Papers, A.C.A.S.C

p. 113, William Earl Dodge Ward Family Papers, A.C.A.S.C.

About the Authors

Wendy Ewald is an American photographer and educator. Her books include *Secret Games: Collaborative Works with Children 1969–1999* (Scalo, 2000), and *Towards A Promised Land* (Steidl, 2006). She is a visiting artist-in-residence at Amherst College.

Thomas Keenan teaches media theory and human rights at Bard College, where he directs the Human Rights Project. His books include *Fables of Responsibility* (Stanford UP, 1997) and, with Eyal Weizman, *Mengele's Skull* (Sternberg Press, 2012). He has served on the boards of human rights organizations and journals including *WITNESS*, the Crimes of War Project, the *Journal of Human Rights*, and *Humanity*.

Martha Saxton teaches U.S. History and Women's and Gender studies at Amherst College. Her books include *Louisa May Alcott* (Farrar, Straus & Giroux, 1995) and *Being Good: Women's Moral Values in Early America* (Hill & Wang, 2003). She is currently working on a biography of Mary Ball Washington, the mother of the first President of the United States.

Fazal Sheikh's books include *The Victor Weeps* (Scalo, 1998), *Moksha* (2005), *Ladli* (2007) and *Portraits* (2011), all published by Steidl. His photographs have been shown at venues including Tate Modern, London; the Henri Cartier-Bresson Foundation, Paris; the Museum of Modern Art, Moscow, and ICP (New York). He was named a MacArthur Fellow in 2005 and a Guggenheim Fellow in 2012. He is currently working on *Erasure*, a series of books about Israel and Palestine, to be published by Steidl in Fall 2014.

Acknowledgments

The editors would like to express their appreciation and thanks to the ten individuals who offered their testimonies with such bravery and candor: Arline Wright, Carmen Rodriguez, Christine Wells, Jafet Robles, Rona Thompson, Luis Manuel Perez, Margarita Albelo, Parvin Niroomand, Paul Vasconcellos, and Sellou Diate.

We are grateful to the students who helped on this project during the Fall 2012 semester. They created the original library exhibition and on-demand book based on their collaborations with members of the Amherst Senior Center: Omar W. Brown, Tian L. Buzbee, Leigh A. Cohen, Amanda B. Klajbor, Gavriela S. Rosenberg, Sophie G. Schultze, Jordan D. Seefried, Jake T. Taylor, Wrenford C. Thaffe, Cory E. Ventres-Pake; with special thanks to Molly S. Taylor.

We would also like to thank President Biddy Martin, Dean Greg S. Call, and the President's office for the support to pursue and complete the many stages of this work.

Thanks also go to Molly Mead and Sarah Barr at the Center for Community Engagement for their ideas and enthusiastic support; to Destry Maria Sibley, who opened many doors to members of the Springfield community, and to Maura Plante at the Amherst Senior Center for her support and for sharing her knowledge about the Amherst community.

Special thanks go to the Library Services, with Mike Kelley at the helm, and Margaret Dakin, who helped hone the material. Their creative engagement with the students and faculty and imaginative work in bringing the Special Collections alive to the College community were the foundation of this and many other projects. See their work at: http://consecratedeminence.wordpress.com.

We are grateful to the department of Art and the History of Art for housing the project and the Collaborative Art course and to Louise Beckett for her constant, thoughtful, logistical support.

We extend thanks to Geoffrey C. Ward, Enrico Ferorelli and Tom McDonough for their wise advice and counsel on the manuscript as well as Rick Griffiths, who helped us come to the topic at the outset.

Our deep appreciation goes to Gerhard Steidl, for the exceptional generosity he offers his artists, and for enabling us to follow our vision.

Finally, this book would not have been possible without the considered devotion of Liz Jobey, who guided the material through each step of the process, and whose essential advice and insight enabled us to complete the publication.

First edition published in 2014

© 2014 Wendy Ewald for the Foreword
© 2014 Thomas Keenan, for the Introduction
© 2014 Martha Saxton for the biographical essays in Part One
© 2014 Arline Wright, Carmen Rodriguez, Christine Wells, Jafet Robles,
Rona Thompson, Luis Manuel Perez, Margarita Albelo, Parvin Niroomand,
Paul Vasconcellos, Sellou Diate, for their testimonies
All photographs courtesy of the above

© 2014 Molly Mead, Destry Maria Sibley for their texts

© 2014 Fazal Sheikh for the Portraits

© 2014 Steidl Publishers for this edition

Book design: Fazal Sheikh, Simone Eggstein, Zürich
Text editor: Liz Jobey, London
Proofreading: Bill Molesky
Separations: Steidl's digital darkroom
Production and printing: Steidl, Göttingen

Steidl, Düstere Strasse 4/37073 Göttingen, Germany
Phone +49 551 49 60 60/Fax +49 551 49 60 649
mail@steidl.de
www.steidl.de

ISBN 978-3-86930-780-0
Printed in Germany by Steidl